DO NOT ERASE

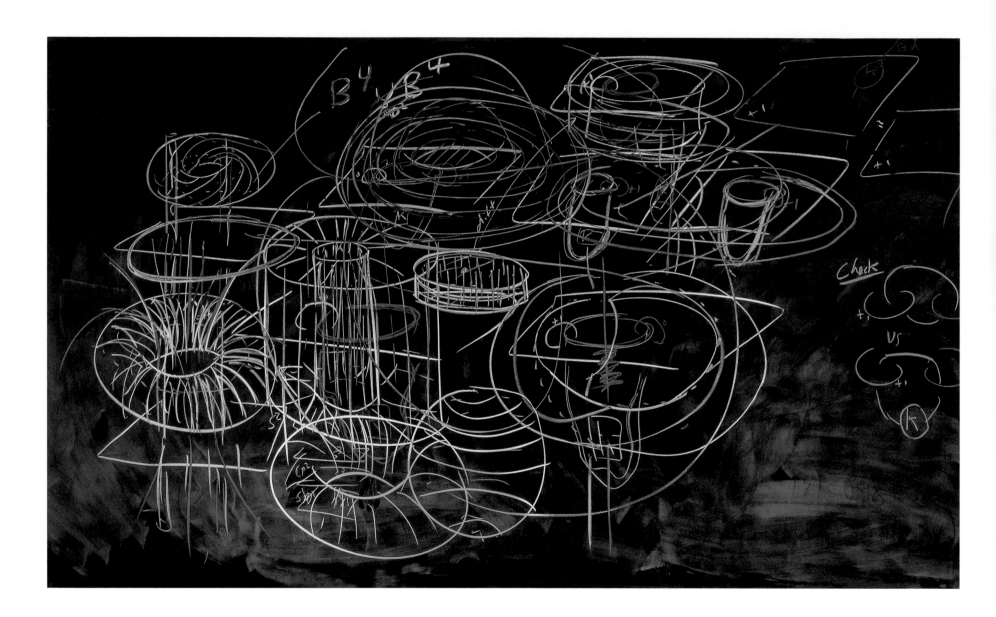

DO NOT ERASE

MATHEMATICIANS AND THEIR CHALKBOARDS

JESSICA WYNNE

AFTERWORD BY ALEC WILKINSON PRINCETON UNIVERSITY PRESS PRINCETON AND OXFORD

For my daughter, Molly

INTRODUCTION

I grew up in a house on the campus of a boarding school in Connecticut. My parents were teachers there—my mother taught art and my father taught history and coached the wrestling team. My life was immersed in this insular world—the school was my home and my playground. On the weekends my sisters and I would play in the classrooms, the rooms were often hot and musty and smelled of teenagers and chalk.

Many years later, I find myself back in dusty, chalk-filled classrooms, photographing the chalkboards of eminent mathematicians. How did I get here? The deeper answer, most likely, is that it still feels like home to me. The more immediate reason, however, comes out of a conversation I had in another part of New England.

Every summer, I take a break from academia and leave my home in New York City to join my family in a small beach town on the outer tip of Cape Cod, Massachusetts. Over the years, I've become very close to my neighbors, who live in a house once occupied by my paternal grandfather. Amie Wilkinson and Benson Farb are a married couple and parents of two. They are also theoretical mathematicians who teach at the University of Chicago. Amie's research focuses on smooth dynamical systems and ergodic theory; Benson's work explores low-dimensional topology and geometric group theory.

Amie and Benson are theoretical or "pure" mathematicians, which means they do "math for math's sake." They are interested in ideas, abstraction, exploring the boundaries of pure reason without explicit or immediate application in the physical world—akin to art, philosophy, poetry, and music. Practitioners of applied math, on the other hand, use theories and techniques to solve practical problems in the physical world. Although their objectives are different, these two branches of mathematics are inextricably linked: there are numerous examples of discoveries in pure math that would be revealed to have revolutionary applications years later. In fact, one could say that all modern technology is derived from pure mathematics.

One day on the Cape, I watch Benson work at his dining room table. He is listening to Indian ragas with the volume so loud I can hear the thumping beats of the tabla through his headphones. For several hours, he sits, thinking, creating, jotting down the occasional note. It looks like he has a secret. I feel like he is creating something so expansive and beautiful it is beyond words, something that exists only in his head.

When I ask him to explain what he is working on, he pauses, appears to struggle for the right words, and replies, simply, "No. I can't."

Later, after giving it some thought, he tells me he is working on "configuration spaces," thinking about all of the possible configurations of, say, 10,000 distinct points moving around in a 4-dimensional space. Benson notes that this is a 40,000-dimensional problem. He's trying to discover patterns within this extremely complex system. Or in his more technical terms: "I'm trying to decompose the cohomology of the space of configurations of n points on a manifold as a direct sum of irreducible representations of the symmetric group S_n, where n can be any number (like 10,000)."

Mathematics at Benson's level is not easily translatable to the layperson. Some things are just complicated and cannot be reduced in a meaningful way to a concise,

easy-to-understand statement. It is like a special foreign language, unknowable to all but a few.

I have always used my camera as a way to understand and explore the world. At sixteen, I left my home in the Northeast to spend a year at a boarding school on a hill station in southern India. (My mother had attended the same school.)

Before I left, my father gave me a gift: a twin-lens reflex camera, medium format, heavy, clunky, with a beautifully worn brown leather strap and case. I loved it. I brought it with me to India and soon discovered that the camera is a powerful tool—it made me feel fearless and allowed me to connect to people and places that were seemingly inaccessible. This was exciting to me.

Thirty years later, I return to India, this time leading a group of my photography students on a study abroad trip. We are in Jaipur, Rajasthan. I arrange a visit to an elementary school so my students can take portraits of the children, and the children can practice their English with us. The principal takes us through a maze of back doors and staircases to the roof of the schoolhouse. We emerge to discover that there are chalkboards surrounding the perimeter. Some are on stands; some are on the ground leaning against a low wall. All are filled with lessons in Hindi, a language that is foreign to me. The boards are beautiful but inaccessible. I walk around the roof and photograph each one.

Back home, as I sort through my photographs from the trip, I keep coming back to the images of the chalkboards. They symbolize so much for me: the interplay of aesthetic beauty and practical use; the foreign and the familiar; understanding and mystery. The writing on the boards in Jaipur reminds me of the mathematical symbols in Benson's notebook. I see this connection and the project begins to take shape.

The chalkboard is one of the oldest and most important analog tools for learning. At first, students used small, individual pieces of slate and would sit at their desks working on their boards. But their teachers had no way to share and demonstrate their work with an entire class. Although there is some dispute about the date, many believe that the first large chalkboard was installed in a classroom in 1801. Eventually it evolved into what we know now: a large object, typically with a black or green surface, hanging on a wall. No longer made of slate, most boards are made out of porcelain-enameled steel.

Despite technological advances (such as the creation of computers), chalk on a board is still how most mathematicians choose to work. As musicians fall in love with their instruments, mathematicians fall in love with their boards—the shape, the texture, the quality of the special Japanese Hagoromo chalk. The boards are their homes, their labs, their private thinking spaces.

When mathematicians start writing on an empty board, they often have no idea where their calculations will go. The board leads them there, like a blank page for a writer, or an empty frame for a photographer.

Working on a chalkboard is a physical, time-based act. It lets the narrative of solving a problem unfold in real time, slowing thought down and allowing the information to be more easily absorbed. The speed of thought, observation, and quiet contemplation doesn't always match the accelerated velocity of digital technology—faster isn't necessarily better when you're creating and discovering.

The tactile experience of holding chalk and drawing on a board influences the way you think. All of your senses are engaged, and your body is moving through space. Your brain lights up. Thoughts are exploding—erupting—at the moment of discovery.

I begin in New York City, my home. The mathematicians at Columbia University, CUNY Graduate Center, and the Courant Institute of Mathematical Sciences at New York University are gracious and welcoming. They are intimately familiar with the beauty of math, and they want to share it with me.

As I start shooting, I begin to set a few parameters. I will only photograph actual chalkboards—no glass or white boards—mainly for their inherent beauty and timeless quality. I ask the mathematicians to write or draw whatever they want on their boards. (Often I end up shooting whatever is already on the board—usually something they are currently working on.) I photograph in a literal, objective, straightforward way—showing the chalkboards as real objects—capturing their texture, erasure marks, layers of work, and all forms of light reflecting off their surfaces.

The formulas and mathematical symbols are inaccessible to me. And I don't mind not knowing. I actually like the tension of being seduced by the formal abstract beauty—the patterns, symmetry, and structure—while simultaneously feeling totally disconnected, not being able to fully access the meaning of their work. This friction of being drawn in and pushed away is exciting to me. I may not know the specific meaning of the theorems, but I do know that beyond the surface they are ultimately revealing (or attempting to reveal) a universal truth.

I am in Rio de Janeiro, Brazil. I travel here with my neighbor, Amie, who comes to judge a math competition. I visit the Instituto Nacional de Matemática Pura e Aplicada (IMPA). This is my first time in Rio, and I am amazed by the landscape—the city surrounded by dramatic mountainous terrain, ocean, and natural wilderness. At the institute, I can see the lush green jungle through the windows of the classrooms. I photograph these details to show the specificity of the place. Mathematics is the same no matter where you are in the world—you can be on 116th Street in New York City or in a small village in France. It is a universal language.

Back home, I crisscross the United States, traveling to the Institute for Pure and Applied Mathematics (IPAM) at the University of California, Los Angeles; Rice University; Princeton University; Yale University; Harvard University; Massachusetts Institute of Technology; Northwestern University; and University of Chicago. Without Amie as my tour guide and translator, I am on my own, and I dedicate myself to getting to know the mathematicians. They are gracious beyond my expectations.

I drive down to the Institute for Advanced Study (IAS) in Princeton. Academic institutes are places where the only job of the researcher is to think—ideally without interruption. Researchers are invited to work in their fields free of teaching responsibilities. Here they are in essence protected from the outside world; their physical environment gives them psychological space.

I meet Helmut Hofer, a German-American mathematician who is one of the pioneers in the field of symplectic topology. He also works in the areas of dynamical systems and partial differential equations. I observe as he draws

an intricate formula on his board for me. It is an explosion of thought—with abstract, swirling, hypnotic lines. The picture shows the mathematical concept of "finite energy foliations" in "symplectic dynamics." He tells me that this theorem represents many years of work and it describes a complex mathematical structure in a very condensed way. He says that this drawing is equivalent to several hundred pages of technical mathematical language. Midway through the shoot, he puts down his chalk and says, "Follow me." It is teatime. I follow as instructed, and soon find myself having afternoon tea with fifteen brilliant mathematicians. Helmut introduces me to many of them, helping recruit more participants for my project.

I enjoy watching the mathematicians work on their boards. It is an ephemeral performance, only occurring once. (And the photographs are the only evidence that this performance has taken place.) They have a heightened aesthetic awareness, distinct styles and ways of using the chalk, just like a visual artist. Some of the formulas are intensely chaotic, with explosive energy, while others feel neat, quiet, serene, and carefully considered. There is also the sheer size and physicalness of the board. It is a large object hanging on the wall—you can live with the work, and multiple people can work on it simultaneously.

I am in Paris, once more with Amie, who is in town to meet with two of her collaborators, Artur Avila and Sylvain Crovisier. It is here, at the Henri Poincaré Institute, thousands of miles away from her home at the University of Chicago, that I photograph Amie's board. Her chalkboard is made of slate and is more than one hundred years old. I think of its history, wondering who else has worked on this board, and what discoveries have been made on its surface.

Amie draws a formula that encapsulates the central argument of a theorem that she and another collaborator, Keith Burns, had worked on for ten years. She tells me that even after finally solving the problem, it still took some time to organize the argument and find the cleanest way to express the proof. There can be many variations of a proof. And the way the proof is expressed is important—it should be elegant and concise. It is like taking the scaffolding away to reveal a beautiful building that you've been constructing for years.

I feel a mounting excitement as I watch Amie fill up her board with colored chalk and three-dimensional shapes—it is extraordinary—and the lines seem to vibrate with energy and depth. I lean in and look into my viewfinder to watch her work. She sees only what is within the frame of the board, as I see only what is within the frame of the lens. She depicts a sequence of shapes that are equivalent to one another, starting with a spherical ball and ending with something called a julienne (since it looks like a thinly sliced vegetable). She tells me that this theorem identifies the criteria that define when a certain dynamical system is "chaotic." Chaos theory explains that even a slight variation in an initial system can produce erratic, complex, and inconsistent effects—often referred to as the "butterfly effect": if a butterfly flutters its wings in one part of the world, it might lead to a tornado in another part of the world.

While in Paris, I also visit the Institut des hautes études scientifiques (IHES), a mathematics and theoretical physics research institute located in Bures-sur-Yvette, just south of Paris. I arrive on foot, after walking several miles from the neighboring town of Orsay (where I

was visiting mathematicians at Université Paris-Saclay). As I wander up the steep hill toward the main building, I am surprised to see chalkboards outside. The boards are standing on thin metal poles, scattered in the grass and woods surrounding this institute. It is disorienting and surreal. I imagine the mathematicians working in solitude and silence among the trees. Patterns and beauty in mathematics are often reflections of the natural world, and the boards filled with formulas seem to be at home in nature.

I am interested in learning about the moment of discovery, the epiphany of solving a problem. Some mathematicians spend a lifetime on one problem and are never able to solve it, while others break through, find the truth, and reveal an elegant mathematical proof. When this moment of realization happens, many describe it as being transformative. It can happen while one is meditating in an isolated cabin in remote rural Ireland (David Gabai, Princeton University) or sitting on a beach in Maui watching a friend kiteboarding (Dimitri Y. Shlyakhtenko, IPAM/UCLA). There is a euphoric feeling when one has that rare flash of insight. Hélène Esnault, a French-German algebraic geometer, tells me, "After the fog, light comes. It is a short and silent moment of joy." Jim Simons, mathematician-businessman-philanthropist, says, "One is perfused with a warm feeling of satisfaction." Others describe this sensation in more visceral terms. My neighbor Benson Farb writes, "I often tell people that I feel like an addict, relentlessly in search of the high that comes from discovering something new, but that's always been there (a mathematical truth was true even before the universe existed; it was there waiting for me all along!)."

These breakthroughs come rarely, and typically come only after repeated failure.

Now, several years into my journey into the rarified world of higher mathematics, I think a lot about patterns. Patterns of images, to be sure, but also of processes. Of how mathematicians and how artists see the world. There are similar patterns not only in how we see but also in how we think, how we work, and how we create. Put differently, even if I still don't understand all of what mathematicians do, I do very much relate to who they are. They live inside their imaginations, follow their intuition, get lost in thought, create with physicality, and explore the unknown.

Their work, like that of all great artists, should be preserved, honored, and recognized: they are expanding knowledge—seeking the truth—and building on what has come before. I am fortunate because I was able to see, and now share, something that most of the world never gets to enjoy—the world of higher mathematics. It is a remote, austere world, and is, to some extent, a secret society. I am deeply thankful to the mathematical community for inviting me in and allowing me to record their work and bring back the evidence that there is discovery, truth, mystery, and beauty all around us, hidden away in dusty, chalk-filled rooms around the world.

—Jessica Wynne

CHALKBOARDS & REFLECTIONS

PHILIPPE MICHEL

Philippe Michel is head of the chair of Analytic Number Theory at the Swiss Institute of Technology, Lausanne, where he has been on the faculty since 2008. He obtained his PhD in 1995 from Université Paris XI and subsequently held several positions in France.

Blackboards are a fundamental component of a mathematical life. The very first thing I did when I arrived in my office in Lausanne ten years ago was to ask that the ugly whiteboard, with its smelly red pen, be replaced by a true chalkboard. I got a very good one. A blackboard has to be as tall as possible so that its boundaries do not interrupt the flow of thinking and writing. In this regard, the immense blackboard in this photograph (which covers an entire wall of the common room in the mathematics department at Columbia) far exceeds expectations.

For a smooth and seamless writing experience, high-quality chalk is also important. I was particularly moved when a postdoc, returning from Christmas break one year, offered me two boxes of the legendary Japanese "Hagamoro Full Touch" chalk. (No need to break into my office; the stock is unfortunately exhausted.)

The last—but not least—piece of the trinity is cleaning. After years of training, I became adept at the Swiss (or is it German?) way. Here is the recipe: clean the board by applying water with a large cloth wiper, and dry it with a large rubber wiper (a colleague of mine in Zurich is even capable of doing both at once). Use that time to clear your mind. With a clean board and a clear mind, you'll be ready to start anew.

This photograph was taken during a discussion with Will Sawin (who is assistant professor of mathematics at Columbia) concerning a joint project in number theory. Although number theory aims to describe the properties and structures of *whole* numbers, it borrows methods and techniques from many parts of mathematics; this blackboard is a good illustration of this. On this board, you can find ideas related to analysis (modular forms) as well as algebra and geometry (cohomology and sheaves).

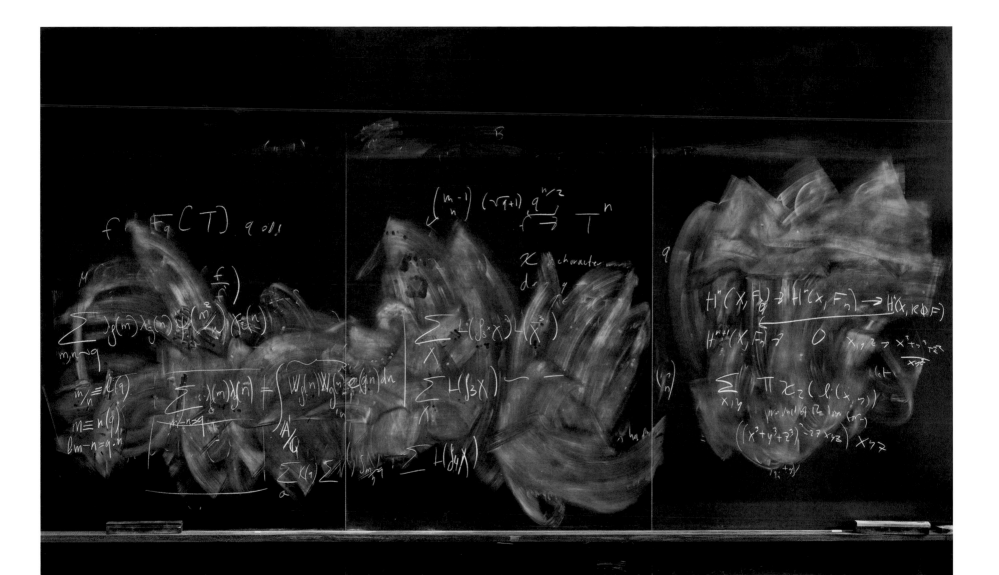

AMIE WILKINSON

Amie Wilkinson is a professor of mathematics at the University of Chicago working in ergodic theory and smooth dynamics. She received her undergraduate degree at Harvard in 1989 and her PhD at Berkeley in 1995. She held post-doctoral positions at Harvard and Northwestern and rose to the level of professor at Northwestern before moving to Chicago in 2011. Wilkinson's research is concerned with the interplay between dynamics and other structures in pure mathematics—geometric, statistical, topological, and algebraic.

I work in an area called dynamics, which is the study of motion. The origins of the subject lie in physics; one of the earliest problems in dynamics was the stability of solar systems. My work focuses more on abstract mathematical spaces, but visualization and drawing pictures are key components of both understanding and discovery.

On this blackboard is a central argument in a paper I wrote with Keith Burns (professor of mathematics, Northwestern University) about a mechanism for chaotic dynamics. It depicts a sequence of shapes that, in a precise sense, are equivalent to each other, starting with a spherical ball and ending with something called a julienne, named for its resemblance to a thinly sliced vegetable. We are proud of this paper; as Keith likes to say, a good paper has one truly new idea, and this one has two.

Doing math on a blackboard is a tactile experience. You are constantly going back to change and modify things you have already written. Sometimes you write something and immediately realize you need to change it, and with a rub of your fist, you can erase the offending material and fix it. Or, when you are explaining something, you might draw an initial picture, write some formulas and explanations, and then go back to the original picture to add more—to explain in the picture what you just explained in words.

Chalk comes in many rich colors. You can shade things in with chalk, indicate depth and form. I love chalk, even though I hate the mess it makes and how it dries out my skin and hair. It is smooth and crisp on a clean blackboard and can be seen from a distance. It is one of my main tools of expression.

TERENCE TAO

Terence Tao was born in Adelaide, Australia, in 1975. He has been a professor of mathematics at UCLA since 1999, having completed his PhD at Princeton in 1996. Tao's areas of research include harmonic analysis, PDE, combinatorics, and number theory. He has received a number of awards, including the Fields Medal in 2006, the Mac-Arthur Fellowship in 2007, and the Breakthrough Prize in Mathematics in 2015. Terence Tao also currently holds the James and Carol Collins Chair in Mathematics at UCLA, and is a member of the National Academy of Sciences and the American Academy of Arts and Sciences.

I see mathematics as this wonderfully connected web of ideas and insights; a thriving ecosystem that spans pure abstract thought at one end of the spectrum, and concrete practical applications at the other.

I don't know where this metaphor originates, but I have often heard mathematics described in terms of a landscape shrouded in fog and mist. At first there is nothing to see; then, as the mist lowers, you begin to observe isolated peaks (a peak of geometry, a peak of algebra, and so forth). A little later, when the mist is lower still, you start to see connections between the peaks (for instance, Descartes's discovery of Cartesian coordinates makes it possible to link geometry and algebra, ultimately leading to the fertile valley of algebraic geometry). When you are experienced enough in mathematical research, the fog dissipates almost entirely, and you finally begin to see the cities and roads at the bottom of the landscape, in between all the peaks. That's where some really interesting stuff happens.

The blackboard shown here depicts part of the web of ideas and results that surround one of my favourite unsolved problems, namely, the twin prime conjecture. This conjecture asserts that there are infinitely many pairs of prime numbers that are separated by a distance of two from one another. This problem has its roots in number theory, but all the progress towards solving it proceeds through analysis—in particular, through trying to establish upper and lower bounds on the count of twin primes, up to a given threshold. This problem remains intractable for a number of reasons, but one of them is the parity problem, which is the frustrating phenomenon that it is difficult to distinguish analytically between numbers with an even number of prime factors and numbers with an odd number of prime factors. But a close cousin of the twin prime conjecture, known as Chowla's conjecture, has seen recent progress, even though it is also subject to the parity problem. Both conjectures are still open, but for the first time there seems to be hope of a breakthrough. The recent progress has connections to many other areas of mathematics: ergodic theory, additive combinatorics, information theory, graph theory . . . we are still trying to understand exactly how it all fits together, but the emerging landscape looks exciting. It certainly looks broader than what can fit on even the largest blackboard.

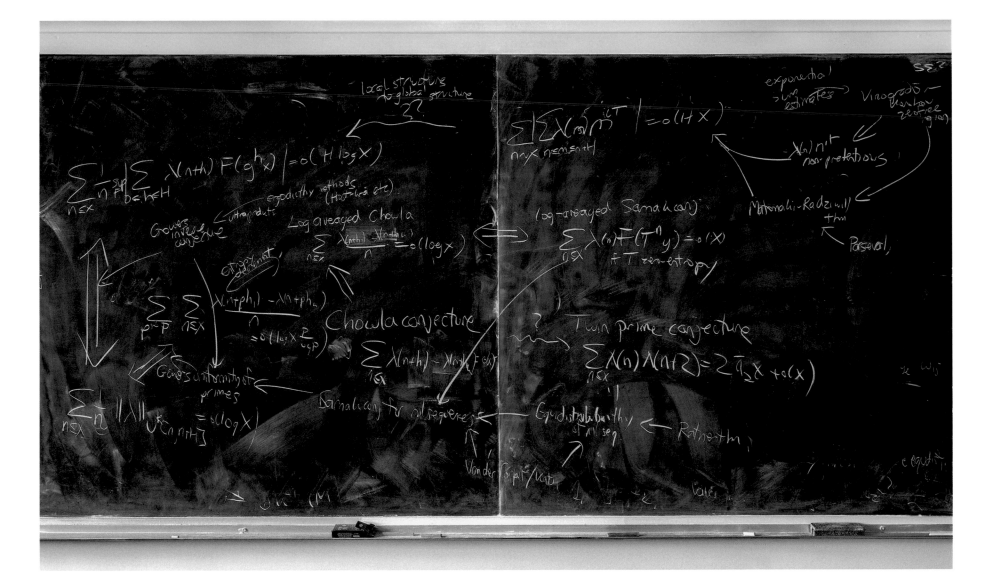

BENSON FARB

Benson Farb is professor of mathematics at the University of Chicago, where he has been since 1994. He obtained his PhD from Princeton University in 1994 under the direction of William Thurston.

Consider all the possible configurations of points moving around in a fixed space: think of the roughly 10,000 airplanes flying around as you read this, the quintillions of molecules moving around in a test tube, or the hundreds of robots moving around in an Amazon distribution center. To mathematicians, each of these systems is a special case of a common framework called a "configuration space." To keep track of such a system—let's take the airplanes as an example—we need to record the longitude, latitude, and height of each plane at any given time. In other words, we need to specify $(4 \times 10,000) = 40,000$ numbers. We can think of the snapshot of all airplanes currently in the air as a single point in a 40,000-dimensional space. Since each plane is changing its position over time, the corresponding "configuration of planes," represented by a single point in this 40,000-dimensional space, is likewise moving around over time.

The space of all possible configurations is extremely complicated, as flight paths (or molecules, or robots) can interweave with one another in complicated patterns over time. The crucial property of all of these systems is that the objects cannot occupy the same point in space at the same time. As a mathematician, if I discover something about a configuration space, it applies not only to airplanes, molecules, and robots but to any possible collection of objects moving around.

Such systems are too complicated for even the most powerful computers. To describe and understand such systems, and to make predictions about them, we can apply the powerful edifice of mathematics. While I can't visualize 40,000-dimensional—or even 4-dimensional—space, I can reason about it. How do I actually do this? How can I communicate this reasoning to others, and they to me?

The main tool that most of us use to communicate our ideas is the chalkboard. (The term "blackboard" is used in Wikipedia, but I don't like that term because not all chalkboards are black.) A computer doesn't help much with 40,000 dimensions, but on a blackboard, I can work up a schematic of the situation, explaining it in real time to a student or collaborator. She can jump up and start writing on the board during my explanation, amending my computations, noting possible problems, unwrapping some equation into a flurry of computations of her own.

Doing this dance at the blackboard with someone is an intense, frustrating, energizing, and sometimes moving experience. It's the kind of connection with the mind of another human being that is rare in everyday life. On a huge chalkboard, or even better, on two adjacent boards (or better yet, double boards), we can move around the physical space, around each other, almost living inside the wild 40,000-dimensional spaces about which we are trying to reason.

Chalkboards are a major part of my life. I couldn't live without them.

The board in this photo contains a famous mathematical example constructed by William Thurston, which involves understanding the motion of a configuration of three points. Although there are only three points (as opposed to 40,000 in the example above), such a system is already quite complicated. The quote by William Blake on the lower right corner—"The road of excess leads to the palace of wisdom"—is one that has been inspiring to me, and seems appropriate for these chalkboard experiments.

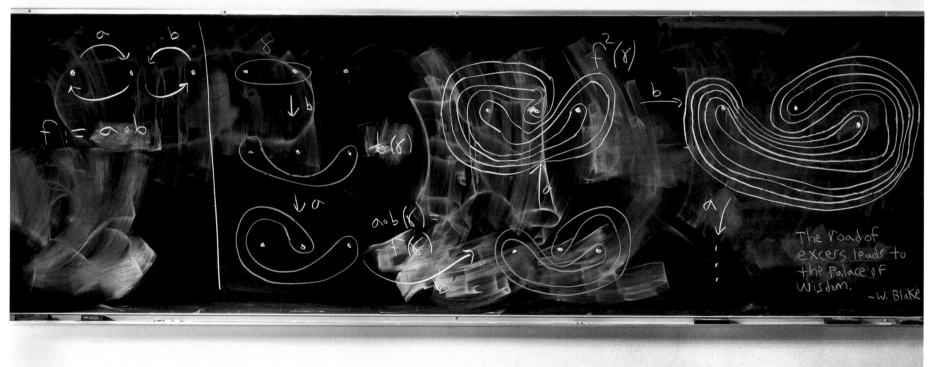

WILFRID GANGBO

Wilfrid Gangbo is professor of
mathematics at the University of
California, Los Angeles. His re-
search interests include nonlinear
analysis, calculus of variations,
partial differential equations, and
fluid mechanics.

I was born in Benin, West Africa, and finished my high school degree there before moving to Switzerland, where I completed my PhD in mathematics at EPFL. Moving from Benin to Switzerland was a cultural shock. I met people whose actions drastically improved my life, but I also met people who constantly kept me under pressure, making me prove that I was equal to everyone else. The campus on which I lived was international, so the pressure there was minimal. People were also polite in the city: however, if you took too long counting your change in the store, the cashier might help you, hoping to save you from the embarrassment of not knowing how to count.

This board contains a brief description of a mathematical problem that was introduced in 1771 by Gaspard Monge, one of the greatest geometers of the past four centuries. Monge, who was born in 1746, was the inventor of descriptive geometry, the precursor to differential geometry. Monge's original problem, which is very simple to formulate, seeks the most efficient way of transporting a pile of dirt to an excavation site, where the cost of transport per mass is proportional to the distance traveled. Here is an example: given a distribution of mines producing iron ore, and a distribution of factories consuming the same total amount of iron ore, determine which mines should supply ore to each factory in order to minimize total transportation costs. Although Monge and his successors had deep insights into this problem, it remained unsolved for more than two hundred years. One of the first breakthroughs was in 1939, when the Soviet economist Leonid Kantorovich, who later won the Nobel Prize, not only extended Monge's problem to more general cost functions but also proposed a remarkable relaxation of the problem. Kantorovich developed an approach during World War II as a way to plan expenditures and returns in order to reduce the army's costs. Remarkably, his work was initially neglected in the USSR.

The chalkboard is the ideal tool for helping others follow your ideas. When you are writing explanations on a chalkboard or a whiteboard, you write at a slower pace than if you are showing previously typed explanations. This makes it easier for someone encountering new concepts to follow along, taking some of the pressure off them.

Optimal transportation theory is a vibrant and rapidly growing area of analysis. Nowadays, there is a large community that uses optimal transport as a tool in various areas of science and engineering, including image processing, economics, population dynamics modeling, social sciences, fluid mechanics, machine learning, medical imaging, and finance.

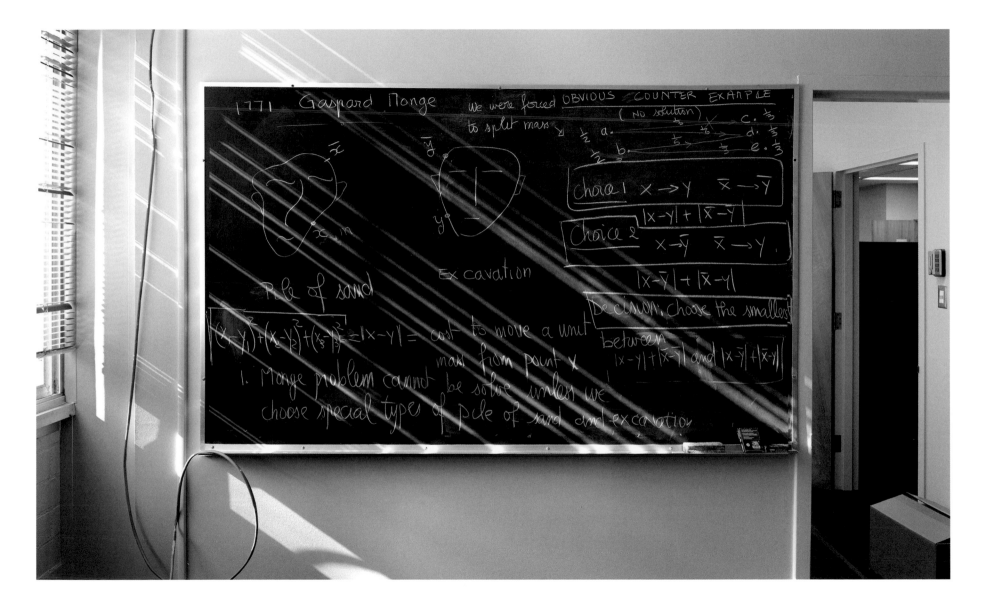

1771 Gaspard Monge we were forced OBVIOUS COUNTER EXAMPLE
 (No solution)
 to split mass $\frac{1}{3}$ c. $\frac{1}{3}$
 $\frac{1}{2}$ a. d. $\frac{1}{3}$
 $\frac{1}{2}$ b. $\frac{1}{3}$ $\frac{1}{3}$ e. $\frac{1}{3}$

\overline{x} \overline{y}

Choice 1 $x \rightarrow y$ $\overline{x} \rightarrow \overline{y}$

\underline{y} $\dfrac{|x-y| + |\overline{x}-\overline{y}|}{x \rightarrow \overline{y} \quad \overline{x} \rightarrow y}$ Choice 2

Excavation $|x-\overline{y}| + |\overline{x}-y|$

Pile of sand Decision: choose the smallest

$\sqrt{(x_1-y_1)^2+(x_2-y_2)^2+(x_3-y_3)^2} = |x-y| =$ cost to move a unit between

mass from point x $|x-y| + |\overline{x}-\overline{y}|$ and $|x-\overline{y}| + |\overline{x}-y|$

1. Monge problem cannot be solve unless we
choose special type of pile of sand and excavation

GILLES COURTOIS

Gilles Courtois (PhD, University of Grenoble, 1987) is director of research at CNRS, Institut de Mathématique de Jussieu.

My chalkboard is an old friend to whom I am constantly writing and sending drawings. His muteness is the most accurate and valuable support I could hope for, at a certain stage of ideas.

Mathematics is a beautiful, deep, moving world where sometimes new sceneries appear after one discovers a passage or simply looks differently at familiar ones.

I particularly like conjectures and theorems that can be expressed and proved in very few, simple words that can be held in a single hand. Sometimes one has to wait a long time before solving problems, just because the existing mathematics does not yet contain the right objects.

One emblematic example is Dido's problem, which asks: among all planar figures having the same perimeter, which is the one enclosing the greatest area? Although the ancient Greeks believed that the circle was the correct answer, many mathematicians have looked for a proof since then. Among them was Zenodorus (c. 200–140 BC), who proved that the circle encloses a greater area than any polygon of the same perimeter. In 1834, Steiner gave a proof with a beautiful, purely geometric construction, but the first rigorous complete proof was not settled until 1879, by Weierstrass. This proof was based on a new emerging field, the calculus of variations, that Weierstrass contributed to. Over time, several other proofs have been discovered and a broad variety of unexpected links with numerous other fields of mathematics have been investigated.

This chalkboard represents an attempt at solving a problem known as the Cartan-Hadamard conjecture. This question addresses Dido's problem in a distinct context where the Euclidean space is replaced by a certain type of non-Euclidean space, called a Hadamard manifold, whose geometry may not be as symmetric as the Euclidean one. Additional subtleties arising from the non-Euclidean nature of these spaces make the question challenging and fascinating. Shortly after this photo was taken, the Cartan-Hadamard conjecture was announced to have been solved.

But getting back to simple proofs, my favorite one is ascribed to Misha Gromov and derives from the following simple observation. On a planet other than a perfectly round sphere, there is no way to balance a stick perpendicular to the ground without it falling down someplace.

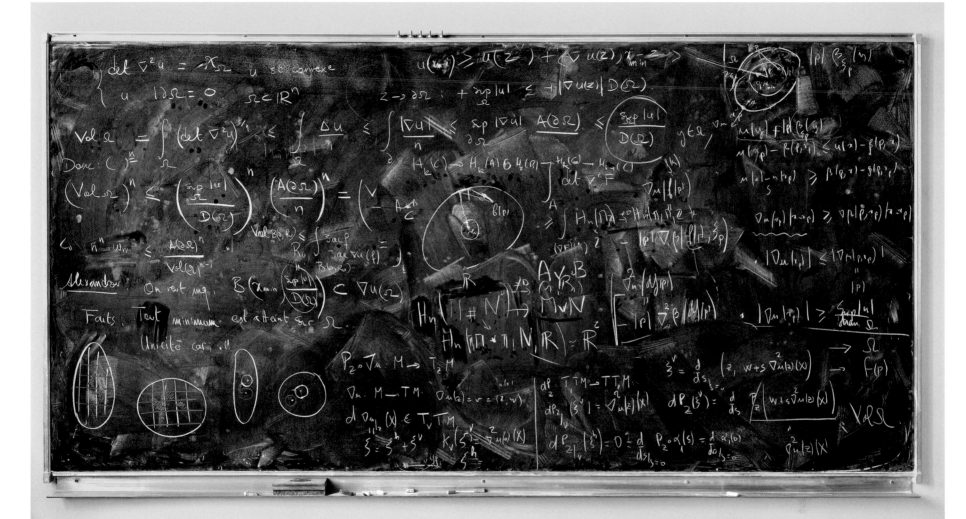

MAGGIE MILLER

Maggie Miller is a postdoc in the mathematics department at Massachusetts Institute of Technology and was previously a PhD student at Princeton University. She studies topology, a branch of mathematics involving flexible shapes and, usually, specifically studies mathematical objects that she can draw or construct. She is interested in mathematical puzzles and games and keeps a collection of over forty variations on the Rubik's cube in her office.

I am a mathematics PhD student at Princeton University. Growing up, I was always very interested in math (my dad used to give me small math problems or puzzles whenever we were out somewhere, as a game) and art (I painted somewhat seriously and showed paintings at the Texas state fair for several years; my mom encouraged me to consider art school). I combine these interests in my research in graduate school, focusing on an area of mathematics that involves a lot of spatial visualization: low-dimensional topology.

Specifically, I study surfaces and three-dimensional objects that are embedded in four-dimensional space. The board in this photograph contains drawings of four-dimensional space. Of course, I can only draw three dimensions at a time: left/right, up/down, and in/out (using perspective). The fourth dimension is represented by time; I typically draw three-dimensional images as frames in a movie that evolve slowly over time. Here we just see several such three-dimensional cross-sections, as I have been trying to zoom in and determine whether two particular objects intersect each other. I usually fill up the whole board before erasing, in case something I thought of earlier turns out to be useful.

I believe the blackboard is an essential tool for mathematics. Usually, to solve (or find) a problem, you have to make many incorrect guesses or other mistakes first. Writing on a blackboard is easily edited, which is useful in the process of shaping one's own thoughts in the process of solving a problem. On paper, even pencil is more difficult to erase, so there is some underlying pressure not to waste space with ideas perceived to be bad—but these "bad" ideas might actually turn out to be very important, or at least inspire progress. Because writing on a blackboard is temporary, it is very easy to put an idea up and see what happens next.

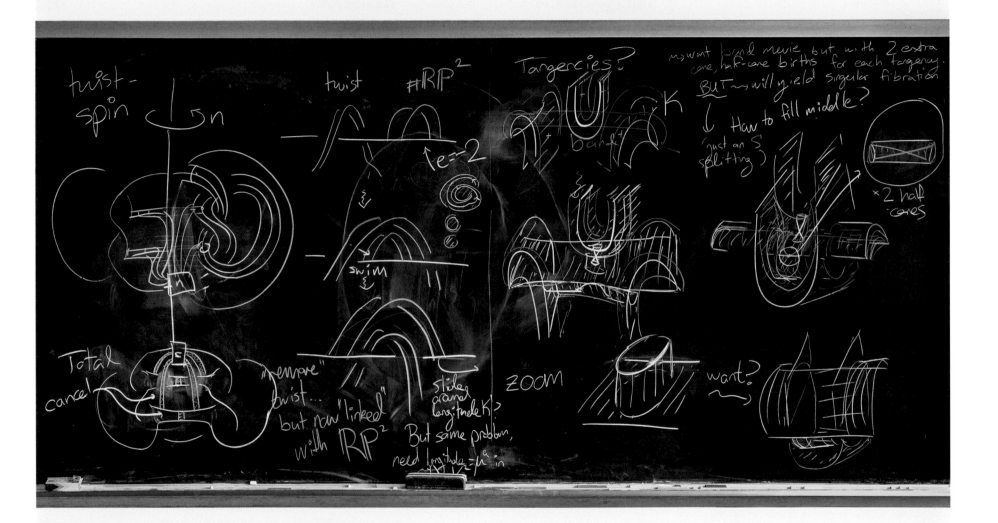

TADASHI TOKIEDA

Tadashi Tokieda is a professor of mathematics at Stanford University; previously he was at the University of Cambridge for many years. He is also active in outreach in the developing world, especially via the African Institute for Mathematical Sciences.

In mathematical expositions, we often need to draw white or black dots. Most mathematicians take a piece of white chalk, draw a wee circle on a blackboard, and call it *white*; they fill in the circle with chalk, and call it *black*.

We mathematicians like to watch mathematics being done with chalk on a board for the same reason that people like to listen to music note by note, in real time. Science, at least mathematics, is made of information plus experience. Our age is addicted to transmitting more and more information, blaring climax ('result') after climax. For us, that's not enough: we also want to experience, indeed to relive personally, how the result has come to be. Only in this way can we create science—and on the side, experience joy.

I grew up as a painter and became a classical philologist (not to be confused with philosopher) before switching to mathematics, while nowadays I try to think physics, all in different countries and different languages. Sometimes, in a familiar world, I forget who I'm supposed to be, then notice something unfamiliar that wasn't supposed to be there. It's like experiencing a moment from another life.

ceci est
un point NOIR

BLANC

SHUAI WANG

Shuai Wang is a PhD student in the Department of Mathematics at Columbia University.

Mathematics teaches us to be humble. It tells us how limited we are as human beings, and shows us the importance and the magic of the diversity of different points of view. More often than not, a change of basis—from local to global, or from spectral to geometric—leads us to a solution, if there is one. At the same time, mathematics also provides us with a deep sense of comfort. Most things are random, but total randomness itself is impossible; mathematics teaches us that patterns inevitably appear. Amid seeming chaos, nature itself follows some universal and simple patterns. To live in a world of sound, light, and heat, and realize that they're understandable—that is the gift that mathematics provides.

Some of the most interesting properties of a given mathematical system are those that are invariant under transformations. Take a deck of cards and start shuffling it. We want to understand how one state of cards evolves into another, and what the most stable states of these systems are. To find the answer to both questions, one good method is to consider the symmetries of the system, by which we mean (numerical) data that remain unchanged under shuffling. Examples include the suits and the number of 8s in the deck—there is no way for a deck of cards with four suits to become one with five suits just by shuffling, or for the number of 8s to change. By investigating the symmetries of the system, we obtain strong constraints on the answers to our questions.

The example on the blackboard in this photograph is an application of this simple fundamental principle. To be more precise, we are computing Yangian symmetries of the equivariant quantum cohomology of Nakajima quiver varieties, which was discovered by Davesh Maulik and Andrei Okounkov.

Mathematics research is like a forest adventure. An explorer learns from a treasure map, and from previous explorers' attempts, that gold and gems might be hidden in a summit of the mist-covered mountains. The blackboard is the mathematician's treasure map. If you want to share your discoveries and your stories, and help other explorers reach the same summit, the blackboard is also a good storytelling place. Ideas and experiences are clarified; routes (called proofs by some) are demonstrated.

Pure mathematical ideas somehow seem predestined to describe the physical world. Mathematicians create rules, and no matter how remote from reality those rules might be, as time goes on, it usually turns out that the rules mathematicians find interesting are those nature has likewise chosen. In mathematics, real numbers are one of infinitely many ways of introducing the notion of continuity on the rational numbers. Indeed, for every prime number p, there also exists a p-adic world. The physical world that surrounds us human beings can be described efficiently by real numbers, but why should nature prefer one particular prime or the real one? A modern fantasy is that on a fundamental level, our world is neither real, nor p-adic, it's adelic—a democracy of all possible continuations of the rational numbers. As a Platonic dream, the discrepancy between quantum physics and general relativity might just be caused by the localization of the adelic world at different p-adic and real places. Mathematics, in other words, can open our ears to the sound of a drum in a p-adic world.

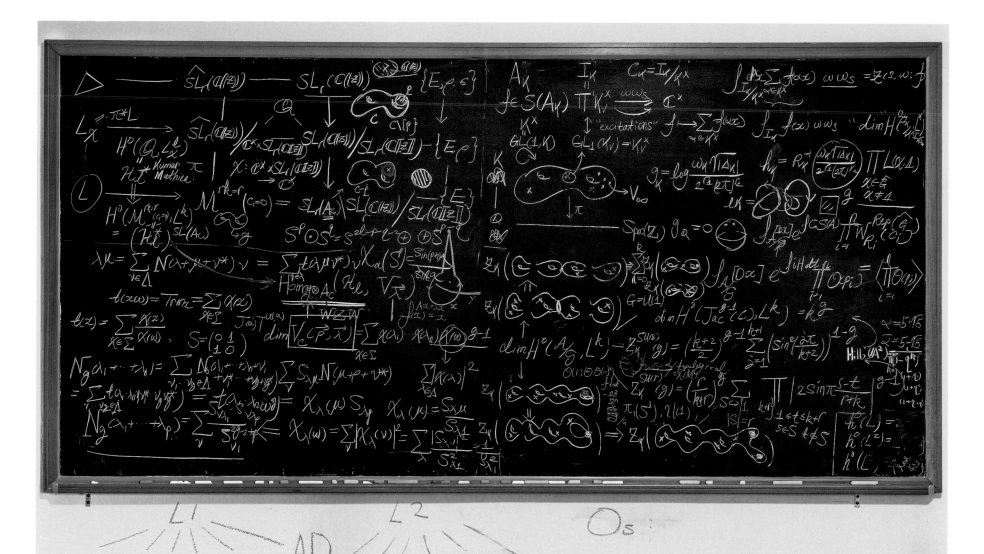

PHILIP ORDING

Philip Ording is a writer and member of the mathematics faculty at Sarah Lawrence College. His first book, *99 Variations on a Proof*, also published by Princeton University Press, received the 2020 PROSE Award for Excellence in Physical Sciences & Mathematics.

Troels's office was on the sixth floor: one flight up the oversize McKim, Mead & White staircase from the math lounge, which boasts the board pictured here; two flights up from what would eventually be my grad-student cubicle; and three flights up from the library circulation desk I then staffed as an undergrad work-study student.

I didn't know what his name meant in the field of geometry when he agreed to supervise my senior thesis. To me, he was a tall, friendly, unassuming Dane. And an extraordinarily patient professor. My answers to his questions met with a "Well, let's see." He would then stand up from his oversized office chair, take a piece of chalk, and draw a figure or write down a Möbius transformation in what seemed like a single gesture. The confidence of these marks on the otherwise spotless board (there didn't even seem to be any dust in the chalk tray) compelled belief in me. Understanding took longer. At one point, rather than give an uncertain answer to a question, I just sat staring at the board. He watched me.

"My mother made me take piano lessons when I was a boy," he finally said. "In the first lesson the teacher asked, 'What do you notice about the keyboard?'" I looked at Troels. "After a very long pause, maybe thirty seconds, the teacher gently remarked, 'Some of the keys are white and some are black.'"

This was Troels's way. If something was obvious to him, he didn't expect we'd feel that way. He knew when we were stuck but was never bothered by it and never showed any disappointment. He identified with his students.

By spring I had begun to make enough progress to take a turn at the board. It was oddly empowering. The surface was perfectly smooth except in an upper corner where a hairline crack was visible at close proximity. Compared to the sliding, enameled porcelain chalkboards in the lecture halls, the chalk produced an inexplicably even sound on this board. And its surface didn't give like the cheap painted Masonite green boards in school. Troels's blackboard was made of slate.

Ever indulgent, he explained how not to make a mess of one's board work. How to keep chalk from squeaking. How to draw figures. The trick to drawing a round circle is posture and momentum. You have to face the board directly—even if it means turning your back to an audience—wind up at the elbow, and do it in one go. To draw a sphere, add two poles and the equator. But don't put the poles on the circle; they never appear simultaneously, except from a point in the equatorial plane, "at infinity." Do draw the equator as though the sphere were partially transparent, with a dashed line for the back half if you want. But don't give it corners like a lens. In the picture plane of the blackboard, the equator projects to an ellipse.

The board in this photo shows how not to draw a sphere.

Of course no one, including Troels, really cares how artful one's board work is if the math isn't interesting. (Was drawing ever a prerequisite for being a geometer?) But a diagram does give us another way to think—or, at least, something to stare at—when language fails. And figuring out for oneself what is and isn't mathematically interesting is never black and white.

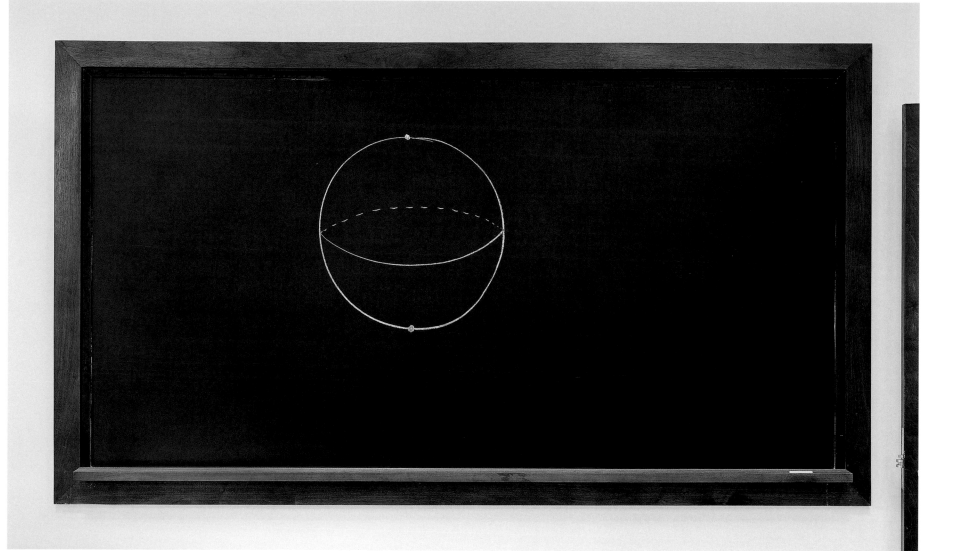

LAURA BALZANO

Laura Balzano is an associate professor in electrical engineering and computer science at the University of Michigan. She is a recipient of the NSF CAREER Award, ARO Young Investigator Award, AFOSR Young Investigator Award, and faculty fellowships from Intel and 3M. Her expertise is in statistical signal processing, matrix factorization, and optimization. Laura received a BS from Rice University in electrical and computer engineering, MS from the University of California in Los Angeles in electrical engineering, and PhD from the University of Wisconsin in electrical and computer engineering.

This photograph has sketches from three different collaborative projects in machine learning and one new idea that I've since decided probably doesn't make sense. With my collaborators, I design and study mathematical models for a variety of data problems. My main research focus is on modeling with big, messy data—highly incomplete or corrupted data, uncalibrated data, and heterogeneous data—and its applications in networks, environmental monitoring, and computer vision. Eight different people were part of the math on this board (either writing or observing), not including my two-year-old daughter, whose art is at the bottom left. Now, during the COVID-19 lockdown, I cannot generate ideas and work with others as easily as I could when I had a board to stand next to and brainstorm on.

I realized I was a mathematician when I was twenty-nine years old, in a required undergraduate math course in the first semester of my engineering PhD. During my master's studies in engineering, I used math every day, but it wasn't until I took this course that I understood how to truly start at the beginning to prove something from the definitions up. Finally, I could conceive of pure math and engineering as parts of one whole.

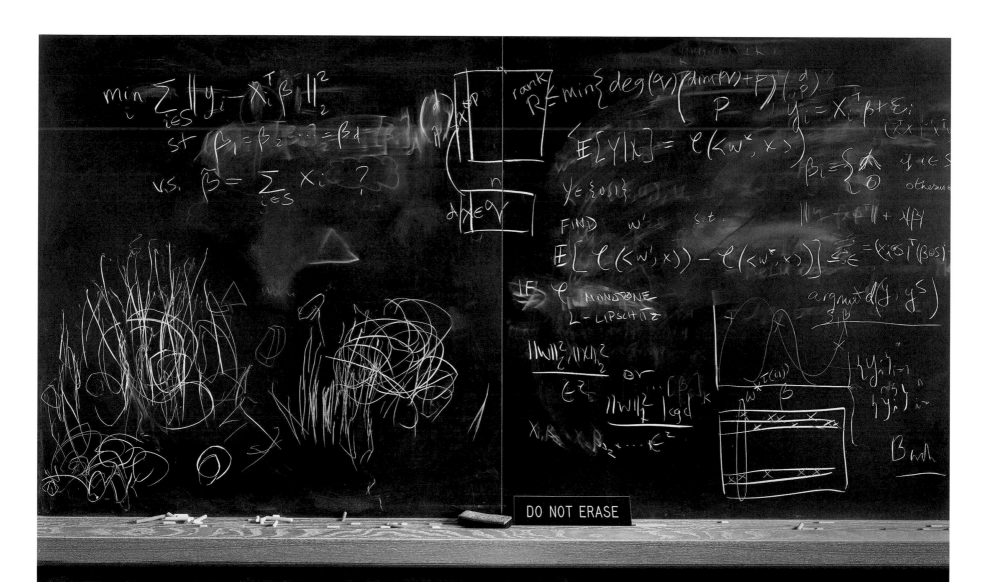

DO NOT ERASE

HÉLÈNE ESNAULT

Hélène Esnault was born in Paris and is a French and German citizen. She was a professor of mathematics at the University of Essen (1990–2012) and is currently Einstein Professor at the Free University of Berlin (since 2012). She was a member of the Jury Cantor Medaille (2001), International Congress of Mathematicians (ICM) Program Committee (2014), ICM Fields Medal Committee (2018), and Shaw Prize Committee (2018–2020); has been selected for the ICM Structure Committee (2022); and has been co-editor of twelve scientific journals past and current. Among her awards are the ICM (2002), ECM (2012), Prix Paul Doisteau—Emile Blutet of the Academy of Sciences in Paris (2001), Leibniz Preis (2003), and Cantor Medal (2019). She is a member of the Academies of Nordrhein-Westfalen, Leopoldina (German National), Berlin-Brandenburg, and Europaea, and was awarded honorary doctorates from the Vietnam Academy in Hanoi and the University of Rennes.

Un matin nous partons, le cerveau plein de flamme,
Le coeur gros de rancune et de désir amers,
Et nous allons, suivant le rythme de la lame,
Berçant notre infini sur le fini des mers.

One morning we leave, the brain full of flame,
The heart full of grudge and bitter desires,
And we go, following the rhythm of the blade,
Rocking our infinity on the finiteness of the seas.

CHARLES BAUDELAIRE (1821—67), *LE VOYAGE*

One morning we took off on a mathematical journey. We talked; we used pictures and geometry to express what might be the first step of a new method. We feared our dream was inaccessible. In the fall, the Spree flowed, sedimenting our thoughts on the historical stones of the museum island in Berlin. The following spring, the wind at Point Reyes assailed our ears, flooded our assumption in its wild wordless beauty. Summer came, a heat wave in the Black Forest, and we merged ourselves in the stream, to breathe. At that moment, a more precise shape offered itself to us. Like hungry children, we swallowed the necessary steps quickly, and the idea took shape.

A proof, when we hold it, is a moment of absolute joy. It is also a farewell. Once it has been produced, it no longer belongs to us: anyone can reproduce it, and use it further. But the peace, which comes after the tense fight with ideas, remains. Sometimes we have the chance to share it with a coauthor, and it becomes a little common treasure.

The blackboard witnesses the privileged moment when we meet. In today's isolation, it feels almost like a souvenir of a past time.

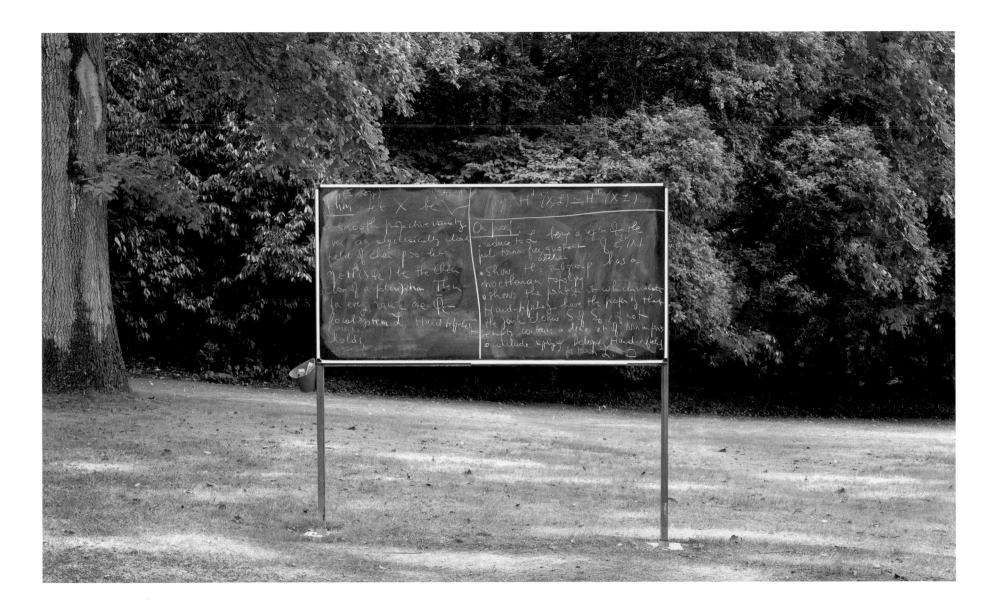

IAN ADELSTEIN

Ian Adelstein is a lecturer at Yale University. His research concentrates in two main areas: closed geodesics and the spectrum of the Laplacian.

This picture was taken during office hours with my multivariable calculus students; we were discussing tangent lines to parametric curves. I often use my board when office hours are busy, allowing everyone to participate in the conversation. When only a few students attend, I have them work together at the board, asking them to sketch solutions for one another. I find the chalkboard to be a wonderful medium through which to communicate mathematics, both in the classroom and during office hours.

One of the reasons I became a mathematician (in addition to the joy of research) is because I love communicating mathematics. At Yale, I have wonderful colleagues who also value mathematics education, and we create an inviting environment in which to learn math. Our calculus classes are active and engaging, not only teaching students how to compute the derivative but also hopefully instilling in them an appreciation for the beauty of mathematics.

Another aspect of the undergraduate mathematics curriculum that I value is the role of guided original research. I direct the Summer Undergraduate Math Research at Yale (SUMRY) program. Each research group is assigned a classroom, and the students often fill the chalkboards with definitions, conjectures, theorems, proofs, and other ideas about their project. The chalkboard not only records a history of their work but also helps illuminate potential new directions.

$$\vec{c}(t) = \langle t, t^2, t+t^2 \rangle$$

$$\vec{c}'(t) = \langle 1, 2t, 1+2t \rangle$$

$$\vec{c}'(2) = \langle 1, 4, 5 \rangle$$

$$\vec{c}(2) = \langle 2, 4, 6 \rangle$$

$$\vec{r}(s) = \vec{c}(2) + s\,\vec{c}'(2) = \langle 2,4,6 \rangle + s \langle 1,4,5 \rangle$$

WILL SAWIN

Will Sawin grew up in Connecticut. He earned his PhD in mathematics at Princeton in 2016, working under the supervision of Nick Katz. He held a postdoctoral position at the Institute for Theoretical Studies at ETH Zurich and then moved to Columbia University, where he is currently an assistant professor in the Department of Mathematics. He is also a Clay Research Fellow.

When I was a graduate student, my friend and fellow graduate student Peter Humphries kept telling me to read Emmanuel Kowalski's blog, and I kept forgetting to. When I finally clicked on the link and dived into the archives, I found it to be more than just entertaining. In one of his posts, Emmanuel offhandedly mentioned a certain vague problem. I realized that a theory called vanishing cycles, which describes how smooth shapes deform into shapes with sharp corners, was the right tool to attack the problem. I sent Emmanuel an email, and he immediately invited me to fly from Princeton to Zurich to discuss my approach. He filled me in on the details behind the brief remark on his blog, which related to his joint work with Philippe Michel. Soon, I came up with a strategy to solve the problem using vanishing cycles, and then we all worked out the details together. Our argument was messy, complicated, and highly specific, but it led to a strong result. We later came up with a simpler strategy, which uses vanishing cycles barely at all. This blackboard contains calculations by myself and Philippe Michel verifying that this strategy should work to prove a more general result.

The part of mathematics I find most beautiful is being able to look at the same object from many different perspectives at once, or in rapid succession. The difference between these perspectives is much more drastic than it is in the everyday, nonmetaphorical meaning of the word—I might think of the same mathematical object as a twisted geometrical shape, a list of abstract symbols with rules for combining them, a type of motion, or a new kind of number system. I can view an object from all of these perspectives simultaneously, or as close to simultaneously as I can manage.

As much as to communicate information, the writing on a blackboard serves to anchor the mind to a complex, multidimensional object that can be viewed from these different perspectives by bringing some small shadow of it into the physical world. In a mathematical conversation between experts, a vaguely drawn squiggle or a fragment of a key equation will often suffice for this.

This is a photograph of a blackboard covered with handwritten mathematical notes. The writing is largely illegible, but partial transcription of the visible mathematics follows.

$$\sum_{r, s_1, s_2} \sum_x \cdots \psi\left(f_{r,s_1 s_2 ,b}(x) \right)$$

$$\psi\left(f_b(x, r, s_1, s_2) + h \right)$$

$$S(b) = \sum_r \sum_{s_1 \neq s_2}$$

$$\sum_b |S(b)|^{2k} =$$

(lower bound) if on a stratum of dim d

the true function $S(b)$ has a component of weight

the $\limsup_{q \to \infty} \dfrac{|S(b)|^{2k}}{q^{d+wk}} \geq 1$

$$\psi(f_b) \, \chi_1(\cdot) \cdots \chi_m(\cdot)$$

$$h) = \sum_+ \psi(\cdot \cdot) + \sum_{r, s_1 s_2, x} f_b(x, r, s_1, s_2) = t$$
$$\alpha = 1 \text{ or } 2$$

$$\sum_{x \cdots x_2} \chi(\cdot) \chi(\cdot) \chi(\cdot)$$

$$\prod K\left(s_{\alpha, i}(r_i + b_i) \right)$$

$$\prod_{i \leq \ell} \quad \sum_b \prod_{i=1}^{2k} K\left(s_{\alpha_i}(r_i + b_i) \right)$$
$$K\left(s_{\alpha_i}(r_i + b_i) \right)$$

$$< q^{\frac{3\ell + 2k}{}} + q^{\frac{6\ell + 4k}{}}$$
$$q^{3k + 2\ell} \downarrow q^{6k + \ell}$$
$$b = 3\ell \quad k = \ell/3$$

$$\sum \frac{1}{t = f(\cdots)}$$
$$a \neq r (\cdots)$$

$$r_6 \quad r$$
$$s_1 \quad s$$
$$s_2$$

$$d + w \cdot \frac{b}{3} \leq 3\ell$$

weight 3 \quad dim 2ℓ
weight 4 \quad dim $2\ell - \ell/3$
weight 5 \quad $2\ell - 2\ell/3$
$\quad \ell$

Assume K has big monodromy

and is not isomorphic or dual

to its conjugate over other translations

only 1 done if

for each $(s_{\alpha, i}, r_i)$ there is $(s_{\alpha, i}, r_j)$ linearly equal
$s_{1,i} \neq s_{2,i}$

this can only happen if it's one distinct

the number of the set of such r, s tuples is $\leq 3\ell$

$b = 3\ell \quad k = \ell/3$

SAHAR KHAN

Sahar Khan has a BA in philosophy and concentration in physics from Columbia University. She has plans to attend law school. She has research experience in nanotechnology and enjoys thinking about the fundamental issues in science and ethics.

In the fifth grade, I became curious about my spatial awareness. It began when we learned about molecular orbital theory, which mathematically describes the wave-like behavior of electrons around a nucleus. The limitations of understanding this "cloud of uncertainty" baffled me. This was the first time in science when I felt that I couldn't follow something intuitively.

Mathematics has served as a beautiful tool for me to further investigate concepts in nature and to shape the way I experience the world.

When I experience beauty in the world, there are overwhelming tones to it that I can only describe in terms of mathematics. When I go to the beach, I often look at the water and link the metaphor of waves to particle behavior. And then I dive into mathematical ideas that describe these physical phenomena. Mathematical symbols and representation on chalkboards are flashes of some of these associations.

This chalkboard depicts a number of mathematical objects known as knots. Knot theory has many interesting and direct applications, but when I think about my knots, I think of simplicity. Since the knots on the chalkboard are simple curved lines of white dust, the recognition of the "doublepoints," or intersections, and orientation is difficult to decipher, which is why thinking about math on a chalkboard is such an artistic endeavor. These squiggles are flattened on an erasable surface, but I imagine them existing in ordinary three-dimensional space and popping out at me. Without this visual imagination and this desire for neatness, mathematics would be quite dull. But in fact, it is filled with these wonderful moments of true enlightenment, and this journey always begins in front of a chalkboard. No matter how distant reality might seem when considering perfect mathematical objects, we always have metaphors that allow us to immerse ourselves in the mathematical world.

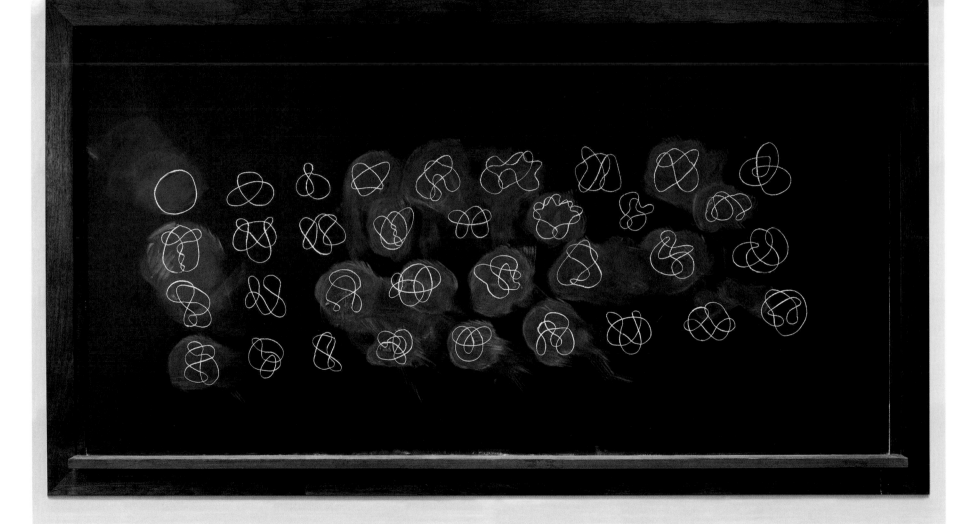

MISHA GROMOV

Misha Gromov is a Russian-French
mathematician whose revolutionary
work reshaped geometry. He is a
permanent member of the Institut
des hautes études scientifiques
(IHÉS) in France and a professor
of mathematics at New York Uni-
versity's Courant Institute of
Mathematical Sciences. Gromov's
numerous prizes include the Abel
Prize in 2009.

What is mathematics?

Non-mathematicians aim to answer this question by asking if mathematics is an art or science, while mathematicians want to know whether mathematics is invented or discovered. The first question is about the position of mathematics in human culture, and the second is a philosophical one. It would be naive to expect a response to either of the two to arrive in the form of a definite, intelligent answer, but indefinite discussion about these matters is enlightening.

Is there an answerable form of the question: "What is mathematics?"

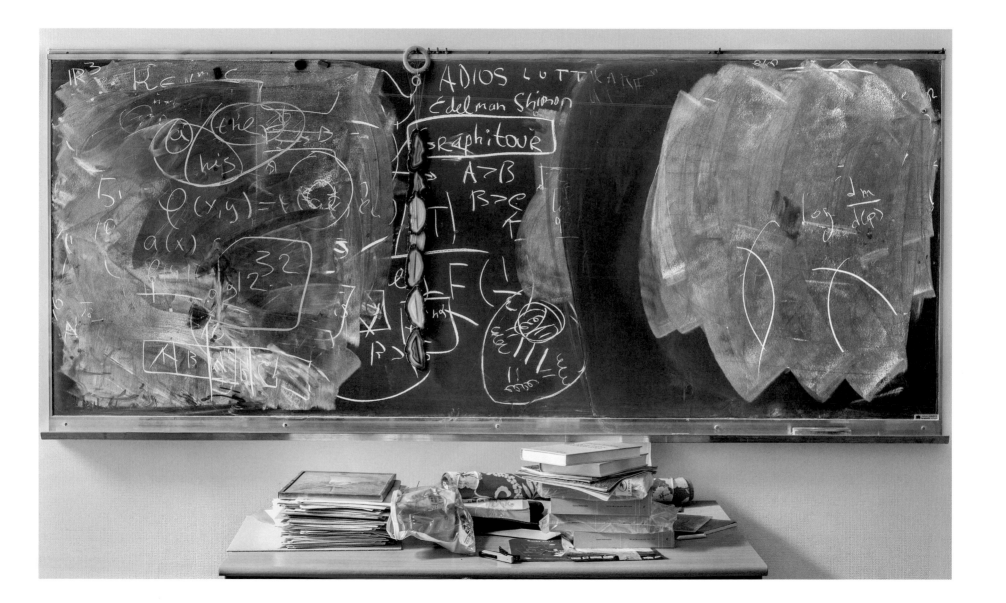

ALEXEI BORODIN

Alexei Borodin is a professor of mathematics at the Massachusetts Institute of Technology working in integrable probability. He received his diploma at the Moscow State University in 1992 and PhD at the University of Pennsylvania in 2001. Before moving to MIT in 2010, he held a Clay Research Fellowship (2001–2005) and a professorship at Caltech (2003–2010). He studies problems on the interface of representation theory and probability that link to combinatorics, random matrix theory, and integrable systems.

This is a depiction of a so-called colored vertex model—a recipe for drawing random colored paths on a square grid that can cross but cannot overlap. Its simple-looking description hides a wealth of deep phenomena. As the number of parts becomes large, and the grid cells become small, the model (and the picture) shows both deterministic and random features, connecting to several domains of mathematics and physics. For example, it's possible to predict quite accurately the number of paths passing below any location in the plane, and the deviations from the predicted value hide one of the most universal probabilistic laws, which can also be observed in slowly burning paper, nematic liquid crystals, and the formation of coffee stains.

Such deceptive simplicity has always been attractive to me; some of the most beautiful mathematical constructs have grown out of mathematicians' attempts to understand seemingly simple-minded questions. I personally find blackboards to be superb research facilitators—a good problem in my domain can almost always be presented on the board in no more than five minutes, and it is those five minutes that have started many of the collaborations I have been fortunate to enjoy.

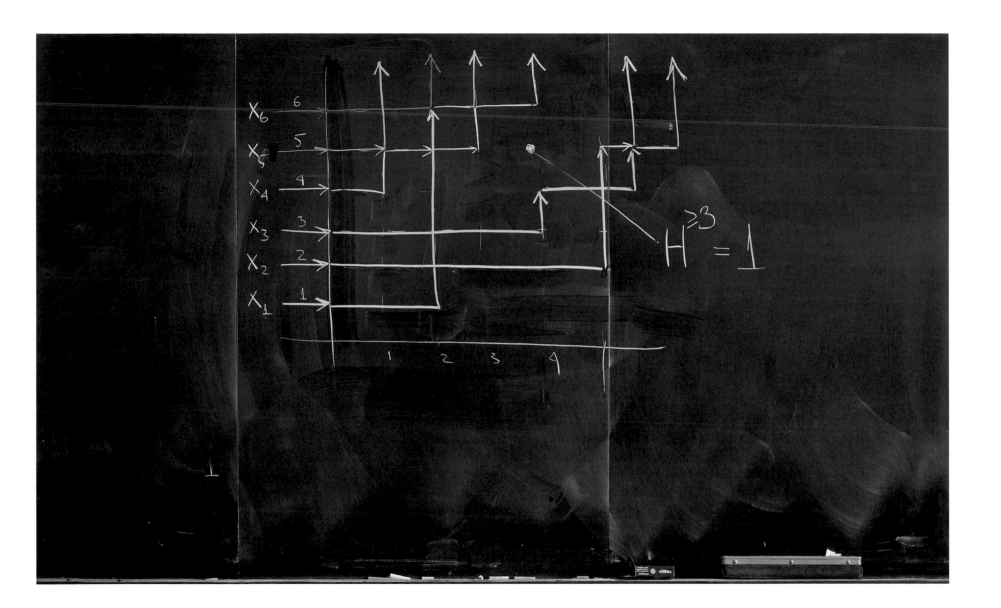

MATTHEW EMERTON

Matthew Emerton was born and grew up in Australia, before moving to the United States for graduate study. He received his PhD from Harvard in 1998, was a postdoc at the University of Michigan for the years 1998–2000, was an assistant professor at the University of Chicago for 2000–2001, and then moved to Northwestern University, where he received tenure and stayed for ten years. He returned to the University of Chicago as a professor in 2011. He is married to Therese Calegari and lives with her in the Hyde Park neighborhood of Chicago.

I enjoy collaborating in my research, and in fact, almost all of my current work is done in collaboration. My collaborators and I work together in various ways: sometimes remotely, over the Internet; sometimes in cafés, writing in notebooks and on our laptops; but most often in one of our offices, with some of us sitting and watching as the person leading the discussion—who could be any one of us, depending on the moment—stands at the blackboard, thinking, writing, and trying to answer calls for explanation and clarification. Sometimes another member of the group will stand up, so that there are two people writing on the board at once—a kind of split-screen experience for whoever is left watching. Writing ideas out on the board seems to be an effective way to echo and enhance the internal creative process, bringing thoughts and ideas from inside our heads out into a common space. Like ideas and leaps of creative imagination, words and symbols on a board are always in a state of flux—momentarily permanent, but susceptible at any instant to being modified, overwritten, or simply erased.

On my board is a fundamental phenomenon in number theory. Many simple arithmetic functions whose domains are the set of primes (for instance, the identity function that sends p to p and Ramanujan's famous tau function) arise as "traces" of representations of Galois groups. This correspondence between concrete mathematical functions and the more abstract, or structured, notions of algebra (groups, representations, and so on) is one of the starting points for contemporary investigations in number theory. The picture on my blackboard is a table illustrating some particular examples of this correspondence.

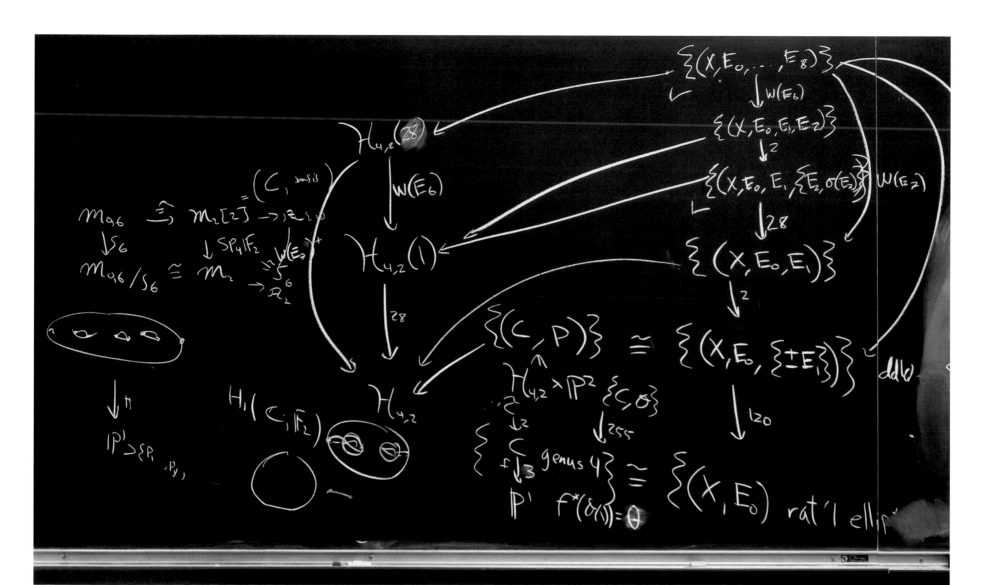

HEE OH

Hee Oh is the Abraham Robinson Professor of Mathematics at Yale University. Previously, she has held appointments at Brown, Caltech, and Princeton. She is the recipient of the Ho-Am Prize in Science (2018) and the Satter Prize (2015), and was named a Guggenheim Fellow in 2017.

I first learned about the triangle inequality in the third grade. I had a hard time understanding it, trying to comprehend that the sum of the lengths of any two sides of a triangle is always greater than the length of the remaining side. In the end, I couldn't. I was able to draw by hand a very flat triangle with sides of five, five, and ten centimeters; or so I believed. I would complain to my father each evening showing him basically the same triangle I drew anew. To me it seemed that either I was so bad in math I couldn't understand something obvious to everyone else, or that the math itself was something in the clouds, totally segregated from reality. Either way, I decided I did not like math.

It was only when I learned about proofs that I became interested in math. To be able to finally reconcile the abstract world of lines of zero thickness and the concrete world of rulers, pencils, and errors, and to realize my old conviction of finding a counterexample to the triangle inequality was ill founded—these all helped me change my view of mathematics.

The picture on the left-hand side of the blackboard in this photograph is an Apollonian gasket. Apollonius of Perga (262–190 BC) showed that, given three mutually tangent circles in a plane, there exist precisely two circles that are tangent to all three. If we begin by noting that the three largest circles in the picture are mutually tangent to each other, we can then add two circles tangent to each of these three circles, as provided for by Apollonius's theorem. If we keep adding new circles in this manner indefinitely, we arrive at an infinite circle packing, called an Apollonian gasket. If we remove all the interiors of the circles inside the largest circle, what remains is a fractal.

In the picture on the right-hand side, if we imagine removing the interior of all the planets inside the universe (one should imagine there are many more small planets, never touching each other, all over inside the greatest sphere), what we are left with is called the limit set of a four-dimensional hyperbolic manifold of infinite volume. Imagine we are traveling in a spaceship, following the red line. When we enter one of the blue planets, we have entered into a "flare" of the manifold, and when we are outside of the blue planets, we are inside the "compact core" of the manifold. The compact core of this four-manifold has a complicated forest in it, and trying to understand how often we can get out of this forest was one of the hardest battles I have fought in my mathematical career.

Visualization is important in my thinking process. I have drawn this picture of planets many times and have stared at it for a long time, while sometimes feeling like a wanderer lost deep in the forest, or sometimes feeling like a painter, trying to decide where the next brush stroke should go in order to complete a very intricate painting. I do my best to draw an approximation of what I would like to realize on the chalkboard while keeping in mind all the rules of strokes I am allowed, or not allowed, to use. When the battle is won, I have completed a perfectly beautiful painting.

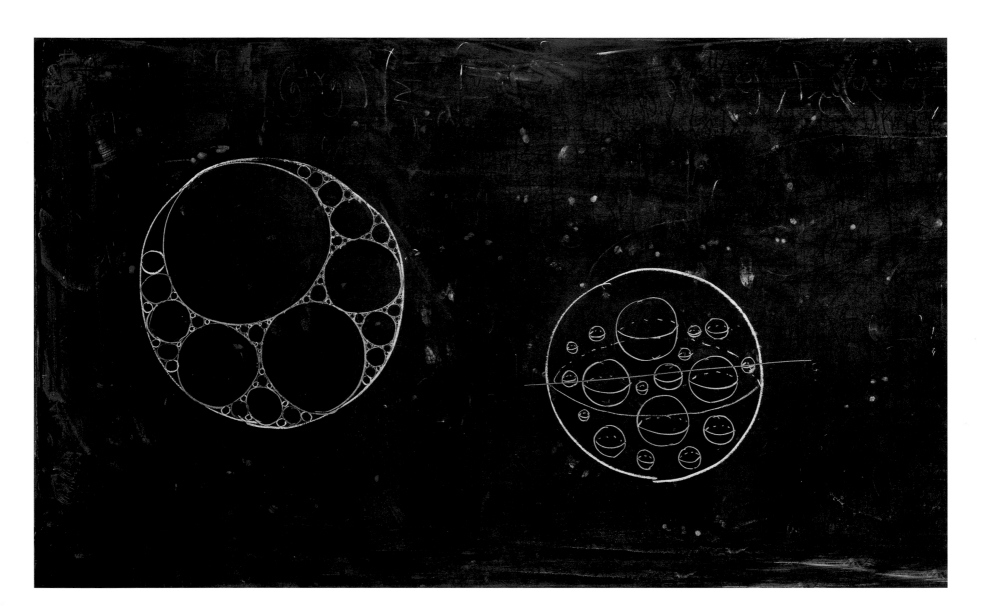

KASSO OKOUDJOU

Kasso Okoudjou was born and raised in Bénin, West Africa. He moved to the US in 1998, and earned his PhD in mathematics at Georgia Tech in 2003 working under the supervision of Chris Heil. He has held positions at Cornell University, University of Maryland–College Park, Technical University of Berlin, MSRI, and MIT, among others. He is currently professor in the Department of Mathematics at Tufts University.

Growing up in Bénin (West Africa), I used to equate learning mathematics to writing it on chalkboards. While I now mostly do my work using notebooks, notepads, and sheets of paper, I miss my college days when my friends and I worked on blackboards. We used to write on them when solving mathematical problems or reviewing our lecture notes. As far as I can remember, almost every one of us had a chalkboard at home, but the chalkboards at Lycée Béhanzin (in Porto-Novo, Bénin) were our favorites. They gave us the opportunity to work together.

After high school, one of my best friends, Armel Kelome, convinced me to major in mathematics. We both ended up graduating from Georgia Tech with our PhDs in mathematics. Armel and I, and a few other friends, used to study together, solving problems and writing proofs on blackboards.

This chalkboard represents some of the work I have been doing in applied and computational harmonic analysis over the last several years. In particular, some ideas on the Heil-Ramanathan-Topiwala (HRT) conjecture and the pth frame potentials are shown on the chalkboard. When working on the chalkboard, I prefer to use cloths rather than erasers because they tend to prevent chalk dust from scattering everywhere and can easily be washed.

JALAL SHATAH

Jalal Shatah is Silver Professor of Mathematics at New York University. He received his PhD in applied math from Brown University in 1983 and subsequently joined NYU's Courant Institute of Mathematical Sciences as a postdoctoral researcher, ultimately becoming professor of mathematics in 1993, and chairing the Department of Mathematics from 2003 to 2008. He is a fellow of the American Academy of Arts and Sciences and a recipient of a Sloan Research Fellowship and a Presidential Young Investigator Award.

I was born in Tripoli, Lebanon, and I knew by the eleventh grade that I wanted to study mathematics. After finishing high school, I fled Lebanon because of the civil war and enrolled at the University of Texas at Austin, where I finished my undergraduate studies with two degrees, one in math and one in engineering.

To me, one of the beautiful things about mathematics is how all the different areas interact, how they come together to shed light on a particular problem. It's difficult to anticipate where the new idea needed to solve a problem will arise. A subject that is considered pure by some might become central in solving real world problems, making it more applied. This was the case in my recent work on wave turbulence, which is the theory used in ocean wave forecasting. When I started working in this area, I expected to make progress by using my expertise in partial differential equations. However, shortly after starting work on wave turbulence and ocean waves, I discovered I had to learn, use, and develop tools from analytic number theory, mathematical physics, and probability. This made the project one of the most enjoyable enterprises in my thirty-six-year career. I became a student again, learning from the experts. The experts in this case were not only my peers in age but also sometimes twenty or thirty years my junior. That was a truly exciting and delightful experience.

My current research focuses on nonlinear waves, such as those represented by the Schrödinger equation (left side of board). Specifically, I study the interactions of waves whose frequencies are integer multiples of one another. These types of interactions are called resonant interactions. We keep track of them using Feynman-like diagrams (middle of board), and their size is estimated by counting lattice points in thin domains (right side of board). Resonant interactions can have catastrophic consequences, such as during the collapse of the Tacoma Narrows Bridge in Washington in 1940. They can also lead to complex behaviors, as in the case of ocean wave turbulence.

$$i u_t - \frac{1}{2\pi} \Delta_\beta u + |u|^2 u = 0 \qquad x \in \mathbb{T}_L$$

$$u(x,0) = u_0(x) = \sqrt{\phi(x)} e^{i\Theta_\omega(x)}$$

$$t \to \infty, \quad L \to \infty \quad \lambda \to 0 \quad u \to ?$$

$$u = \frac{1}{L^d} \sum a_k e^{2\pi i \, k \cdot x - Q(k)t}$$

$$i \dot{a}_k = \sum a_{k_1} \bar{a}_{k_2} a_{k_3} e^{-2\pi i \Omega t}$$

Expand in the data \iff normal forms Calculations (IBP)

$$a_k(t) = \sum_n^N J_n(a) + R_{N+1} \qquad \text{Counting lattice points in Quadratic forms}$$

Poisson $\sum \hat{f}(n) = \sum f(n)$

Theorem Bourgain (Pair Correlations)

$$\sum_{\substack{a < Q(p) - Q(q) < b \\ |q|, |p| \le L}} 1 \sim L^{2d} \int 1 \, d\xi \qquad \frac{a}{L^d} < Q < \frac{b}{L^d}$$

ALAIN CONNES

Alain Connes was born in 1947 in Draguignan, France. He is professor at the Collège de France, Institut des hautes études scientifiques (IHES), and distinguished professor at Ohio State University. He was awarded the Fields Medal in 1982. He is a member of the French Academy of Sciences, as well as the Danish, Norwegian, Russian, and US Academies of Sciences.

The formula on the blackboard expresses a relation between two quite different worlds. The left side belongs to the world of "toposes," which were first discovered by Alexander Grothendieck. This particular topos is obtained from the action of the integers by multiplication on the half-line. It is a familiar object in music: in the musical setting, the points of the half-line represent frequencies, and the action of the integers by multiplication has a natural harmonic meaning. Multiplication by two, for instance, corresponds to doubling the frequency—in other words, playing the same note one octave up. Similarly, multiplication by three (which is very pleasant to the ear) has the effect of transposing to the next key and going up one octave.

On the right side of the blackboard, we have a quite different world: that of noncommutative geometry. This world is populated by very tricky spaces, such as the space of Penrose tilings of the plane. The characteristic property of these spaces is that it is impossible to distinguish their elements from finite information. For instance, any local configuration of tiles occurring in a Penrose tiling will in fact also occur in any other such tiling. Such spaces cannot be understood using classical tools—but quantum mechanics provides the right framework. The noncommutative space featured on the right is one that I related to the zeros of the Riemann zeta function in 1996. The equality written on the blackboard was discovered in collaboration with Katia Consani in 2014. It gives a bridge between two quite different approaches to the problem of localizing the zeros of the Riemann zeta function.

The blackboard (but not its pale imitation, the whiteboard) is an indispensable tool for a mathematician; it allows one to freely express ideas that come to mind. There is always a way to use the blackboard to produce an expression of a mental picture, whose elaboration in the human mind is the daily bread of a researcher.

DEANE YANG

Deane Yang is a professor of mathematics at the NYU Courant Institute of Mathematical Sciences. Prior to that, he was a professor of mathematics at Polytechnic University in Brooklyn for twenty-five years. Previously, he held faculty positions at Rice University and Columbia University. His current research, all done in collaboration with Erwin Lutwak and Gayong Zhang, is in convex geometric analysis. He lives in New York with his wife and two black cats, Izzy and Henry.

I never did decide to become a mathematician: I was just going to try it for a while. I would then switch into a more manageable career. Growing up, I saw that my father's colleagues, who had tenure, still seemed trapped and unhappy in their jobs. I didn't want to end up the same way. But I've enjoyed my life as a math professor. I'm trapped by now, but happy.

I have very limited skills as a research mathematician. If I decide that I want to answer a specific question or solve a specific problem, I always fail miserably. Whatever I've done has always arisen in the same way: I study something specific and manage to understand it well enough to decide I don't like the way others do it. So I try to reformulate it all using my own mathematical language and notation. If I succeed, then I find myself with a hammer I know how to use really, really well. I then go looking for every nail I can hammer successfully.

On this board are two almost identical mathematical problems. They can be understood, perhaps with a little explanation, by interested high school students. One of these problems was posed more than 120 years ago by the mathematician Hermann Minkowski, who proceeded to solve it himself. The other was asked only seven years ago by my collaborators and me, and it remains unsolved. The efforts to solve both of these problems, as well as their generalizations, have spawned a beautiful area of mathematics that is, at its core, geometric but provides deep insights into many other areas.

After I understand something really well, I write it up carefully. In the past I would use pen and paper. Today I type it up on my computer using Emacs and LaTeX. But before that, I really prefer to do a lot of my work on a chalkboard. I'm always changing my mind about what calculation to do and what notation to use. I'm always making mistakes. I'm always erasing and trying again. Once I finally have something that seems correct but I'm not sure where to go next, I like to slouch in my chair and just stare at it on the board.

The feel of writing with chalk is also very satisfying. There's just the right balance between friction and smoothness to write everything firmly and legibly. For me it's much easier to do this with chalk on a board than with pen on paper. I also have this need for everything to look just right. So, even if the math is correct, if I don't like how it looks on the board or on paper, I am always compelled to redo it. On paper, this means tossing what I've written and starting again with a clean sheet. It feels less wasteful to erase the board and start again.

Minkowski Problem (1903)

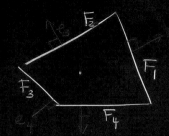

F_2, F_3, F_1, F_4

P = compact convex polytope.

F_1, \ldots, F_N = faces of P

A_i = area of F_i } (*)

u_i = outer unit normal to F_i

Minkowski asked: Given $A_1, \ldots A_N > 0$
and $u_1, \ldots, u_N \in S^{n-1}$, when does there exist
a compact convex polytope P
satisfying (*). Minkowski himself solved this

Logarithmic Minkowski Problem (2002, 2012)

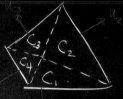

C_3, C_2, C_4, C_1, u_2

P = compact convex polytope

F_1, \ldots, F_N = faces of P

C_i = cone with base F_i and vertex at O

V_i = volume of C_i } (**)

u_i = outer unit normal to F_i

Stancu (2002) and LYZ (2012) asked:
Given $V_1, \ldots, V_N > 0$ and $u_1, \ldots, u_N \in S^{n-1}$,
when does there exist a compact convex polytope P
such that (**) holds. STILL UNSOLVED!

SILVIA GHINASSI

Silvia Ghinassi is a postdoc at the University of Washington in Seattle. Prior to this, she was a member in the School of Mathematics at the Institute for Advanced Study in Princeton. She obtained her PhD in 2019 at Stony Brook University and, prior to that, did her undergraduate studies at Sapienza, in Rome, Italy, where she was born and raised.

This photograph shows the chalkboard that is in my office at the Institute for Advanced Study. I work in geometric measure theory, and my thesis provided some sufficient conditions to obtain a smooth parametrization of a set in Euclidean space. Loosely speaking, given a bunch of points in the plane, I identified some properties that guarantee that there exists a curve that connects them all and does not have corners.

A question I was interested in, when I moved to the IAS, was understanding if these conditions were also necessary (this would yield a characterization, which mathematicians love). The blackboard pictured here shows a counterexample that I constructed. Namely, these sufficient conditions are not necessary after all. One would think this would be a disappointment for a mathematician, but there is something about finding counterexamples which I really enjoy. Proving theorems is of course a mathematician's main goal, but counterexamples always leave me with a sense of satisfaction and fulfillment that proofs don't give me. As strange as it might sound to non-math ears, counterexamples feel very concrete, as if I had built something.

It has now been two months since I last got to use my chalkboard, or even see it. The COVID-19 pandemic has disrupted most activities in the world, and mathematics is no exception. People always say that to do math, it is enough to have pen and paper, but it doesn't seem to matter how many pens or pieces of paper I find in my apartment; it is not enough.

The human component of mathematics, whether it is a collaboration, or just a chat over some coffee, cannot simply be taken away. Many of these interactions happen in front of a blackboard. I spend many hours in video conference calls these days, attending seminars, working with collaborators and giving presentations. I always hated giving presentations with slides—I am a big fan of what we call "chalk talks." Recently, I gave a talk via videoconference, sharing my screen. Almost an hour into it, I decided to switch to a whiteboard I had in my apartment. I realized that a good portion of the information I convey is through body language (which makes a lot of sense in retrospect, as not only am I a mathematician, I am also Italian). The switch to the whiteboard worked: I could gesticulate and point at pictures and make shapes with my hands. But I could not shed the feeling that something was off, and then I finally understood: if only I could hold a chalk, instead of a marker . . .

thm $\quad \vartheta^*(\mu,x) < 0 \quad + \quad \sum \left(\frac{\beta(x,r_k)}{r_k^\alpha}\right)^2 < \infty \quad \Rightarrow \quad \mu \quad C^{1,\alpha} \text{ rectifiable}$

$\qquad\qquad \theta_*(\mu,x) < \infty$

BUT

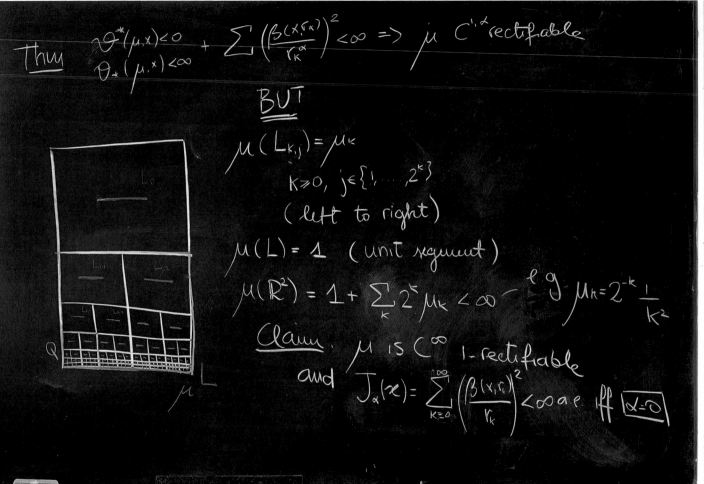

$\mu(L_{k,j}) = \mu_k$

$\qquad k \geqslant 0, \quad j \in \{1 \dots 2^k\}$

\qquad (left to right)

$\mu(L) = 1$ (unit segment)

$\mu(\mathbb{R}^2) = 1 + \sum_k 2^k \mu_k < \infty \quad e.g. \; \mu_k = 2^{-k} \frac{1}{k^2}$

Claim: μ is C^∞ 1-rectifiable

and $\quad J_\alpha(x) = \sum_{k \geqslant 0}^{\infty} \left(\frac{\beta(x,r_k)}{r_k}\right)^2 < \infty \; a.e. \; \text{iff} \; \boxed{\alpha = 0}$

DO NOT ERASE

DENIS AUROUX

Denis Auroux is a professor of mathematics at Harvard University. He began his mathematics studies at the École normale supérieure in Paris in 1993, and obtained his PhD in 1999 from École polytechnique. Prior to joining Harvard University in 2018, he held positions at CNRS (from 2000 to 2003), at MIT (as assistant professor from 2002 to 2004, and associate professor from 2004 to 2009), and at UC Berkeley (as professor from 2009 to 2018). His research work is in the field of symplectic geometry, with a particular focus on the homological mirror symmetry conjecture.

Different mathematicians have different ways of coming up with insights in their research. As a geometer, I find it hard to think clearly about something that I cannot represent visually, and so my thought process always begins with a picture—even though the abstract nature of my research often makes it impossible to faithfully depict the mathematical objects at hand. The picture on this board, for example, actually represents three-dimensional objects inside a six-dimensional space.

This drawing depicts some of the geometry relevant to the homological mirror symmetry conjecture, a key problem at the interface of modern geometry, algebra, and mathematical physics. The picture represents the complex three-dimensional mirror space of a "pair of pants" surface. This is a picture that I have revisited multiple times over the past decade, as a concrete illustration of several deep (and often still mysterious) geometric phenomena that I am trying to understand.

The sheer size of a blackboard and its versatility make it my favorite work surface, whether for individual research, small-group collaboration, or meetings with students. The physical format not only makes it possible to display and work with a large amount of information at once, it also invites collaborative efforts—mathematicians doodling side by side at the board, taking turns jotting down formulas, or simply staring together at a picture to decipher its mysteries.

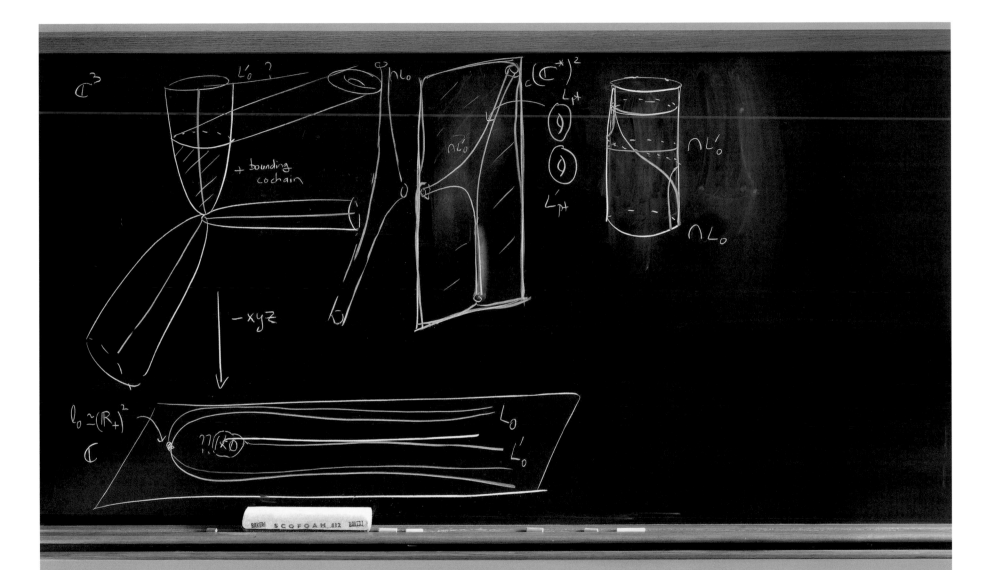

NOGA ALON

Noga Alon is a professor of mathematics at Princeton University and a professor emeritus of mathematics and computer science at Tel Aviv University. He works in combinatorics and graph theory and their applications in theoretical computer science. He is a member of the Israel Academy of Sciences, of Academia Europaea, and of the Hungarian Academy of Sciences and has received several awards, including the Pólya Prize, the Gödel Prize, the Israel Prize, and the Emet Prize.

I grew up in Haifa, Israel. At a young age I was already interested in mathematical puzzles; I read several books about the history of mathematics and participated in mathematics competitions. I had a superb mathematics teacher for the last two years in high school, and during my final year, I also met Paul Erdős, a legendary Hungarian mathematician who used to travel around the world, delivering lectures in mathematics that focused mainly on open problems in combinatorics, graph theory, and number theory. I found combinatorics, which is the mathematics of finite objects, fascinating, and I still work in this area and its applications—in theoretical computer science, information theory, number theory and geometry—today. The problems in this area are typically very simple to state and understand, and yet their solutions often require not only a significant amount of ingenuity but also applications of sophisticated, deep tools. The blackboard in this photograph deals with graph coloring problems, an important subject in combinatorics.

One aspect of mathematics that always fascinated me is its objectivity. When I was twelve years old, my parents had friends visiting during the Eurovision song contest. They amused themselves by trying to guess the final results of the contest, which are determined by the votes of the participating countries—they agreed on a formula (which I am not including here) for computing a score to each guess given the end results, and when the results were announced, they found out that all the scores had been even integers. This led to a discussion about whether this must always be the case. My mother (who had excellent mathematical intuition) thought that it was indeed the case, but one of the guests, who was an engineer,

insisted that this wasn't so. Since they were unable to agree, my mother suggested asking me. Although I was quite young, she knew I liked mathematics and believed I would be able to settle the question. I thought about the problem and realized that, indeed, the score must always be even.

The main reason I remember the story, however, is not because I was able to find a proof, but because I managed to show the engineer that he was wrong. The fact that a twelve-year-old can convince a grown engineer about such a statement is an impressive demonstration of the objective nature of mathematics. It is probably safe to assume that there has never been an argument between two parties on, say, a political topic, that has ended with one party telling the other, "You are right; I am wrong."

This event made an impact on my decision to become a mathematician. One cannot argue about the validity of a mathematical theorem, and its beauty when written on a board can often reach far beyond the way it appears to the untrained eye.

In my own work, blackboards feature not only as the main way to teach courses and deliver lectures but also as the most effective way to exchange ideas when working with collaborators. During the months since mid-March 2020, we have all been forced, due to the COVID-19 pandemic, to replace the traditional blackboards with more sophisticated electronic alternatives. This experience convinced me that blackboards cannot be replaced electronically, and they will keep playing a crucial role in my work and in the work of my professional colleagues in the coming years.

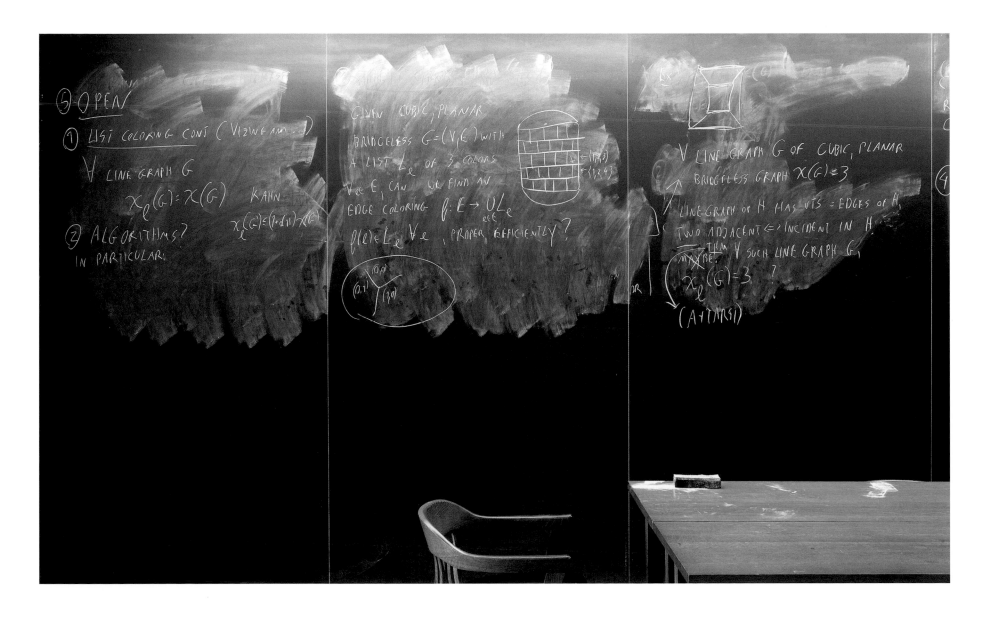

ENRIQUE PUJALS

Enrique Pujals is a professor at the Graduate Center at the City University of New York, and was previously a professor at IMPA. His main areas of research include dynamical systems and ergodic theory and its applications. He is a member of the Brazilian Academy of Sciences and the World Academy of Sciences. He is also the recipient of the Brazilian Order of Scientific Merit and was a Guggenheim Fellow. He won the TWAS Prize in Mathematics in 2009, the ICTP Ramanujan Prize in 2008, and the UMALCA Prize in Mathematics in 2004. He was an invited speaker at the International Congress of Mathematicians in Beijing in 2002.

When I was in high school, back in the 1980s in Argentina, I did not have any interest in mathematics. I graduated in 1984, at the same time that democracy was finally restored in my home country. Like many others, I was motivated by the social and political events of the time, and this brought me to focus on the social sciences—I started studying sociology, and from there I migrated to economics. I began to feel like I needed a stronger tool kit to grapple with economics, so I decided to take some classes in the math department; by the time I realized that I was on my way to becoming a mathematician, it was too late.

Sometimes I feel like the theorems we prove exist only to make sense of the scribbles that first appear on the chalkboard. The result shown on this board is a continuation of my joint work with Sylvain Crovisier. It was the product of many such scribbles on the chalkboard.

After proving an initial result about systems that exhibit chaotic behavior, we began to wonder about the transition from simple systems—whether physical, biological, economic, or social—to chaotic ones. We were hoping to understand the universal mechanisms that explain that transition, and how those systems that operate in a region between order and complete chaos can be described mathematically. In this new endeavor (which Charles Tresser subsequently joined), we proved that the systems that exist "on the edge of chaos" are infinitely renormalizable.

To describe an infinitely renormalizable object, imagine that looking from far away, you see a Ferris wheel with a bunch of carts that rotate around the center. When you get closer, inside each cart, you will see that each cart is in fact another rotating Ferris wheel. This process never stops, with the caveat that eventually, when you look deeper, the Ferris wheels start to have only two carts.

In the sciences in general, the phrase "route to chaos" has become a metaphor for the transition of some physical, biological, economic, or social system from one exhibiting order to one displaying randomness (or chaos). We used to joke that there is only one way to stay on the edge of chaos (the only place where life can thrive): "renormalize or die."

For mild
dissipative
diffeos
In the
"Boundary
of chaos"

Henon $(x,y) \rightarrow (1-ax^2+y, bx)$

$0 < b < 1/4$

Renormo $\begin{cases} 1-\text{Stabilization} \\ 2-\text{Decoration} \\ 3-\text{Keep repeating} \end{cases}$

Lizable

"Pete and Repete"

Zoom out

\Rightarrow

To be
In the
boundary
of
chaos
have to be
Infinitely
Renormalizable

SYLVAIN CROVISIER

Sylvain Crovisier is director of research at the CNRS and works at the Laboratoire de mathématiques d'Orsay (Université Paris-Saclay). His research deals with topological and differential dynamical systems and their perturbations.

A branch of mathematics called dynamical systems studies the longtime behavior of systems driven by a law of evolution. The theory tries to show the changes that occur over time in both physical and artificial "systems." A few examples include the motion of celestial bodies, population growth, the stock market, a clock pendulum, and water flowing in a pipe.

In the seventies, Michel Hénon proposed a planar equation as a highly simplified model for the atmospheric convection. It quickly became apparent that this system would also make it possible to describe many other ones. But its rigorous study has proven to be particularly difficult, and a lot still remains to be understood.

One way to grasp such dynamics is to rely on its periodic orbits. Enrique Pujals and I recently discovered that periodic orbits appear abundantly within the Hénon systems. (We found this property by chance, while working on a different problem.)

On the blackboard, I have illustrated it and the idea behind its proof, which is sometimes referred to as a "closing lemma."

The blackboard is an essential tool of the mathematical activity—both a medium for sharing ideas and a support for creation.

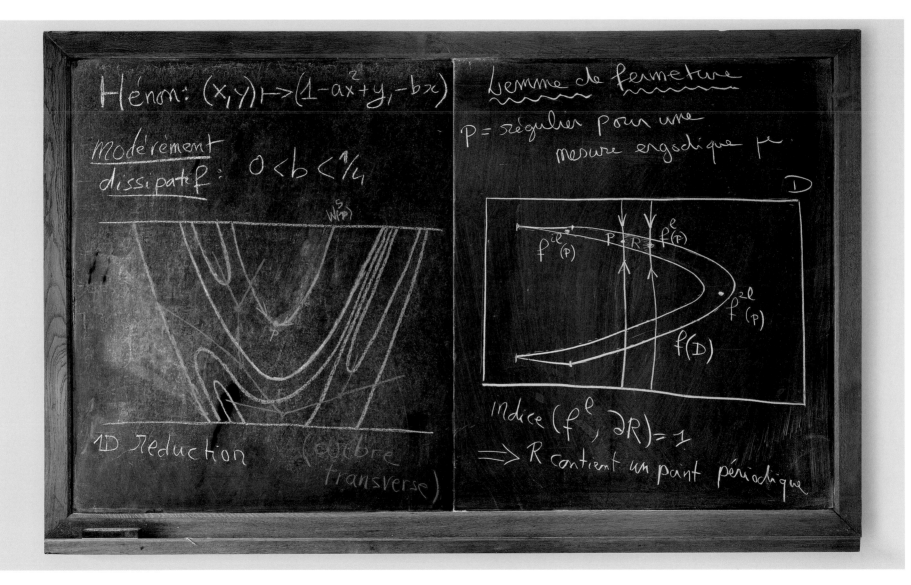

Hénom: $(x,y) \mapsto (1-ax^2+y, -bx)$

Lemme de fermeture

Modérément
dissipatef: $0 < b < \frac{1}{4}$

P = régulier pour une
mesure ergodique μ

$W^s(P)$

1D réduction

(arbre transverse)

D

$f^{-\ell}(P)$ P R $f^{\ell}(P)$

$f^{2\ell}(P)$

$f^\ell(D)$

Indice $(f^\ell, \partial R) = 1$

$\Longrightarrow R$ contient un point périodique

DIMITRI Y. SHLYAKHTENKO

Dimitri Y. Shlyakhtenko is a professor of mathematics at UCLA and the director of the Institute for Pure and Applied Mathematics (IPAM). He received his PhD from UC Berkeley in 1993. He is a fellow of the American Mathematical Society and a Sloan Fellow and gave an invited talk at the International Congress of Mathematicians in 2010. He studies free probability theory and operator algebras.

The picture on this board represents a mathematical construction called planar algebra cohomology, which has appeared in my joint work with Stefaan Vaes and Sorin Popa. The Fields medalist Vaughan Jones first discovered that it is possible to describe a large variety of mathematical objects—what he called planar algebras—by associating pictures with operations on their elements. The pictures then tell you how to perform standard operations, such as multiplication, with the objects. An example can be seen on the upper right corner of the board: this picture shows how to multiply matrices. But there are many other pictures that can be drawn, each representing a mathematical operation, showing the richness and flexibility of the structure of such planar algebras.

Vaughan also served more directly as inspiration for our work—some of the diagrams on the board came to my mind after watching him kiteboard in Maui.

Blackboards are amazing tools for collaboration. They are just the right size to enable you to present the correct amount of information that a colleague or a student can follow at a time. As a communication tool, it is truly remarkable that the board can be used to communicate so much different information—text, illustrations, graphics. I always prefer listening to blackboard presentations to talks using computer slides, because I subconsciously get more information out of seeing the process of someone laying out their explanation on the board. Blackboards are truly magical objects for mathematicians!

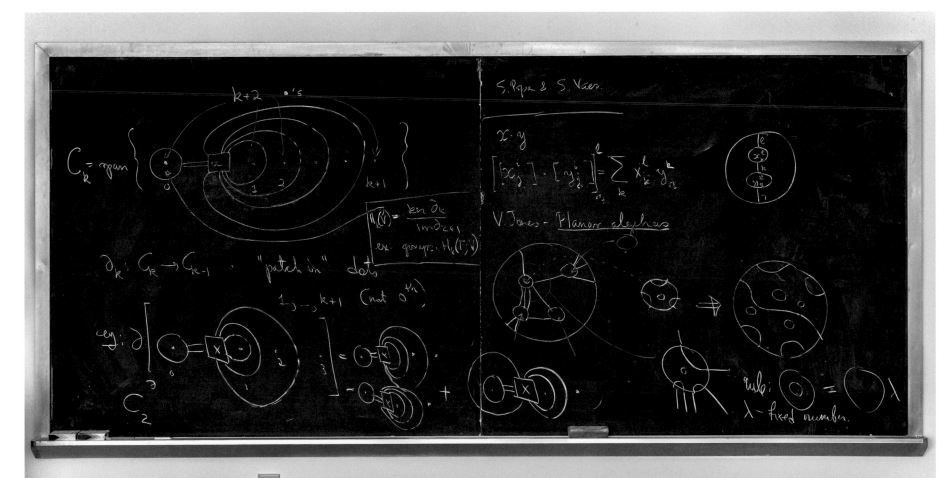

YANG LI

Yang Li is a postdoctoral researcher based at the Institute for Advanced Study. His work focuses on differential geometry. Outside of maths and physics, Yang is interested in a number of academic disciplines, such as philosophy, theology, and history.

The right-hand half of this board is an excerpt from the *Classic of Poetry*, which is part of the Confucian canon:

> Behold yonder meandering stream,
> Amidst the thriving bamboos,
> The elegant gentleman (is studying),
> As if polishing the jade.

(According to the established interpretation, polishing the jade is a metaphor for personal refinement, both intellectual and moral.) This text is chosen as a good depiction of scholarly pursuits in an earthly Elysium, just as at the Institute for Advanced Study.

The left of the board specifies the time of writing, which is included by convention. It reads: the spring of the year of Geng Zi. The words Geng and Zi stand respectively for the ordinal numbers 7 and 1, and belong to a calendar system of heavenly stems and earthly branches, which form cycles of periods 10 and 12, so the pattern repeats after 60 years, the least common multiple of 10 and 12.

Mathematics as a human pursuit lies somewhere between discovery and invention. Solutions to deeper problems are usually imbued with individual expressions: you produce your own heuristic, decide your own paths, design your own tools, and take your problems into the woods. Oftentimes this searching for answers is solitary, bewildering, unpredictable, or even austere, as if walking through the night, aided by a few hints and some friendly discussions. The finished product is quite uniquely personal. In this sense, it is one of the most creative human activities. Yet a recurrent theme in maths is that seemingly wildly divergent approaches lead to the same ends, and diverse ideas from thin air are shown to be deeply interwoven into the fabric of the universe. In this sense, the finest mathematics seems to be part of a preordained unity that transcends individual minds, to be admired but not originated. Herein is mathematical beauty: through much effort, the mind recognizes its affinity with Nature, both visible and invisible, and contemplates the truth, at once external and internal.

瞻彼淇奥綠竹

猗猗有斐君子

如切如磋如琢

如磨

庚子春

DO NOT ERASE

KEITH BURNS

Keith H. Burns was born in New Zealand and grew up in Australia. He completed his PhD at the University of Warwick in England. Since then, he has worked in the United States, and has been at Northwestern University for thirty years. Over the years he has written papers with more than thirty coauthors.

Pictures have always been an important part of my thinking. There are times when I am forced to calculate, but those calculations are usually guided by pictures—mental or actual.

The picture on the left half of the board comes from a paper with two colleagues, Werner Ballmann and Misha Brin. The purpose of the paper was to construct a counterexample to a claim made by the distinguished German mathematician Eberhard Hopf more than seventy years ago. There are several pictures in our paper that show how the different parts of the argument work. This one shows how they all fit together. The two humps of the dinosaur are carefully constructed in order to influence the curve that can be seen going through their centers. The legs are necessary to "make room" for the humps in the middle. Because of this picture, our example has come to be known as "the dinosaur."

The history of our counterexample goes back to 1943, when Hopf first wrote the paper containing the false claim. His paper was accepted for publication in Germany in 1943 but was then destroyed in an air raid. Hopf learned of its loss after the war, and the paper was finally published in the United States in 1948.

In his paper, Hopf considers a particular solution of the Jacobi equation (the unstable solution) that is defined for surfaces with no conjugate points. He correctly points out, and uses, the fact that it depends measurably on the geodesic. He also remarks in parentheses that "by a somewhat longer argument one can even prove its continuity."

Roughly forty years later, one of our friends and colleagues, Gerhard Knieper, wanted to use this parenthetical remark of Hopf's, and asked us if we knew the proof. After having assured Gerhard that we would soon send the proof to him, we realized that Hopf's assertion was incorrect.

Eberhard Hopf was an excellent and very careful mathematician. Much of what I have done in my career is based on ideas from his papers. I am sure that he would have noticed a gap in his argument if he had actually written it down. I like to say that a careful mathematician makes mistakes only in parentheses.

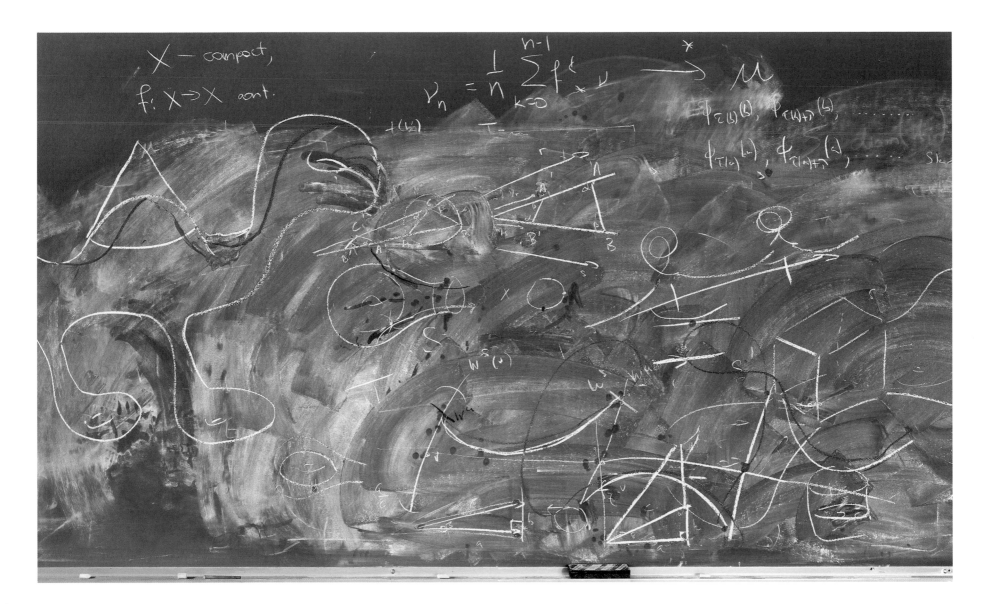

X — compact,

$f: X \Rightarrow X$ cont.

$$\nu_n = \frac{1}{n} \sum_{k=0}^{n-1} f^k$$

MICHAEL HARRIS

Michael Harris is professor of mathematics at Columbia University and Université Paris 7. He is the recipient of the Grand Prix Sophie Germain de l'Académie des Sciences (2006), the Clay Research Award (2007), and the Grand Prix Simone et Cino del Duca de l'Académie des Sciences (2009, collective) and is a member of Academia Europaea and the American Academy of Arts and Sciences.

When Yu-Sheng Lee, a graduate student at Columbia, asked me to explain a passage in one of my papers, I offered to work it out with him at the big blackboard in the common room. The passage had to do with the relation between two elaborate constructions in number theory. One construction uses a formula that you can read at the bottom of the second board from the left, starting with LFg. The second construction is more abstract and only appears implicitly on the board, in the equation on the middle of the third board:

$$\Theta_{\psi,\chi}^{s}(\pi) \otimes \gamma_1 = \Pi_{\chi^{-1}}^{s}(\check{\pi} \times 1) \otimes \gamma_1$$

The left side denotes the first construction, the expression on the right represents the second construction, and the equals sign between them tells you that they both yield the same answer. Yu-Sheng was concerned that the two constructions seem to involve different amounts of information. The drawing on the board displays how the information on the two sides matches up. The Greek letters appear wearing different decorations in the two expressions: π on the left resurfaces on the right under a check mark, χ acquires a -1. This kind of alteration can generate confusion—or even anxiety—a risk that our session at the board averted.

Hundreds of pages of reflection are condensed in formulas in the mathematical literature, and the one given here is a representative example. To prove them requires thousands of pages of reasoning by dozens of people scattered around the world. And the implications are limitless: some of them spiral out from the formula onto the surrounding boards—and, through exchanges like mine with Yu-Sheng, into the next generation's consciousness.

In my career, I have had a few episodes of ecstatic recognition—a sudden realization that some X is also a Y—that literally changed my life's trajectory. But each time, the realization was a purely conceptual event; I don't recall blackboards being involved. Nevertheless, we are material beings, and a concept has to be given material form before it can be shared. My kind of mathematics is not rich in visual stimulus; the material is usually just a string of letters and numbers and mathematical symbols. Making it visible on the board is one way we give each other permission to continue.

JONATHAN FENG

Jonathan Feng is professor of physics and astronomy at the University of California, Irvine. His work has been recognized by an NSF CAREER Award, the Outstanding Young Researcher Award from the International Association of Chinese Physicists and Astronomers, a Sloan Research Fellowship, a Guggenheim Fellowship, and Simons Fellow and Investigator Awards. At UC Irvine, he cofounded "What Matters to Me and Why," a speaker series in which faculty and staff members tell their personal stories and share the most valuable lessons learned along the way.

This blackboard shows some things I've been working on for a long time that were once fringe topics but have now become mainstream. If you set out to describe the universe as a whole, you will very quickly realize that what we know about is not all there is. In fact, most of the matter in the universe is not made of atoms. It's made of other kinds of particles, provisionally called dark matter. When I first started out, this was known, but it was mainly considered a problem for astronomers. Eventually, it was realized that physicists and mathematicians who study the fundamental laws of physics might also have something valuable to contribute. In particular, theoretical work showed that experiments designed to probe the inner workings of atoms and nuclei could also create dark matter in the laboratory.

This has now become a central topic. The blackboard shows some theoretical work I've done that has motivated the construction of new experiments. We're hoping that these experiments will make particles that have never been seen before and give us our first glimpse of what most of the universe is made of.

When I was young, my parents took me to meet Shiing-Shen Chern, a great mathematician who was also a family friend. I asked him for advice about how to do research. He said one should work on topics that everyone considers important, but also work on fringe topics that aren't attracting a lot of attention. I thought this was pretty worthless advice. It reminded me of famous words from Hugh of Saint Victor, who said, "Omnia disce, videbis postea nihil esse superfluum," which, roughly translated, means "Learn everything; you'll need it." But it turns out it was great advice, some of the best I ever got. Now when students ask me about how to do research, I tell them the same thing. I also tell them, "Don't think this is worthless! I thought it was worthless when I first heard it, but it is not." But I can tell they don't believe me.

Blackboards engender optimism. When you confront your profound ignorance of what the universe is made of every day, you need something to pick you up. Erasing a big blackboard and standing in front of it, you get the feeling that it's just waiting there, ready for something great to happen.

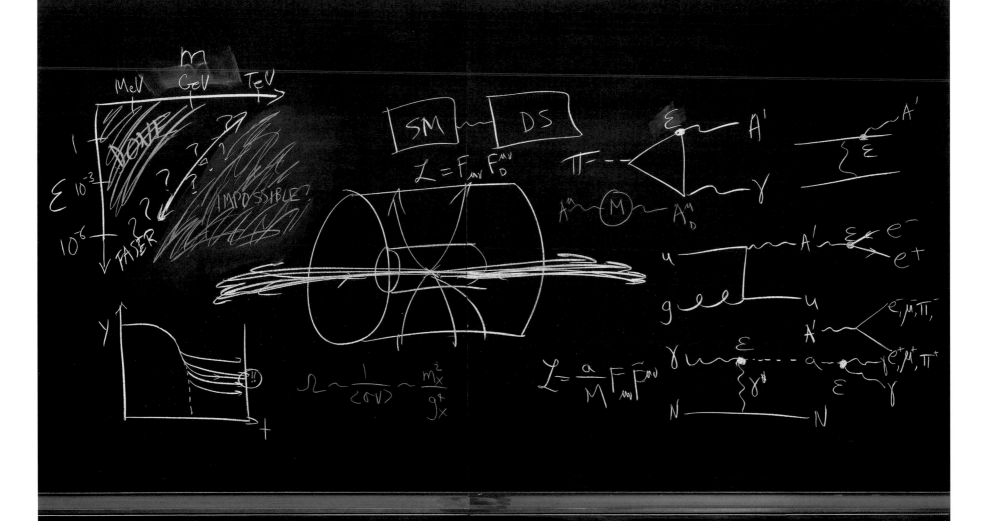

RONEN MUKAMEL

Ronen Mukamel is a mathematician and geneticist conducting research at Harvard Medical School and Brigham and Women's Hospital in Boston. He spent twelve years studying pure mathematics at MIT, Stanford, University of Chicago, and Rice University. He is currently focused on understanding repetitive regions of the human genome and their contribution to heritable human diseases.

Imagine a billiard table with an exotic geometry, like that of a pentagon, an octagon, or an L-shape. A ball placed on the table and set in motion in a particular direction will travel along an idealized path (one with no friction or spin) according to the familiar laws of physics. Mathematicians are concerned with classifying the possible trajectories in these types of systems. One possibility is that the ball will eventually return to its initial position and initial direction, in which case it will repeat its trajectory over and over again, and so the trajectory is closed. Another possibility is that the ball will chaotically visit every corner in the billiard table, and the trajectory will distribute itself uniformly across the entire table. And there is a whole host of possibilities in between. The range of possibilities depends in subtle ways on the particular shape of the billiard table. The symbols on this blackboard concern surprising algebraic resonances among the equations describing the geometric structures that arise in mathematical billiards.

The chalkboard provides an antidote to some of the major pitfalls of modern forms of communication. Chalkboard communication naturally occurs at the speed of human thinking, since the presenter must physically write everything that will appear on the board. Anyone who has sat through the deluge of a poorly planned Power-Point presentation understands this reasoning. At the same time, the chalkboard liberates the presenter from the constraints of traditional print media: the presenter can organize the order in which symbols, text, and drawings appear on the board in a way that is impossible in a book or research article. When presenting my research and teaching, the chalkboard helps bridge the divide between me and my audience. Chalk-covered fingers are the physical reminder of a presentation well made.

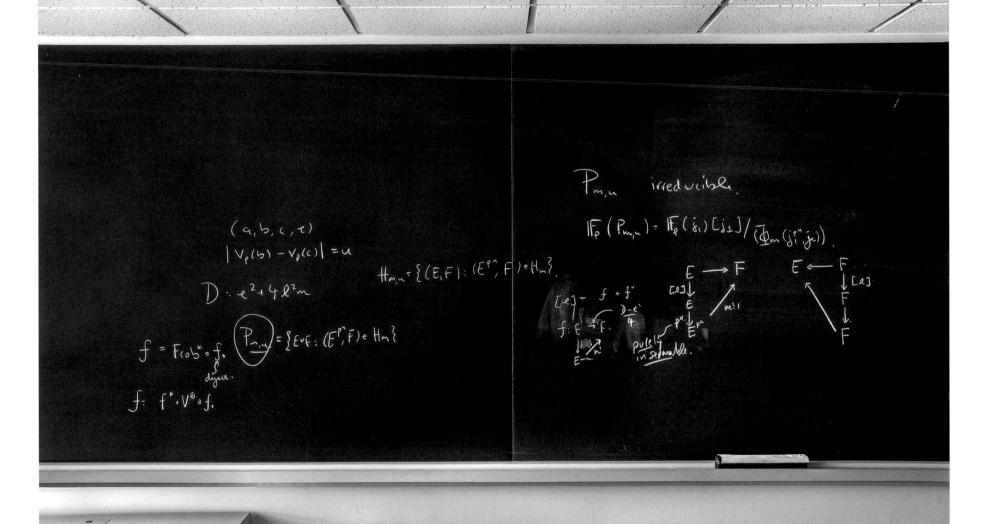

NATHAN DOWLIN

Nathan Dowlin is currently a Ritt
Assistant Professor at Columbia
University working in knot theory.
He received his PhD from Princeton
in 2016, advised by Zoltan Szabo.

I think that mathematicians prefer chalkboards because
an idea written down on paper has a sense of permanence,
whereas on a chalkboard, the idea can evolve gradually,
the way it does in your mind. There is no pressure to get
it perfect the first time, or even to get it right, since it's
going to be erased in an hour or two anyway.

The graph in this photo represents some information
about a knotted string in three-dimensional space, which
can in turn tell us about how geometry works in four di-
mensions. The goal in this area of math is to turn deep
geometric content into simple, concrete objects that can
be counted. Here, I am counting certain types of paths in
the graph and trying to relate them to a known geometric
quantity associated with the corresponding knot.

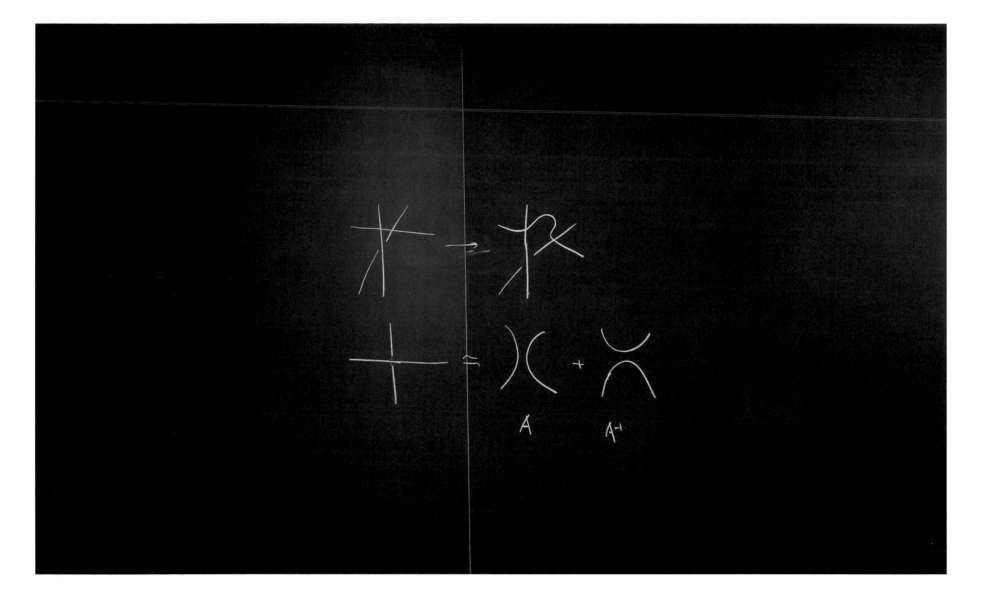

SIMION FILIP

Simion Filip is an associate professor of mathematics at the University of Chicago. He held the Clay Research Fellowship from 2016–2021. He is the recipient of the 2016 Dynamical Systems Prize for Young Mathematicians, and the 2020 Prize of the European Mathematical Society.

I rarely use the blackboard alone. It is, however, indispensable for communication with other mathematicians—whether I am learning from somebody else or explaining something myself, I greatly prefer the blackboard to any other medium.

The blackboard in this photograph shows interactions between groups—mathematical concepts that are used to describe both symmetries of other objects and how objects change. The two groups that appear here are of different natures—one describes infinite but discrete symmetries of a surface, while the other is a group of continuous symmetries of a higher-dimensional space. A map relates the two groups, embedding the geometry of the surface into the more complicated, and richer, higher-dimensional space.

The blackboard is an active space, ready to change and willing to carry any thought. It doesn't have the restricting linear quality of a written text, and it allows the user to organize the material according to its natural, spatial characteristics. Compared with writing on a page, the blackboard invites wider gestures and larger symbols. This broader physical space makes it psychologically satisfying to work on a blackboard. With a brief gesture and a sponge, one can modify past thoughts, fix mistakes, and express an improved understanding of a problem. The blackboard makes it easy to keep what is deemed good and remove what isn't. Unlike text on the page, content on the blackboard has no definitive end.

Perhaps the best use of a blackboard is for collaboration—working together to deal with a mathematical challenge—where it provides a shared space on which an argument develops from individual contributions. The process of teaching and learning is also well suited for the blackboard. A lecture on the blackboard goes more slowly than one using slides, and so the audience can absorb the material more deeply. The flow of the lecture is recorded on the surface of the blackboard, and the audience therefore gains an expanded short-term memory. The blackboard also exposes the lecturer to the risk of making mistakes, but that's a good thing! Such mistakes, when caught by the audience, can be easily corrected and are particularly instructive. What is learning if not this ebb and flow of getting from *tabula rasa* to *tabula inscripta*?

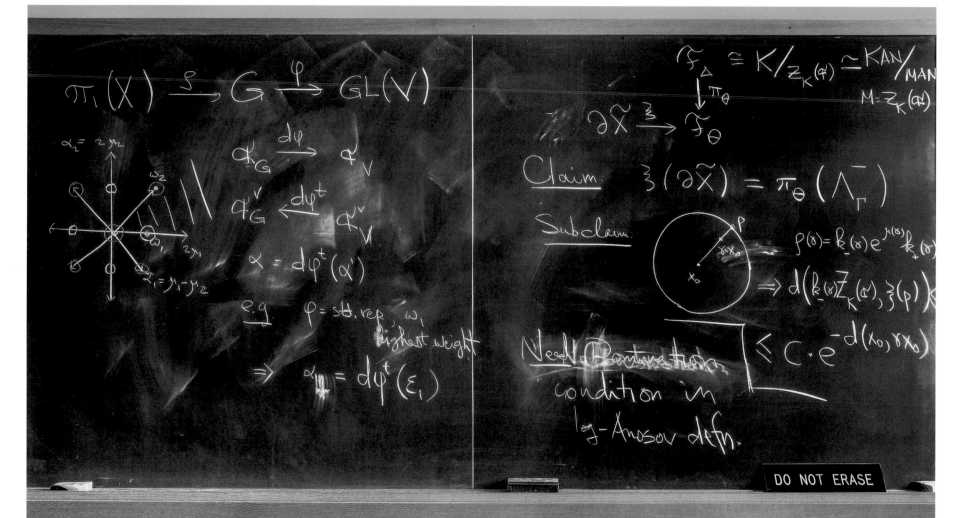

PATRICE LE CALVEZ

Patrice Le Calvez is a professor
at Sorbonne Université. From 1992
to 2008, he was a professor at the
University Paris 13. Since 2018,
he has been a senior member of the
Institut Universitaire de France.
He received the Charles-Louis de
Saulces de Freycinet Prize of the
French Academy of Sciences in 1995
and was an invited speaker at the
International Congress of Mathema-
ticians in Madrid in 2006.

The curves drawn on the blackboard are Brouwer lines of a homeomorphism of the plane, and the picture represents a topological horseshoe naturally defined by these curves. Such a mathematical object is the hallmark of chaos in dynamical systems: it shows how stochastic behavior can appear in deterministic systems. The work on the board illustrates a proof of a recent result we developed with Fabio Tal at the University of São Paulo, which gives a simple criterion for existence of a horseshoe for surface homeomorphisms. This criterion yields sufficient conditions to ensure that a given dynamical system on a surface is chaotic.

My research is in the field of dynamical systems, and I am particularly interested in the dynamics of maps defined on a surface, studied from a topological viewpoint. So, it is no surprise that blackboards are precious for my research—while talking with collaborators, of course, but also alone, just to help my thinking. I do not usually write many formulas on boards; I mainly draw figures. Sometimes, as in this photograph, I draw complex pictures with pieces of chalk in different colors (which is impossible to do on a whiteboard, with its limited markers). But more frequently, I create rough drawings that are quickly erased, drawn again, erased again, and so on. When I am concentrating on a problem, I will often be sitting in a chair and looking at the blackboard, which often has a muddle of points and curves, or sometimes just a single point, and a new idea will emerge. Strangely, this process does not work quite so well on a whiteboard.

The crutch that can be seen on the right is a souvenir from a one-month stay at Tsinghua University. A few days after my arrival in Beijing, while I was walking around the city, my foot met a small hole in the sidewalk. What I thought was a small sprain turned out to be a fracture, and a pair of crutches and an electric bicycle became necessary for the rest of my stay. The bicycle stayed in Beijing, but the crutches came back with me, and they now serve as decorative objects in my office.

JOHN TERILLA

John Terilla has worked in topology, deformation theory, probability theory, quantum computing, and machine learning. He is a professor of mathematics at Queens College and a member of the doctoral faculty at CUNY Graduate Center.

My friend, the mathematician Yiannis Vlassopoulos, once said that language is a one-dimensional painting. I really like that notion. At the time my board was photographed, I was working on the mathematical structure in natural language.

Natural language, such as spoken or written English, is compositional. Short phrases can be combined to make longer expressions. Language is also statistical. The fact that "red fire truck" has been expressed more often than "green fire truck" reflects something about what a "fire truck" is. Both compositionality and statistics are very mathematical notions, and I was (and still am) working on understanding how those notions can be combined to better understand how meaning emerges from sequences of symbols or sounds in natural language.

When I was in college, I used to write mathematics in graph paper composition books in tiny print using a fine point mechanical pencil. I took great delight in how such complicated ideas could be expressed in a line of little symbols, greek letters, and logical quantifiers. Later, in graduate school, I learned to write very large from my advisor, Mike Schlessinger. During lectures, Mike would fill the chalkboard with his huge, loopy script. There'd be chalk dust everywhere. His entire desk was covered with a gigantic tablet of paper so he could write anywhere on the surface. When it would get filled up, he'd tear off the top sheet, and there'd be a new, blank sheet underneath. I got myself some giant sketch pads and would work lying on the floor, filling them up with math using broad-point pens or pencils with the softest, thickest lead I could find. I was figuring out that a picture (or a commutative diagram) was worth a thousand words. Like

the alien heptapods in Ted Chiang's "The Story of Your Life" (on which the movie *Arrival* was based), mathematicians working on sketchpads and chalkboards are using a kind of two-dimensional language that can communicate so much more than a string of symbols written in a one-dimensional line.

It's an interesting irony that on the board pictured, I'm using a kind of two-dimensional mathematical language to try to understand the structure of one-dimensional natural language. But it makes a certain kind of sense, too, since the spoken or written language that humans produce is more like a one-dimensional shadow of a deeper, higher-dimensional structure from within the human brain—or, more accurately, many interacting human brains.

$\mathcal{L} \xleftarrow{} $ Free monoid on \mathcal{A} \qquad $db = \mathcal{L}$

$\Pi_n : \mathcal{A}^n \longrightarrow \cdots \longrightarrow [0,1]$ \qquad α, β with $\underbrace{}_{\beta}^{\alpha}$ \qquad $\alpha \longleftarrow \Pi_n(\beta) \longrightarrow \beta$ \qquad $\Pi_n(\beta | \alpha)$ \qquad $\beta \in \mathcal{A}^n$

$\longrightarrow \Pi_n \longrightarrow \Pi_{n+1}$ $\qquad\qquad$ $\Pi_k(\alpha)$ \qquad (α, β)

$[0,1]$ closed, monoidal, $\mathrm{Mor}(\alpha, \beta)$ $\qquad\qquad$ $= \Pi(\beta | \alpha)$

$\Pi : \mathcal{L} \longrightarrow [0,1]$

or

$\begin{array}{c} \alpha \\ \downarrow \\ \beta \end{array} \quad \begin{array}{c} \alpha' \\ \downarrow \\ \beta' \end{array}$ $\qquad \alpha\alpha'$

\exists Functor $F : \mathcal{L}, \Pi \longrightarrow \mathcal{D}$ $\qquad \chi$ $\qquad \Pi(\beta | \alpha)$ \qquad $\Pi(\alpha) := \sum$

$\hom(\alpha, \beta) \in [0,1]$

$\Pi_n(\beta\beta | \Pi_k(\beta'|\alpha')$ \qquad $\hom(\alpha, \beta) \otimes \hom(\beta, \gamma) \longrightarrow \hom(\alpha, \gamma)$ \qquad closed

$\beta\beta' \quad \Pi(\beta\beta' | \alpha\alpha')$ \qquad + id, $\hom(\alpha, \alpha)$ \qquad $z = \begin{cases} \frac{z}{x} & \text{if } z \leq x \\ 1 & \text{otherwise } z > x \end{cases}$ \qquad (co)complete

$\Pi_n(\gamma\alpha) \Pi_k(\gamma|\beta)$ \qquad + associativity $\qquad\qquad$ $\alpha = $ red $\quad \alpha = h$

$= \Pi_k(\gamma|\alpha)$ \qquad $\beta = $ redhot chili pepper

$\mathcal{L}' \leq k \oplus V \oplus V^{\otimes 2} \oplus \cdots \oplus V^{\otimes n}$ \qquad $\beta' = $ are not as hot

PAUL APISA

Paul Apisa is a mathematician. He received his PhD in 2018 at the University of Chicago while working under the guidance of Alex Eskin. Apisa is currently a Gibbs Assistant Professor at Yale University. Starting in autumn 2020, he will be a postdoctoral fellow at the University of Michigan.

If you take nothing else away from this essay, I hope you will take away the following thought, which I've paraphrased from Bill Thurston: the ultimate goal of mathematics is not to amass theorems but to increase human understanding. Of course, at first blush, this may not seem to directly pertain to chalk and blackboards.

There are two axioms I would like to throw out that I imagine few people will object to: first, mathematics can be complicated; and second, humans think slowly—or, to make the second axiom less grandiose, I think slowly. We all need time to absorb complicated mathematics. The last thing I want when mathematics is communicated to me is a gusher of text whizzing by at electronically enabled speeds. Technology has enabled rapid data transmission, but at the moment, it has yet to increase the data processing speed of the human brain. A virtue of chalk, and talks that use it, is that it checks the Icarian desire of a speaker to communicate too much, heedless of the capacity of the listeners to comprehend.

But perhaps the more important virtue of chalk is that it enables bad drawings. The world of mathematics can be infinitely complicated. As an example, if you set out to understand water spiraling down a drain, there are myriad molecules engaging in myriad collisions each second. But if you gave a piece of a chalk to a child and said, "Draw water going down a drain" you would likely come back to a chalkboard that had a curve on it spiraling down to a point. The complexity of a vast number of particles interacting in complicated and intertwined ways would have been flattened down to a one-dimensional curve making a familiar trajectory.

And this parable reflects one reason for my own affinity for chalk. It forces you to draw cartoons that only capture the essential features of a complex system and forces you to think about what exactly those features are.

So, now, a word about what's depicted on the chalkboard and how it came about. The objects on the board will be familiar to everyone—they are polygons. But these polygons live another life. One of the profound insights that initiated my branch of mathematics was that a complicated class of mathematical objects—"holomorphic one-forms on Riemann surfaces"—has a down-to-earth interpretation as polygons. This perspective shift led to the formulation of a number of questions that only really make sense to ask once you understand something in the gut-instinctual way that you understand polygons. When it was shown that "holomorphic one-forms on Riemann surfaces" were polygons, nothing about the objects changed, but a new world of mathematics was opened by the perspective shift.

The drawings on the chalkboard were put there over the course of a conversation with colleagues working in my area. They are cartoonish. They were added to the board only as fast as the physical limitations of chalk permitted them to be. They are the relics of a conversation that slowly used chalk drawings of simple objects to increase human understanding.

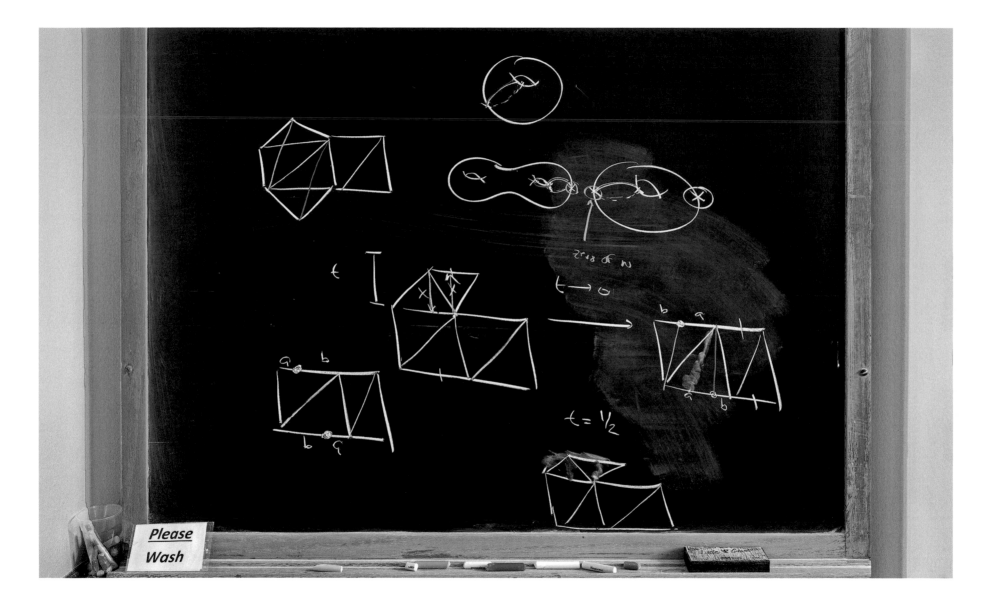

LORENZO J. DIAZ

Lorenzo J. Diaz obtained his PhD from IMPA in 1990 under the guidance of Jacob Palis and is currently a professor at the Pontifical Catholic University of Rio de Janeiro. He has been a member of the Brazilian Academy of Sciences since 2012 and a member of the World Academy of Sciences since 2018. He was an invited speaker at the ICM in 2018.

I did not decide to become a mathematician; life decided for me. I was always interested in mathematics, its beauty, and its structures. But there are many interesting subjects in the world—mathematics was the one that appeared at the right moment. I often imagine parallel lives in which I work in botanics, physics, or history.

I do not have a work process. I enjoy talking with other mathematicians and enjoy mathematics as a social activity. Sometimes—not very frequently—these discussions lead to new problems and new collaborations. Solutions to problems appear in unexpected ways, often when I'm walking, cooking, or taking a shower. Transforming your problem into an obsession is part of the solution. When I was working on my PhD, I had scheduled a meeting with my supervisor to discuss changing my thesis problem. The meeting was postponed, and while I was waiting, I suddenly found the solution, without consciously thinking about it.

My research deals with dynamical systems and the generation of chaotic dynamics from several points of view (topological, geometric, and probabilistic). On the blackboard in this photograph I have depicted a heterodimensional cycle and a blender, two key mechanisms for generating chaotic dynamics, as well as a skew product, one of my favorite objects in dynamics. These three objects were, and are, very important in my mathematical career.

On the subject of writing with chalk and chalkboards: some years ago, I developed an intermittent allergy to chalk. Thus, I prefer to avoid its use. These days, I am trying to discover the beauty of whiteboards.

TAI-DANAE BRADLEY

Tai-Danae Bradley is a PhD mathematics graduate from the CUNY Graduate Center, working in the intersection of category theory, quantum physics, and machine learning. She is also the creator of the popular math blog, Math3ma.

The process of writing is, to me, a thrilling part of being a mathematician. I often imagine that by writing, I am creating a mathematical painting with thoughtfully chosen words as the medium. Perhaps fittingly then, I also love pictures of handwritten mathematics. They've played an especially prominent role on my blog Math3ma, where my own handwriting appears throughout the website's visual design as well as in the content of the articles. I love the artistic, organic feel conveyed by the mathematics in this way.

As a young girl, however, I used to think that mathematics was just a slew of cryptic hieroglyphics meant to frustrate and confuse. But once I was taught how to see beyond the symbols to the conceptual ideas that lie beneath, I began to treasure them. Now, as a mathematician, I believe there is something deeply special in having an idea transfer from your mind to your fingertips, as the words and symbols come to life in a way that others can see and appreciate. Sharing these ideas is, for me, one of the biggest joys of working in mathematics, and watching them take shape on a crisp blackboard, with high-quality chalk in hand, is a particularly unique and special feeling.

Incidentally, the way in which ideas come together is not unlike the mathematics shown in the photograph here. The drawings illustrate an algorithm for reconstructing the state of a large composite system given information about the states of smaller pieces that comprise it, together with information about how those pieces interact with each other. This is similar to the process of learning mathematics, where one first accrues little bits of information and various notions, and then those ideas later assemble to form a larger, holistic understanding. The simplicity of the mathematical diagrams in the photograph reflects the simplicity of this analogous idea. And the ideas captured on the blackboard are likewise just a small piece of a much larger mathematical story.

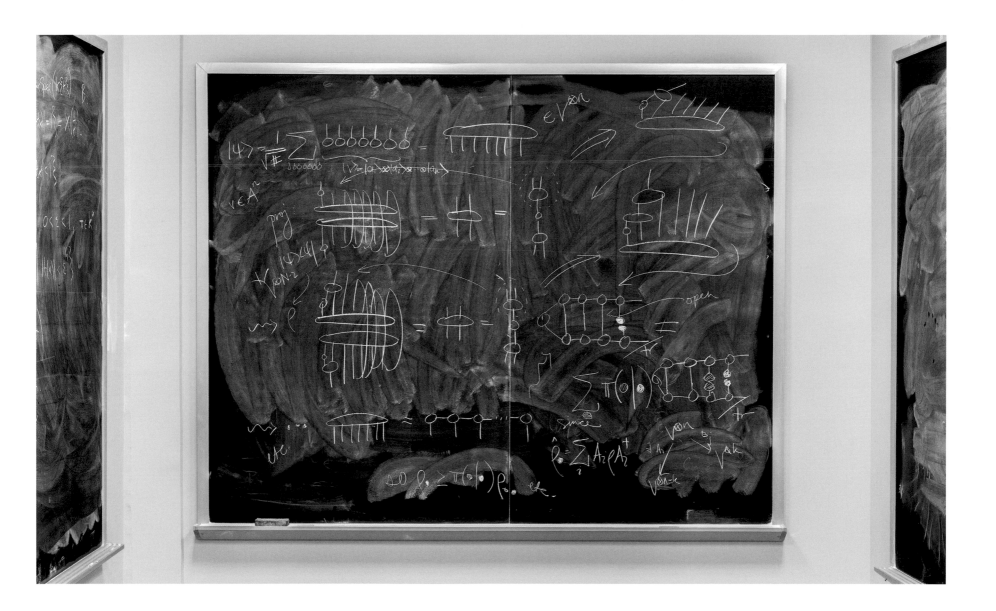

KA YI NG

Ka Yi Ng is an adjunct assistant professor at Columbia University, teaching in the master of arts program in Mathematics of Finance. She has twenty-two years of professional experience in the FinTech industry, specialized in derivatives pricing and market risk management. She is also a senior consultant at Finch Lead Inc., providing advice and assistance to financial institutions in the Treasury and capital markets. She received her PhD in mathematics from Columbia University.

This chalkboard reflects my current interest in the applications of machine learning to quantitative finance. For many decades, the Black-Scholes option model (introduced in the 1970s) and its variants have been used in the pricing, trading, and risk management of derivatives. This option model allows us to reduce or eliminate the sensitivity of an option position to the underlying market prices by using what's known as a delta hedging strategy. This provides a quick way to manage risk dynamically. However, for more complex models, where numerical methods or simulations are required, we may not be able to compute fast enough to run a delta hedging strategy. With advances in machine learning techniques and the availability of big data, we hope that machines can help us predict optimal hedging strategies in real time.

My interest in doing mathematics started back in my junior high school days. I was intrigued by how the basic algebraic operations and factorization could turn complex expressions that looked unmanageable into neat expressions, thus making the problem easier to solve. Later, when I discovered the formula for integration by parts before my teacher taught it to our class, I realized that even an ordinary high school student like me could rediscover ideas that mathematicians discovered centuries ago. Such rewarding experiences and little moments have encouraged me to study mathematics throughout the years.

Mathematics is the collective work of inquisitive minds. It is a common language for people to communicate ideas in a structured manner. It also serves as an essential tool to understand, explain, and solve problems in many disciplines. No matter what level of mathematical maturity you have, you can always appreciate mathematics and be fascinated and surprised by its results. Everyone's journey in mathematics is personal and unique, but we all share the same experience that mathematics is beautiful and crucial.

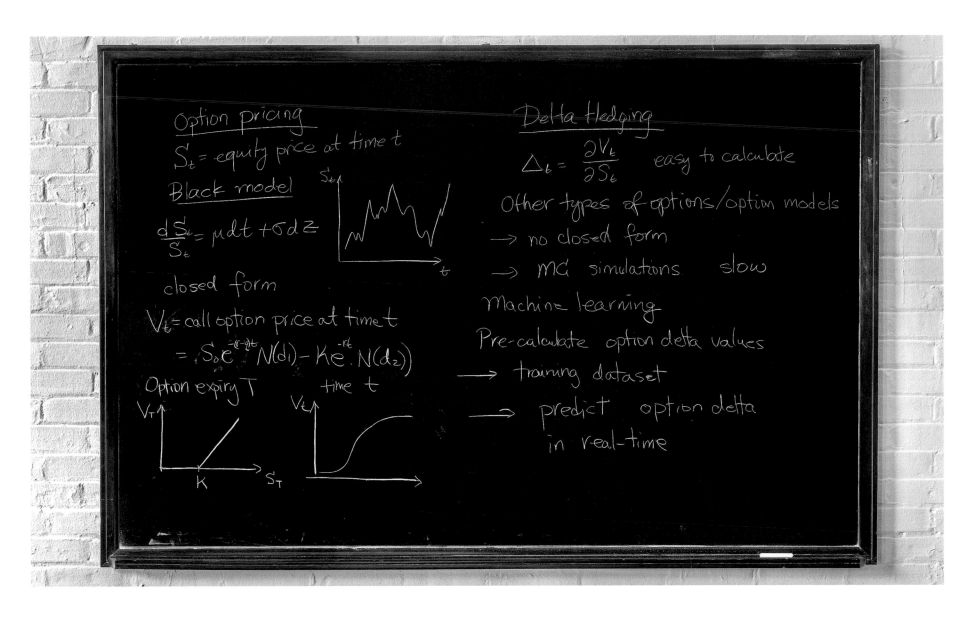

Option pricing

S_t = equity price at time t

Black model

$\frac{dS_t}{S_t} = \mu dt + \sigma dz$

closed form

V_t = call option price at time t

$= S_0 e^{-(r-q)t} N(d_1) - Ke^{-rt} N(d_2))$

Option expiry T time t

Delta Hedging

$\Delta_t = \frac{\partial V_t}{\partial S_t}$ easy to calculate

Other types of options/option models

→ no closed form

→ MC simulations slow

Machine learning

Pre-calculate option delta values

→ training dataset

→ predict option delta
 in real-time

DUSA McDUFF

Dusa McDuff was born in London and grew up in Edinburgh, and got her PhD from Cambridge University. After studying with I. M. Gelfand in Moscow and working in topology with Graeme Segal, she moved into the area of symplectic geometry in the 1980s. She has held positions at York, Warwick, and Stony Brook Universities and now is Helen Lyttle Kimmel '42 Professor of Mathematics at Barnard College, Columbia University. She has published more than a hundred research articles and gave a plenary address to the International Congress of Mathematics in 1998. She is a fellow of the Royal Society of London, is a member of the US Academy of Sciences, and was awarded the Royal Society's Sylvester Medal in 2018.

For almost forty years now, I have been working in the field of symplectic geometry. Rather than measuring lengths and angles as in Euclidean geometry, a symplectic structure measures the area of two-dimensional surfaces. This rather strange measurement turns out to be a way of capturing very basic physical phenomena such as the entanglement between the position and velocity coordinates of a moving particle. Since its beginnings in the mid-nineteenth century, symplectic geometry has been closely tied with ideas and developments in physics—most recently with the phenomenon of mirror symmetry.

I study symplectic geometry from a mathematical point of view, ignoring its connection with physics. Often I am simply trying to understand the geometric behavior of transformations that preserve this structure, wondering, for example, how a simple geometric figure such as a high-dimensional ball can move in space if we insist that all its symplectic measurements are preserved.

A related problem that turns out to be surprisingly interesting is to study when a four-dimensional ellipsoid can be put inside a four-dimensional ball. Such an ellipsoid is a four-dimensional analog of a standard two-dimensional ellipse, with its shape determined by the ratio of the areas of its two (two-dimensional!) axes. If you fix this shape, how large must the radius of the ball be? Surprisingly, the answer turns out to depend delicately on the numerical properties of the shape parameter. This problem also turns out to have hidden symmetry that you can exploit to halve the effective dimension. Thus four dimensions become two, and you can obtain much relevant information by drawing diagrams, as illustrated on my blackboard. It turns out that a four-dimensional ellipsoid corresponds to a two-dimensional right-angled triangle with a sloping hypotenuse. The obstructions to putting the ellipsoid inside a ball are then determined by the way this triangle can be cut up into a series of smaller, "standard" triangles.

Sometimes a problem is much more amorphous, and you have to move things around in your mind for a long time until you find a feature that can be captured, defined, and analyzed. Once, as I was walking along a street in Berkeley, thinking about an email a collaborator of mine had just sent, I suddenly saw how the ball that we were trying to understand could be separated into two parts, joined by a thin film that could be twisted and manipulated to put the ball where we wanted it.

In another project, which involved objects that started off as eight-dimensional and so had to be imagined in four dimensions, it took me over a year to begin to understand how to think about their geometry. Again, the breakthrough came in discussion with a collaborator, who found a key example that gave hints as to the kind of structural features that we could name and then try to understand.

I usually work out my geometric problems in my mind or on paper. However a blackboard is essential to my teaching, because I can make the force of an argument visible to students by writing it up step by step on the board, explaining as I go. The physical and visual process of writing and drawing diagrams makes the thinking process more concrete and, one hopes, more accessible.

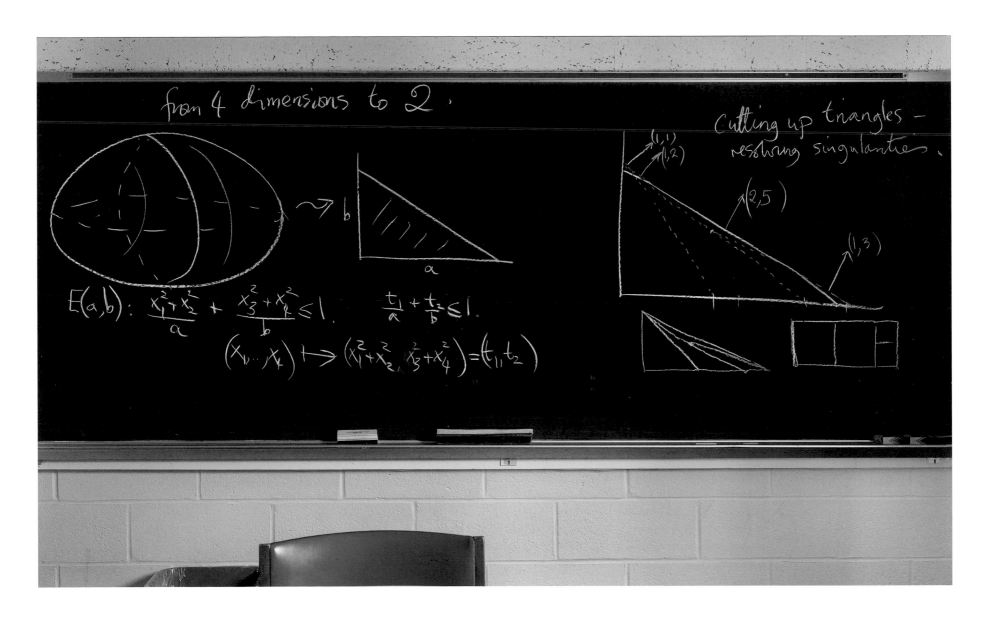

NICHOLAS G. VLAMIS

Nicholas G. Vlamis was born in Stroudsburg, Pennsylvania, in 1986. He received his PhD in 2015 from Boston College. In 2018, he started a position as an assistant professor at Queens College of the City University of New York after completing a postdoctoral fellowship at the University of Michigan. Vlamis's primary areas of research are topology, geometry, and group theory.

Mathematics has a rich culture steeped in history and tradition that is supported by a dedicated international community. At a time when the basic structure of social groups is rapidly changing, mathematics provides what can feel like a large extended family. We have rituals and responsibilities such as teaching, mentoring, and taking part in departmental committees, seminars, and colloquia that bring together people from different nations and generations with various opinions and interests.

For instance, nearly every week during the semester, we have a visitor from another university come and share new and interesting mathematical ideas with our group at a local seminar. As part of this process, I routinely find myself sharing a meal with someone I've never met before, alongside my colleagues whose birth dates represent every decade from 1940 to 2000. And yet, the conversation flows naturally and freely, bouncing from one topic to another. It includes mathematical research, travel, popular culture, politics, and maybe most importantly, stories told and passed on about mathematics and mathematicians—its folklore.

Shown on the chalkboard is a standard part of my talks in which I communicate, via pictures, the types of mathematical objects I study, namely surfaces. Despite having a formal mathematical definition, intuitively, the usage of the word *surface* in both mathematics and the English language agree. Standard examples of surfaces are the surface of a ball—known as a 2-sphere—and the surface of a doughnut—known as a torus. We say that a torus has genus one owing to its single hole and the 2-sphere has genus zero as it lacks a hole. Much of my recent work focuses on the symmetries of "big" surfaces, such as those shown on my board. One particular example here is colloquially referred to as the Loch Ness monster surface because it can be drawn—in a topologically equivalent way—as to look like the standard image of Nessie swimming in Loch Ness. The fact that we can tell when two surfaces are (topologically) equivalent by inspection is due to a beautiful theorem known as the classification of surfaces.

The chalkboard is the glue that holds together this community and its rituals. Whether it be one-on-one discussions or a seminar, we communicate with one another through the board. My closest adult friendships have all begun through mathematical collaboration, standing in front of a chalkboard trying to understand, together, some mathematical puzzle. This experience, somehow, leads to friendship; it has been one of the great joys of my life.

Classification of Orientable Surfaces

Zoo of infinite-type surfaces

Closed:

Sphere
$g=0$

Torus
$g=1$

genus-2 Surface
$g=2$

Classified by genus (or # of holes)

Finite-type: Finitely generated Fundamental group, or obtained by deleting a finite # of points from closed surface

e.g

& Loch Ness Monster Surface

Not homeomorphic!

& Jacob's ladder surface

Cantor tree Surface
$\cong S^2 \setminus$ Cantor set

blooming Cantor tree Surface

JARED WUNSCH

Jared Wunsch received his PhD in 1998 from Harvard University under the direction of Richard Melrose. He held an NSF postdoctoral fellowship at Columbia University and was assistant professor of mathematics at Stony Brook University before coming to Northwestern University in 2002. He is currently professor of mathematics at Northwestern, where he served as department chair from 2012 to 2015. He has held visiting positions at MSRI, the University of Nantes, the University of Paris, Institut Henri Poincaré, and the Australian National University. Wunsch is a fellow of the American Mathematical Society.

The blackboard shows a proof of "propagation of singularities," a mathematical principle that governs how the energy of a wave moves around in phase space—that is, how its position and momentum change in time as if the wave were really a particle. This argument is one mathematical expression of what physicists call the correspondence principle, which relates the quantum world to the world of classical Newtonian mechanics. It actually applies not just to quantum theory but to all sorts of equations describing waves that show up in mathematics and physics.

As a concrete illustration, imagine an infinitely large billiard table, equipped with one or more bumpers. If most of the ways you can shoot a billiard ball result in the ball dinging off a few bumpers and then zipping off to infinity, then a wave propagating on the same table will disperse quickly and decay to nothing. By contrast, if there are lots of ways to shoot the ball so it stays trapped among the bumpers, then a wave may linger for a long time. A wave does eventually have to die away, though, in contrast to a billiard ball, which might be trapped forever between two bumpers. A lot of my research is focused on this subtle interplay between the billiard motion and the wave motion, and the ways in which the former does or doesn't completely describe the latter.

I learned the argument shown on the blackboard (which originated with Lars Hörmander) from my doctoral advisor, Richard Melrose, and it's one of the first tools I teach my own students. The argument is an appealing blend of geometry and analysis (calculus), hence the mixture of drawings and inequalities on the board.

I interact with collaborators and students at my blackboard. The give-and-take when two of you are standing there with the chalk, scratching your heads and trying stuff out, is the most pleasurable way of doing research. I use the fancy Japanese chalk, which makes it kind of a sensual pleasure.

The thought bubble over the board, indicating bafflement, was a gift from a student, David Miller, who wrote an undergraduate thesis under my supervision. It's supposed to show how confused he felt, standing at the board and trying to explain to me what he'd figured out. That kind of confusion is always part of the deal when you're doing research.

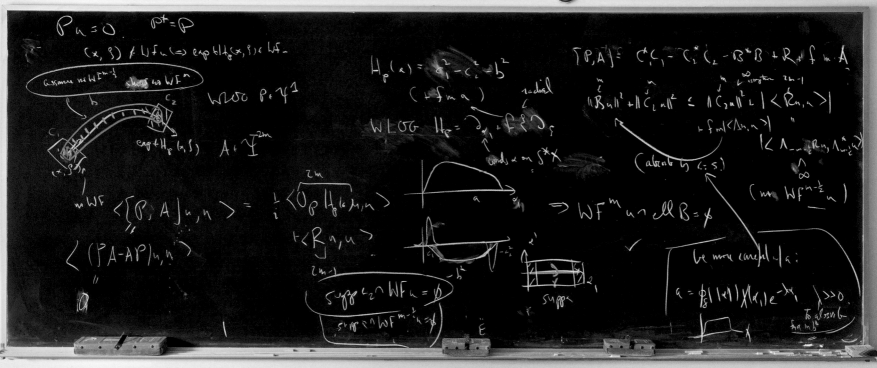

CALVIN WILLIAMSON

Calvin Williamson is a professor in the Science and Mathematics Department at the Fashion Institute of Technology in New York City. He has a PhD in mathematics from the University of Michigan and teaches mathematics, statistics, programming, and color science. He has also worked as a software engineer specializing in computer graphics and film production software for special effects companies like Rhythm and Hues Studios in Los Angeles.

The little diagrams in this photograph show how symmetry operations, like reflections or rotations, can be combined. When I first learned about the idea of multiplying or combining symmetries, I was very excited. I think it was one of the things that drew me to mathematics as a discipline. I had a blackboard in my dorm room in college, and I would draw reflections, rotations, and glides over and over again. Something about putting the mathematics up easily and in full view allowed me to think about it more deeply. To this day, it still amazes me that two reflections might combine to become a rotation.

Much of mathematics is about finding ways to combine objects; a simple example is combining numbers by multiplying or adding. The work on this chalkboard shows that the symmetries for a type of border pattern have some surprising relationships when they are combined. Imagine that we start with a motif, some simple design, like a little "b." Then we apply one of the symmetries, say a horizontal reflection, to that motif. Then we apply another, say a vertical reflection. This is the same as a 180-degree rotation; we could say that these two reflections combine, or multiply, to become a rotation. In fact, the way symmetries combine determines the types of patterns that you can build using these symmetries.

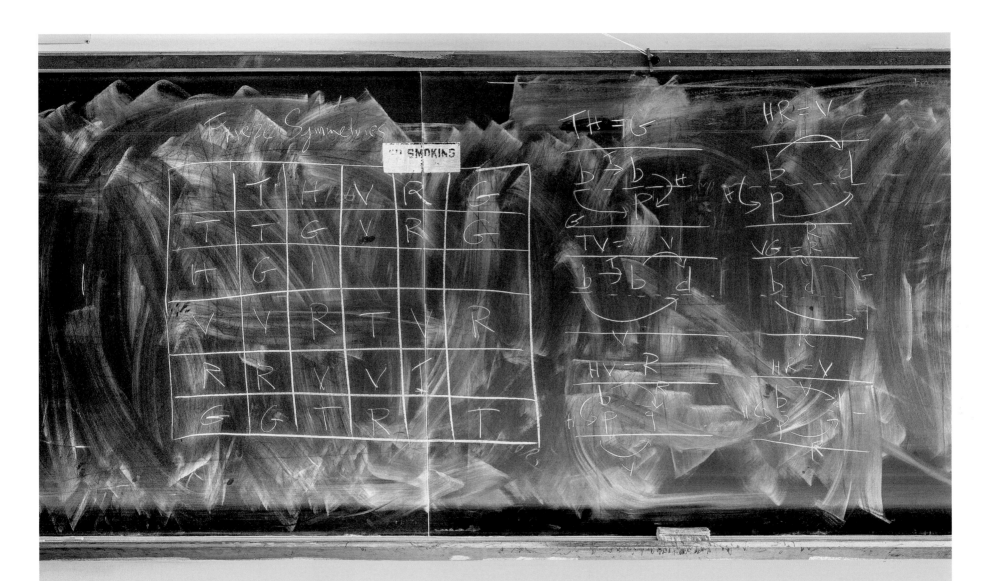

MARCELO VIANA

Marcelo Viana is a researcher at IMPA, the Instituto de Matemática Pura e Aplicada in Rio de Janeiro. He is also IMPA's current director. As the director of IMPA, he oversees the realization of the Brazilian Math Olympiad, which involves over 18 million students every year. He was the president of the Brazilian Mathematical Society and a vice-president of the International Mathematical Union. He was twice invited to address the International Congress of Mathematicians, the second time as a plenary speaker. He has received several academic distinctions, such as the Grand Prix scientifique de la Fondation Louis D. of the Institut de France, and is a member of several academies of sciences. He actively promotes the popularization of mathematics in society through a wide range of initiatives, such as the Brazilian National Math Festival. He writes a weekly column about mathematics and science in *Folha de São Paulo*, Brazil's most prominent newspaper.

When I was fifteen, my mom asked what I wanted to do in life. My reply was swift: "I want to be a math professor." She was impressed by my precision and determination, particularly at such a young age. But of course I had no idea what I was asking for. The "math professor" thing turned out to have many more dimensions than I could possibly suspect back then. But I do not regret it, not in the least.

My process for doing mathematics involves a lot of writing and rewriting, writing and rewriting. To stare at what I've written and try to improve it really helps me think. And that is why chalkboards play such an important role in my work: with chalkboards, it is easy to start all over again, to erase some parts while keeping others, to combine text with figures with various levels of precision. Besides—and I think that this is really important for many mathematicians—working on the chalkboard is naturally interactive. The chalkboard is particularly well suited for lively collaborations with others in the development of new ideas.

I work in dynamical systems, an area of mathematics that combines concepts from many other areas, including geometry and topology; it is an area where all those features of the chalkboard are particularly useful.

I recall a time in graduate school when I was working on a problem that perplexed me: I spent tons of chalk on it. The solution eventually popped into my mind while I was watching television. It came in the form of a figure: I instantly knew that the solution was in that figure, although it took me several days to understand why. And I worked it out back on the chalkboard.

The writing on the board in the photo belongs to two different conversations with students, on two different days. I recall that we just went on erasing the first conversation, which was about "chaotic" behavior in certain one-dimensional models, to make room for the second one, about some linear cocycles that have been intriguing me for more than two decades. Alas, I'm afraid we haven't made much progress on either problem so far.

It would not be much of an exaggeration to say that most of the happiest (and almost all of the unhappiest) moments of my career as a mathematician happened in front of a blackboard, with my fingers covered in chalk dust.

YVES ANDRÉ

Yves André is a mathematician and research director at the French National Research Center in Paris, working on algebraic and arithmetic geometry.

When I was young, after reading Jules Verne's novels, I wanted to be an adventurer: for the challenge, the freedom, the encounters with the unexpected and the marvelous. Then, regrettably, I learned that to be an adventurer like Verne's characters was no longer possible in our time. But as a young student, I found that it was possible to be a modern adventurer by studying mathematics, and so I became a mathematician.

This chalkboard shows the trace of an intense adventure of three years, the challenge of which was a classic fifty-year-old problem that ignited me when I learned about it, and which I resolved by making a long, unforeseen detour in a whole other region of mathematics: the marvelous perfectoids.

suite "lim Cohen-Macaulay"

$S = S_0$ S_n

$H_i(\bar{S}_n)$ $i > 0$

petit. asymptotiquement quand $n \to \infty$.

(par rapport à $H_0(S_n)$).

car p : S_0, $S_1 = S^{1/p}$, ... α V

car. mixte ? S_i

 g. discriminant

R_{∞} $r_{S_j} = W(h)[[\pm]]$ $R_{\infty,i} = W(h)(S_{i,0})[[\pm^{1/p^\infty}]]$

$R_{\infty,i}$ p-complétion de $R_\infty[\pm^{1/p^\infty}]$

action Galois $G = \mathbb{Z}_p^n \rtimes \mathbb{Z}_q^\times \curvearrowright$ S_∞ $S_{\infty,0} = \text{lic}(R_{\infty,0}, S \otimes R_\infty[\frac{1}{p}])$

 U $S_\infty^{G_n} = S_n$??

 G_n indice fini

LINDA KEEN

Linda Keen was born and grew up in New York City and earned her PhD at NYU. She was a professor at Lehman College and the Graduate Center of CUNY for more than fifty years, where she is now professor emerita. She has held visiting positions at UC Berkeley, Columbia, and Princeton, among others, and has lectured in many places in Europe, Asia, and South America. She is a former president of the AWM and former vice-president and trustee of the AMS and was the founding editor of the AMS electronic journal *Conformal Geometry and Dynamics*. She is an inaugural fellow of both the AMS and the AWM.

As a sophomore in high school I had two terrific math teachers, both of whom were very encouraging to me, a female student—something unusual in 1950s America. Although I had no idea what a mathematician "was," I majored in math in college, did well, and was encouraged to continue on to graduate school. This was a time when there were many barriers for women in science: many universities took no or very few women students; many places would not hire a woman; and of those that would, many would not let a pregnant woman work. There were also nepotism rules, so couples couldn't work at the same place—and the list goes on. Nevertheless, the Soviet launch of Sputnik set off a major push for science education and created many more jobs and support for scientists, enough so that it was possible for the few women graduating to get jobs. I was lucky in that a number of my professors in graduate school, particularly my thesis adviser, were extremely supportive. Once again, I got the encouragement I needed to go on, and I have had a long and, on the whole, very satisfying, career.

I was always drawn to mathematics that was more geometric than algebraic, and began my career in an area called "Riemann surface theory," in which we try to understand and catalog the possible geometries a given surface may have. For example, a bagel may be very round or very long and thin, so the ratio of width to length does the job. I spent about half my career working on problems of this sort.

At one point, though, the things I knew began to be applied to certain types of dynamical systems. The field of dynamical systems is the study of what happens when you have a function mapping a space to itself, and involves trying to understand where various points in the space go when you iterate the function.

There are two central problems in dynamical systems. The first asks whether nearby points stay close under iteration or whether there is a "chaotic set" where they eventually go very different ways. The second problem asks what happens when you perturb the function a little by introducing a parameter. The parameter space divides into infinitely many regions where the "dynamics" are qualitatively different. There are many systems that exhibit a surprising relationship, where parts of the structure of the chaotic set for a given map are reflected in the structure of the parameter set. I have been interested in this duality between the dynamics and the parameters for certain families of functions of complex variables, such as polynomials of a fixed degree, or the family of quotients of linear functions of the exponential.

In the example on the board, we have two planes: the domain of our function, and the parameter plane. On the right is the dynamic space of a particular function in the family of quotients of exponentials. The yellow curves measure "how fast" points tend to a fixed point under iterates of the function. On the left is a picture of the parameter space, where the white curves are boundaries between regions with different dynamics.

Understanding and describing this picture is part of a program of research I am working on now with two colleagues, Tao Chen and Yunping Jiang. In fact, most of my career has involved joint work, and one of its great pleasures has been gathering around a blackboard to explain and try out ideas.

PETER JONES

Peter Jones received his PhD at the University of California, Los Angeles, in 1978, under the supervision of John B. Garnett. He is a professor at Yale University and works in the areas of fractal geometry and harmonic analysis. Jones is a member of the American Academy of Arts and Sciences, the US National Academy of Sciences, and the Royal Swedish Academy of Sciences. He received the Salem Prize in 1981.

I am an analyst, and most of my work uses sequences of involved estimates. The estimates usually have some associated geometry that covers a large number of scales, and the different pieces appearing in a problem typically interact with each other. While most of my work is not directly about probability theory, the arguments in my proofs almost always use structures that arise naturally in probability theory. My usual method for solving those problems requires drawing complicated pictures, often with many boxes, and estimating the interactions that arise. That is why my blackboards and notes are covered with pictures.

My first attempt is typically to draw simple pictures consisting of many interrelated boxes, and then see if I can find some way to figure out how to get all the various interactions under control. At this point, I usually need a good amount of time to find a methodology to control the interactions. Most of my work then stops being done with pen and paper or on a blackboard, and instead consists of finding a mental image of boxes that come in a variety of sizes and colors. When properly done, this allows me to estimate the contributions from the other boxes in the "picture" on any fixed box. At that point in my work, I spend a lot of time just thinking day and night about the images. Are the boxes the correct size and color? Are they in the correct places? I am not sure I have ever managed to explain this methodology to other mathematicians. Fortunately, my blackboards are willing to put up with this approach, and many of my drawings stay on my blackboards for several years. The pictures on my blackboards at present did lead to the solution to a problem that has bothered me for thirty-five years. I have not yet erased anything because I want to get more out of it.

I am fortunate to have a lot of blackboard space. One half of my blackboard space is not to be touched by anyone, myself included. The other half is used for discussions with students or researchers.

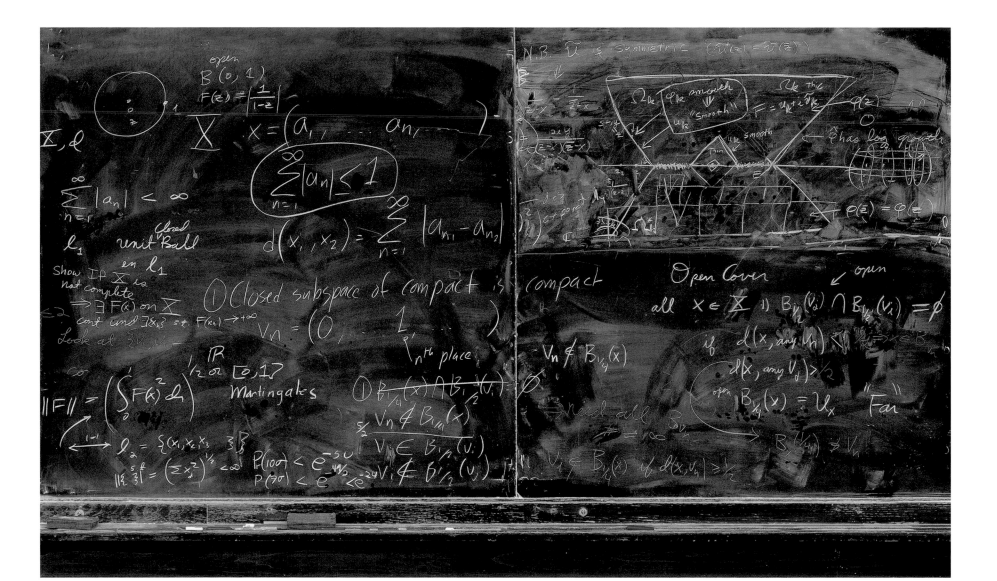

MARIO BONK

Mario Bonk received his PhD from the Technical University of Braunschweig in Germany in 1988. His research interests include the geometry of negatively curved spaces, geometric group theory, dynamics of rational maps, and analysis on metric spaces. He moved to UCLA in 2010, where he is currently chair of the Department of Mathematics.

A blackboard (or, more recently for me, a whiteboard) is absolutely essential for my work as a mathematician. I believe that the old-fashioned method of teaching with a blackboard is superior to using computer technology. Of course, technology has some advantages—for instance, if you want to show elaborate graphics or video clips—but in general, I prefer the blackboard.

Many of my colleagues prefer blackboards to whiteboards. Often the pens used on a whiteboard are worn out and the writing becomes faint; the worn-out pens are a constant nuisance. Moreover, writing with a marker usually results in thinner lettering than writing with chalk. Therefore, in larger classrooms, it is hard for students to see what is written on the whiteboard—this is a frequent source of complaints in bigger classes.

The very process of writing on the board sets a pace that allows the audience to follow your thought process, which can be quite elaborate in mathematics. In general, good blackboard technique is an important skill for a mathematician. Blackboards (or whiteboards) are also essential for my research collaborations. You can jot down pictures or formulas that convey the essence of a mathematical argument, which really helps in exchanging complex ideas. It has happened many times that after a lively discussion with a collaborator involving heavy use of the blackboard, we stepped back and stood in awe of the final result—not only for its mathematical value but also for its artistic appeal.

The blackboard pictured here shows two examples of the geometric construction of so-called Thurston maps. These maps appear in an area of mathematics called complex dynamics.

Construction of
exp. Thurston maps
using triangular
pillows.

JEAN-PIERRE BOURGUIGNON

Jean-Pierre Bourguignon is a mathematician specialising in differential geometry and mathematical aspects of theoretical physics. Bourguignon has been a fellow of the Centre National de la Recherche Scientifique for forty-four years. He holds a PhD from University Paris VII (1974). Director of the Institut des Hautes Études Scientifiques in Bures-sur-Yvette (1994–2013), he taught at École polytechnique (1986–2012) from where he graduated (class of 1966).

There are many virtues that make chalkboards the privileged companions of mathematicians. One can test ideas on them; one can write; one can draw shapes and diagrams or do calculations; one can correct oneself easily (this is why using chalk is so important); one can distance oneself from what one has just written by using the space to get some physical activity, which is not possible while sitting at a table. This last point is critical. Regaining control over a situation in which the local dynamic—induced by doing a calculation, for example—has made one lose the global perspective is often the key to making the breakthrough one hopes for.

Chalkboards are also wonderful instruments to share what one has written, whether with a large class or a small group of collaborators. Because writing on them is a rather slow process, it forces the presenter to adopt a pace that will allow the audience, small or large, to absorb the material presented. Indeed, except for a brilliant few, understanding what one is confronted with takes time. Simply reading what someone else has written and listening to him or her is not enough; one still has to make sense of it, which requires connecting the new input with other facts or ideas that must be brought into the picture.

There is an artistic dimension, a whole choreography, inherent to the use of chalkboards, from deciding where to begin writing to determining what size characters or drawings one should use. These decisions, of course, depend on the space needed to express the full content, and on the size of the audience. Talented teachers construct their blackboards as artists would construct a painting: such that, in the end, the result can be photographed, leaving behind a complete summary of the message to be transmitted—a true piece of art.

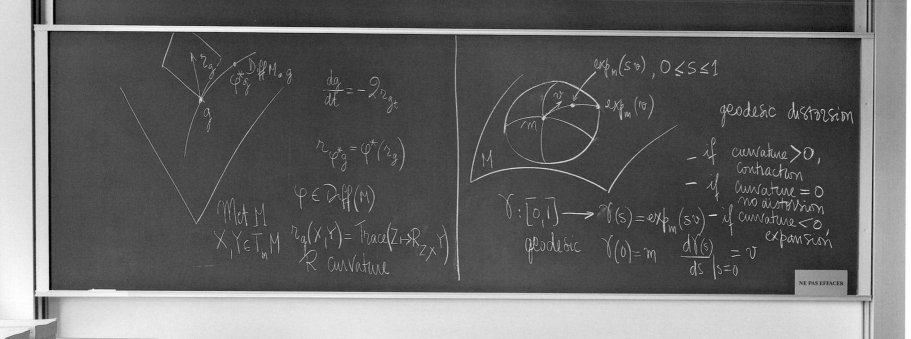

$$\frac{dg}{dt} = -2\, r_g t$$

$$r_{\varphi^* g} = \varphi^*(r_g)$$

$$\varphi \in \mathrm{Diff}(M)$$

$M \in M$
$X, Y \in T_m M$ $r_g(X,Y) = \mathrm{Trace}(Z \mapsto R_{Z\,X}\,Y)$
R curvature

$\exp_m(sv)$, $0 \le s \le 1$

$\exp_m(v)$

$\gamma : [0,1] \longrightarrow \gamma(s) = \exp_m(sv)$

geodesic $\gamma(0) = m$ $\left.\dfrac{d\gamma(s)}{ds}\right|_{s=0} = v$

geodesic distorsion

– if curvature > 0, contraction
– if curvature $= 0$ no distorsion
– if curvature < 0, expansion

CHRISTINA SORMANI

Christina Sormani is a professor of mathematics at the City University of New York. In 2015, she was named an AMS Fellow for "contributions to geometry, including the study of Ricci curvature, and for mentoring activities, especially for young mathematicians from under-represented groups."

I always loved geometry and physics in high school and, as an undergraduate, I learned of Ricci curvature in a course on gravitation. I was intrigued by the idea that spacetime was curved by gravity, and that the formula for this curvature was so simply written in terms of the Ricci tensor. As a doctoral student, I learned of Milnor's conjecture, which states that a noncompact manifold that extends out to infinity has only finitely many holes if its Ricci curvature is positive. I recall sitting in class as my future doctoral advisor wrote the conjecture across the board, amazed that there was an open question in mathematics that could be stated so simply and beautifully.

Five years later, I realized that every hole in a space with positive Ricci curvature is forced to be quite large, so that there is very little room for a ray of light to escape past it. Again and again I drew pictures trying to understand how this might be applied to prove the conjecture. Finally I proved this special case of the conjecture assuming the volume growth is only linear. The key was to realize there was a second picture involved.

My theorem is shown here on the board along with the key pictures. I recall the first time I presented the full proof at a conference on a great system of sliding blackboards: one hidden behind the next, each with a new diagram or formulas to reveal, until every step was completely understood by all.

Theorem: If M^m is a complete noncompact manifold with

$$Ricci \geq 0$$

Average curvature is Positive

and

$$\limsup_{r \to \infty} \frac{Vol(B_p(r))}{r} < \infty$$

then $\pi_1(M^m)$ is finitely generated.

finitely many holes

This is a partial solution to the Milnor Conjecture!

Proof idea:

γ_i are generators of π_1 based at p of length L_i

$\gamma_i(\frac{L_i}{2})$ ← Is a uniform cut point

all geodesics entering this ball are cut

This leads to a contradiction due to the lack of volume

JB.

PETER SHOR

Peter Shor was born in 1959 in New York City. He is the Morss Professor at the Massachusetts Institute of Technology. He was awarded the Nevanlinna Prize in 1998. He is a member of the National Academy of Sciences and the National Academy of Engineering.

My most famous result, "Shor's algorithm," is an algorithm for prime factorization on a quantum computer. Quantum computers use quantum mechanics in their fundamental operations, and in some sense they are really physics experiments. The ones that have been built so far have been too small and noisy to do anything useful, but they are steadily getting better. I had seen a talk by Umesh Vazirani on quantum computers about a year prior to proving this result, and I started thinking about whether quantum computers could be any faster for useful problems (while also pursuing less exotic research on algorithms for digital computers).

The critical insight came when I saw Dan Simon's paper on his quantum algorithm. A crucial step in his algorithm was taking a quantum Fourier transform over binary strings, and I realized that taking a different Fourier transform might be useful for factoring and for computing discrete logs, two number theory problems that are critical for our current methods of encrypting data. I figured out how to apply these quantum Fourier transforms to get algorithms for these problems. These algorithms mean that if you can build a quantum computer large enough and reliable enough, you can break the codes used for protecting data on the Internet.

When I am working on my own research, I generally work on paper; I only use the blackboard when I am collaborating with other people. What is on the blackboard in this photograph is a question one of my collaborators asked, and some ideas for trying to attack it.

I didn't tell anybody that I was working on factoring on quantum computers because I thought it was such a long shot. I am sure that lots of other mathematicians are working on famous problems without telling anybody, like Andrew Wiles did on Fermat's Last Theorem. I am not sure whether this is a good aspect of the culture of mathematics. Maybe if all the mathematicians working in secret on the Riemann hypothesis got together and compared notes, they could solve it.

GRIGORY MARGULIS

Grigory Margulis is the Erastus L. De Forest Professor of Mathematics at Yale University. He received his PhD in 1970 from Moscow State University. He was awarded a Fields Medal in 1978, a Wolf Prize in Mathematics in 2005, and an Abel Prize in 2020, becoming the fifth mathematician to receive the three prizes.

I was born in Moscow in 1946. I suppose I was destined to become a mathematician from an early age. My father was a mathematician, and he was interested in mathematical education. In the seventh grade, I began participating in mathematical circles, a sort of math club run by students at Moscow University. I also participated in mathematical olympiads. The prizes from the olympiads consisted of collections of mathematical books, which were quite advanced, and incidentally, were very cheap during Soviet times.

In 1962, I entered Moscow State University. The university is subdivided into so-called faculties, and I was a student in the division of mathematics in the faculty of mechanics and mathematics. There were an enormous number of seminars during that time, and I attended quite a few of them—maybe too many. It was not unusual for undergraduate students at Moscow State University to do research. I wrote my first paper, "Positive harmonic function on nilpotent groups," in Eugene Dynkin's seminar when I was a third-year student. At the end of my third year, Yakov Sinai became my advisor. His influence on my formation as a mathematician is hard to overstate.

In 1991, I became a professor at Yale University. This was the start of a new period in my mathematical and nonmathematical life. The style of my work changed. While in Moscow, I wrote all of my papers by myself. Since coming to Yale, almost all of my papers, during the last thirty years, have been written jointly with other mathematicians.

The left half of the chalkboard, pictured here, was drawn by my former student Thomas Hille. This formula is related to my joint work with Friedrich Goetze on the distribution of values of quadratic forms at integral points. I haven't erased this part of the board in several years—mainly because of its complexity, but also because it would be difficult to rewrite the computations each time. Recently Paul Buterus (a student of Goetze), Goetze, Hille, and I submitted for publication a significant improvement of the above-mentioned paper.

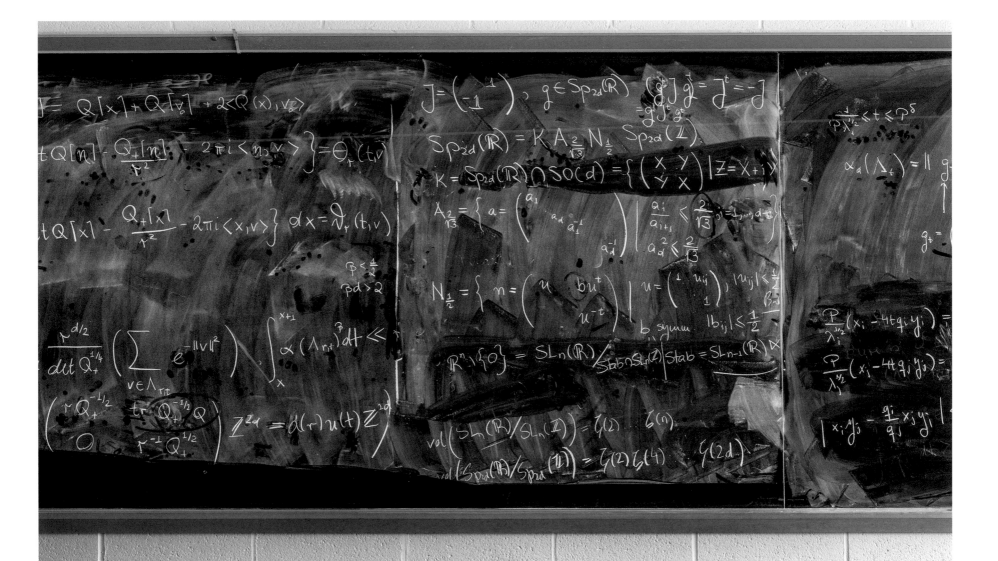

JACOB PALIS JR.

Jacob Palis Jr. was born in Uberaba, Minas Gerais, Brazil, in 1940. He received a degree in engineering at the University of Brazil and a PhD in 1967 at the University of California—Berkeley. His areas of research are dynamical systems and ergodic theory. He was a member of the executive committee of the International Mathematical Union (IMU), IMU president, TWAS president, and director of Instituto Nacional de Matemática Pura e Aplicada (IMPA) as well as emeritus professor at IMPA. He has directed forty-one PhD students and has about 271 scientific descendants. His publication list includes more than eighty papers in main journals.

Research in mathematics involves a great deal of curiosity. Mathematicians—in fact, scientists in general—are moved by curiosity. However, this search for answers sometimes makes curiosity flirt with obsession, where lots of thinking blends together with nights of no sleep. What makes mathematics different from the other sciences is the fact that we do not usually work in laboratories; the tools that we use are limited to pen and paper and blackboards. So wherever we go, we are always thinking.

One evening, when I was a PhD student, I suddenly had a breakthrough in my research. I was about to go out to see a movie, but instead, I ended up knocking on Charles Pugh's door at 10 PM, excited to share what I had just discovered. He smiled and said, "Jacob, we can talk about it tomorrow."

One of the reasons that talking to my collaborators is so important for my research process is that presenting lectures and sharing different points of view is what makes the discussion flow. Jean-Christophe Yoccoz, one of my longtime partners in mathematics, and I always had our hands covered in chalk dust from our discussions in front of the blackboard.

Looking back at my scientific career, I can split my work into two phases: my early research on structural stability and my later work on unfolding homoclinic tangencies. The blackboard in this photograph is related to the unfolding of homoclinic tangencies, a major mechanism for complex dynamical behavior that was discovered by the great French mathematician Henri Poincaré at the end of the nineteenth century. I formulated a series of conjectures to the effect that homoclinic bifurcations are the key mechanism underlying global instabilities of dynamical behavior.

Mathematics (and science) is not just about solving problems and doing research. Science has the power to change people's lives. This is why the creation of the Third World Academy of Sciences (TWAS) feels like one of my and my collaborators' deepest legacies. I have had the pleasure to see TWAS take mathematics to places where no one thought about doing mathematics before, to touch people who probably never would have had the opportunity to see this kind of mathematics.

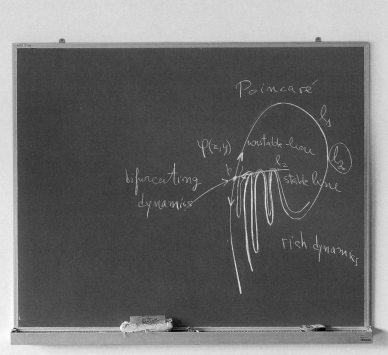

ALEXEI A. MAILYBAEV

Alexei A. Mailybaev is a professor at the Instituto de Matemática Pura e Aplicada (IMPA), Rio de Janeiro. He specializes in fluid dynamics, mathematical physics and singularity theory.

Whether randomness in nature is purely an artefact of our imperfect knowledge or whether it has a more intrinsic source is an open question of modern science. Problems of this type are well known in the quantum world but also emerge in other branches of science. Lorenz's butterfly effect explains apparent randomness by pointing to the fast amplification of initial uncertainties: "Does the flap of a butterfly's wings in Brazil set off a tornado in Texas?"

In the study described on the chalkboard—done jointly with Theo Drivas from Princeton University and Artem Raibekas from Universidade Federal Fluminense—we approach the nature of another type of randomness, this time intrinsic. This type of randomness is not tied to any kind of external information loss—it is spontaneous. The picture on the board is related to the proof of the emergence of such spontaneous randomness in a simple mathematical model.

Spontaneous randomness is believed to underlie complex multi-scale phenomena in nature, ranging from the micro-world of quantum fluids to motions in Earth's atmosphere and oceans, and extending further to supernovae and interstellar clouds. A basic mathematical understanding of spontaneous randomness is important for developing the theory of turbulence—the long-standing open problem that should unify all the aforementioned phenomena. The study on this board is our attempt to formulate these ideas with full mathematical rigor.

I learned to use blackboards from the very early years of primary school, forming an ability to express my thoughts using symbols and geometric forms in a concise and simple way. In spirit, the exercise of drawing on a blackboard is closely related to mathematics, which relies on abstract ideas expressed by symbols. The chalkboard allows us to depict abstract forms that represent the essence of mathematical ideas, and these depictions build bridges among the minds of mathematicians when they are working on a problem together. Writing on a chalkboard is a kind of special language that I use to talk to my collaborators and students. Almost every new idea or project starts with a discussion on a blackboard.

$\tilde{A} = T(A)$ via stable foliation

m induces $\tilde{m} \to$ measure in Δ

$\tilde{m} \ll \mu$

$\mu(X^{-T}(\tilde{A}) \cap \tilde{B}) \longrightarrow \mu(\tilde{A})\mu(\tilde{B})$

B

\tilde{B}

$X^{T}(A)$

A

X^{-T}

$\overbrace{\int \chi_A \circ X^T \, \chi_B \, dm}^{m(X^T(A) \cap B)} \longrightarrow \int \chi_A \, d\mu \int \chi_B \, dm$

$m = $ leb em 3-D

μ-SRB on Lorenz

$m(X^{-T}(A) \cap B)$

\downarrow

$\mu(\tilde{A})\mu(\tilde{B}) \cdot L$

\downarrow

$\int \chi_A \, d\mu \int \chi_B \, d$

STAN OSHER

Stan Osher received his PhD in mathematics from New York University in 1966. He is now a professor of mathematics, computer science, electrical engineering, and chemical and biomolecular engineering at UCLA. He has been elected to the US National Academy of Science, the US National Academy of Engineering, and the American Academy of Arts and Sciences. His current interests involve data science, which includes optimization, image processing, compressed sensing, machine learning, neural nets, and applications of these techniques.

I decided to become a mathematician for economic reasons. I entered graduate school in 1962, five years post-Sputnik. There was a desperate need, or so it seemed, for the United States to catch up with the Russians in mathematics and science, and the opportunities were unlimited. I was a poor boy from Brooklyn, good at math, and I was awarded an NSF fellowship, which guaranteed me five years of free tuition to attend the Courant Institute (a terrific place for analysis and applied math), a living stipend, and a chance to live in Greenwich Village in the early '60s.

My work process usually involves talking to domain scientists about mathematical issues that confront them in their research. I then use mathematical tools, often new ones I help develop, to try to address these difficulties. One example of a breakthrough is my work on image processing, done in the late 1980s. I met Leonid Rudin, my future collaborator, and he pointed out a link between my work on supersonic flow in aeronautics and possible applications in image processing. This led Leonid and me to develop a very popular algorithm, along with Emad Fatemi, which introduced a whole new way of reconstructing degraded images. As recently as two years ago, this was used to reconstruct the first images of black holes.

For me, the chalkboard is indispensable. Most of my work is collaborative, and jumping up and down, to and from the board, is a great way of interacting. What's on the board is typical of what I do. In this case I'm trying to develop a useful link between optimal transport (finding the best way to move mass from point A to point B) and the structure and behavior of deep learning algorithms. It never ceases to amaze me that beautiful, elegant, and simple-to-explain algorithms have such profound uses in the real world.

$f_\theta : \Omega \to \Omega$

(H,π)

E.g. $\bar{f}(\rho) = \int U(x) \rho(x) +$

Reparametriz...
(push —

$g_\theta : Z \to \mathbb{R}$

$\partial_t \rho + \nabla \cdot (\rho v_\theta) = 0, \quad \rho(0) = \rho_0$

$P(z)$ known

$Z \sim P(z)$

$g_{(\theta, z)} \sim$

$\int L(x,v) \rho(t,x) - \bar{f}(\rho_t)\, dt\, dx$

$\mathbb{E}_{x \sim \rho(\theta,x)} L(x, v_{t,x}) - \mathbb{E}_{x \sim \rho(\theta,x)} \bar{f}(x_t)$

$\frac{d}{dt} g_{(\theta(t), z)}$

$= v_\theta\big(g_{(\theta(t), z)}\big)$

$\int_{\mathbb{R}^n} f(x)\, \rho_{(\theta, x)}\, dx$

$= \int_{Z} f(g_{(\theta, z)})\, P(z)\, d$

SUN-YUNG ALICE CHANG

Sun-Yung Alice Chang was born in Xian, China, and grew up in Taiwan. She is Eugene Higgins Professor of Mathematics at Princeton University, where she was chair of the mathematics department during 2009–2012. She is a fellow of the US National Academy of Science; Academia Sinica, ROC; and foreign member of the Royal Swedish Academy of Sciences.

The big blackboard on the wall is the best part of my office; I often go in to work just to use it. I enjoy the discussions with my co-workers where we write our long computations on the board—we can check each formula, make corrections, and rewrite together. I often save the conclusions on the board and stare at them afterwards.

In this photograph, the formulas I wrote on the board represent one of the results I am most proud of, called the "4-dimensional conformal sphere theorem." It is a joint work between Matthew Gursky, Paul Yang, and me, where we characterize a 4-sphere by "conformal invariants." This work was done in the early 2000s, and it still influences my work today.

Despite the computer age we live in, the type of talks I enjoy the most are still those in which the speaker writes on the blackboard line by line and explains his or her thoughts.

Conformal Geometry on 4-manifolds

(M^n, g) Riemannian manifold, $\hat{g} = e^{2w}g$ is conformal to g (closed)

Gauss-Bonnet

$n = 2$ $\displaystyle\int_{M^2} K_g \, dV_g = \int_{M^2} K_{\hat{g}} \, dV_{\hat{g}} = 2\pi \chi(M^2)$

is integral conformal invariant

$n = 4$ $\displaystyle 8\pi^2 \chi(M_{,g}^4) = \int_{M^4} \|W\|_g^2 \, dV_g + \int_{M^4} \left(\frac{1}{6} R_g^2 - \frac{1}{2} |Ric|_g^2 \right) dV_g$

Weyl curvature $\|W\|_{\hat{g}}^2 = e^{-4w} \|W\|_g^2$ pointwise conformal invariant

\therefore $\displaystyle\int_{M^4} \sigma_2(g^{-1}A_g) \, dV_g = \int_{M^4} \sigma_2(\hat{g}^{-1}A_{\hat{g}}) \, dV_{\hat{g}}$ is

an integral conformal invariant

Thm (Chang-Gursky-Yang) M^4 orientable.

① $g \in A = \{ [g] \mid Y(M, [g]) > 0, \int_{M^4} \sigma_2(g^{-1}A_g) \, dV_g > 0 \}$

\Longleftrightarrow

$\exists \, \hat{g} \in [g]$ $R_{\hat{g}} > 0$ and $\sigma_2(\hat{g}^{-1}A_{\hat{g}}) > 0$

② Conformal sphere Thm $g \in A$

$\displaystyle\int_{M^4} \|W\|_g^2 \, dV_g < 4 \int_{M^4} \sigma_2(g^{-1}A_g) \, dV_g$

\Longleftrightarrow (M^4, g) is conformally equivalent to (S^4, g_c)

VIRGINIA URBAN

Virginia Urban is a native New Yorker and proud alumna of New York City public schools. After graduating from the High School of Performing Arts, she earned a degree in mathematics from Oberlin College and a degree in mathematics education from Teachers College, Columbia University. She has taught every grade from nursery through college (with the exception of junior high school) and has called the Fashion Institute of Technology her home since 1996.

I have been teaching developmental mathematics at the Fashion Institute of Technology in New York for over twenty years. These courses are intended to help students become more proficient in their basic math skills. Students in developmental mathematics courses are one of my favorite groups to teach. Many of them have a history of poor or failing performance in their mathematics classes throughout their school careers. They often come in hating math and thinking they are bad at math, or that they are not "math people." Some of my challenges are to help them overcome their fear of math, to enable them to see that math has useful applications to their lives and careers, and to show them that they do have the skills to succeed in a math course.

I have seen many methods of instruction come and go during this time. These days, with everyone having calculators on their phones, my focus has shifted from having students memorize facts to having them work on more involved contextual problems, with the emphasis placed on reasoning skills. All methods of solution are acceptable as long as the students use good mathematics and can explain what they did and why. On the blackboard in this photograph, we were calculating the cost per mile of driving your own car versus a rental car and comparing that to the IRS standard mileage rate. What you see is the result of much discussion and many attempts at finding a reasonable solution. A blackboard has a special quality—while incorrect or discarded ideas are easily erased, the haze is still visible as a reminder of the work that went into arriving at the solution. It also is a visual metaphor that things will get messy in the process. This doesn't happen on a whiteboard or a piece of paper.

When I write on a blackboard, my senses engage—there is the feel of the chalk and the sound it makes, the smell of the chalk dust, seeing my "board handwriting," which differs from how I write on paper. And there is the knowledge that I am writing on a surface that has held the ideas of decades of people that came before me, and that I am now a part of that legacy. I attended a performing arts high school and was blessed to have two amazing female math teachers—they were a huge influence on my decision to become a math teacher, and I think of them often. I had my struggles and failures with mathematics in college, which is one reason I identify with the developmental students.

I tell my students that my goal for the semester is to have them leave class hating mathematics a little less than when they started, but my real hope is that they come to see mathematics as beautiful and useful and not something to fear. The real reward is when students come back to visit and tell me they applied what they learned in my class to situations in their other classes, or in their lives, or that they are more confident when doing math. That is what makes it all worthwhile.

IRS reimbursement: $.56/mi

Jenna's car

oil $\frac{\$40}{3000mi} = \$.013/mi$

tires $\frac{\$920}{50,000mi} = \$.018/mi$ $\Big\}$ $\$.053/mi$

repairs $\frac{\$328}{15,000mi} = \$.022/mi$

gas $\frac{\$3.50\ gal}{22\ mpg} = \$.16/mi$

total cost/mile = $.213/mi

Profit: $.56 - $.213 = $.347/mi

Rental car

gas: $\frac{\$3.50/gal}{40mpg} = \$.09/mi$

fixed cost: $114.12

total cost/mile $.386

for a 386 mile trip

Profit: $.56 - $.386 =
$.174/mi

NO SMOKING
PENALTY

ERIC ZASLOW

Eric Zaslow lives in Evanston,
Illinois, with his wife and
two children.

We seek clarity through the haze. Sometimes this means taking a nap, cleaning the kitchen, or changing the air filter.

To a high schooler, math can be a muddle of formulas, rules, and memorized facts: the binomial theorem, completing the square, the law of cosines, trigonometric identities. Undergraduate math majors begin to see that mathematics is connected and explained by some basic truths.

Likewise in physics, a small number of foundational theories account for a myriad of physical phenomena. But there is a problem: these physical theories can be mathematically complex. Can we find a complementary viewpoint that also elucidates, simplifies, and unifies the math?

My advisor, Cumrun Vafa, whose work influences and eclipses my own, has a knack for simple, geometric explanations of some of the most intricate aspects of theoretical physics. At my best, I contribute to the collective understanding. But make no mistake: most of the time, the haze prevails.

I love my blackboard. I love the look and texture, but it's more than that: when students see you work on a blackboard, they know the material is emanating from you, not out of a can. Your presentation comes in sync with your thoughts, and never too quickly. As for research, it can capture an entire vista of ideas: what monitor has an eleven-foot diagonal?

Pictured on this chalkboard is a mathematical distillation of a phenomenon in physics: duality. In certain physical settings, a circle of radius 2 is equivalent to a circle of radius 1/2. A circle of radius 3 is equivalent to a circle of radius 1/3. And so on: a radius can be replaced by its reciprocal, and the resulting circle will be equivalent, as far as the physics is concerned. If you think of a sphere as a bunch of circles—like slices of an apple—you can replace each radius by its reciprocal and get a different shape. If the resulting physical theories are the same, then so must be the different mathematical descriptions of them, leading to a clear connection between distinct mathematical realms. It will sound silly, but this diagram is an amalgam of decades of work. Like I said: most of the time, the haze prevails!

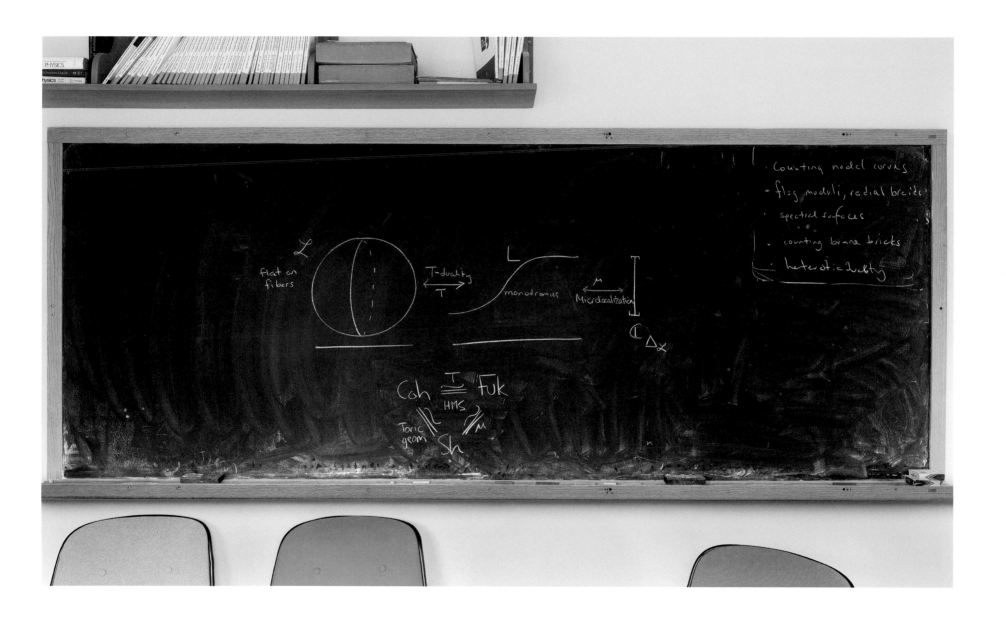

KATRIN GELFERT

Katrin Gelfert is a professor in the Department of Mathematics at the Federal University of Rio de Janeiro, Brazil, where she has been since 2010. She received her PhD in mathematics in 2001 (Technische Universität Dresden, Germany). Her research interests include dynamical systems theory and ergodic theory.

I always have been immersed in a scientific environment. From the time I was very young, my father, an engineer and computer scientist, would explain all kinds of mechanisms to me, often including calculations. I remember sunny afternoons studying maps and spherical distances, which went far beyond what I was learning at school. Certainly, this immersion in scientific questions and constant curiosity made it inevitable that I go on studying science. In some way, mathematics just managed to keep me fascinated. In a way, mathematics decided for me. In general, though, I continue to be curious about all kinds of things; nowadays, I could picture myself having chosen one of the other sciences.

My fields of research are dynamical systems theory and ergodic theory. The drawings on this board explain what my collaborators and I call "porcupines." They can be seen as an extension of the famous Smale horseshoe, the hallmark of stable chaotic dynamics, to higher dimensions. In a porcupine, some points explode into intervals, giving rise to unstable chaos. Understanding this very simple model helped us to obtain some better guesses as to what happens in more general settings—a process that is somewhat typical in math. The funny name perhaps helped make the work popular. Porcupines can also be easily drawn, and their features easily grasped.

I really enjoy working on the chalkboard and discussing problems with other people; it is an important social aspect of my work. Discovering—and drawing—good pictures to explain ideas always remains a challenge, but it is a part of my work that I greatly appreciate. Every mathematician has perhaps a different way of imagining structures.

Math is like an endless walk: overcoming a mathematical obstacle is like climbing a hill just to get a better view, to experience the pleasure of having reached the top, only to discover that there are even bigger mountains. Trying to find the solution to a problem can keep you busy and capture all your attention. Finding a solution on your own can make you feel exhilarated. Working with collaborators sometimes makes the climb easier, not only because it brings together experiences and techniques from different fields, but also because the process of extracting difficulties and reformulating a problem sometimes leads to its solution.

interval

$F : \Sigma_2 \times [0,1] \Rightarrow$

$F(\xi, x) = (\delta \xi, f_{\xi_0}(x))$

$P = (\bar{0}, p)$
$Q = (\bar{0}, q)$

$\mathcal{M}_{eg}(\Sigma_2 \times [q,1]) = \mathcal{M}_{g}^- \dot{\cup} \mathcal{M}_{g}^{\circ} \dot{\cup} \mathcal{M}_{eg}^+$ $\qquad \mu \in \mathcal{M}_{eg}^{(*)} \longmapsto h(\mu) + \oint \varphi d\mu \quad , q \in \mathbb{R}$

$\alpha \in [\alpha_{min}, \alpha_{max}] \quad , \quad \alpha \longmapsto \sup \{ h(\mu) \in \mathcal{M}_g : \int \varphi d\mu = \alpha \} = \mathcal{E}(\alpha) \qquad \boxed{\alpha \longmapsto \mathcal{E}(\alpha)}$

$\rightsquigarrow \mathcal{E}^-(\alpha) , \mathcal{E}^{\circ}(\alpha) = ? , \mathcal{E}_c^+(\alpha)$

DAVID DAMANIK

David Damanik hails from Frankfurt, Germany, where he completed his PhD at the Johann Wolfgang Goethe-Universität in 1998. He has been a professor of mathematics at Rice University since 2009. His areas of research include spectral theory, dynamical systems, and aperiodic order. Damanik has received the Annales Henri Poincaré Prize in 2014 and the Humboldt Prize in 2018. He also currently holds the Robert L. Moody, Sr., chair in mathematics at Rice University and is a fellow of the American Mathematical Society.

My career trajectory has been somewhat unusual. I decided to become a mathematician quite late, around my mid-twenties. Up until that point, I had done mathematics mainly as a hobby, and it was just one among many others. Several key events kept me from abandoning it in favor of other endeavors. In the twelfth grade, I had a mathematics teacher who inspired me and opened my eyes to the beauty of mathematics. This prompted me to major in mathematics during my undergraduate studies. But I still wasn't very serious about it, and spent most of my time playing sports or living hip-hop in all of its facets. Toward the end of my undergraduate studies and into the early stages of my graduate studies, a friend of mine—who was a member of the same research group, a couple of years ahead of me—allowed me to witness the creative process that goes into discovering new mathematics for the first time. It was at that point that I transformed from being a purely passive learner into an early-stage researcher who seeks to ask the right questions—and to answer some of them. My interest was piqued. When I arrived at Caltech as a second-year graduate student, the weather, the beaches, and of course the excitement of working in Barry Simon's group did the rest. I realized that this mathematics thing was one I'd like to pursue as a career.

I wanted to join Simon's group because in the years prior, he and his collaborators had investigated a phenomenon in quantum mechanics—the occurrence of singular continuous spectra—that I found fascinating and wanted to understand better. Much of my early work was devoted to that topic. Singular continuous spectra are somewhat difficult to explain in simple terms. Their occurrence is a phenomenon that sits between two common phenomena and it used to be considered unusual or exotic. It corresponds to anomalous quantum transport. I also studied other phenomena in quantum mechanics that had originally been considered exotic but that were now understood to occur with some persistence, such as Cantor spectra and anomalous transport. In the course of these investigations, I was naturally led to study and use tools and ideas from neighboring mathematical areas such as fractal geometry, ergodic theory, and dynamical systems. Even better, I got to meet, interact with, and become friends with the people in those areas. This has been by far the most rewarding aspect of this journey.

This brings me to the blackboard. It shows one of the most important results that has emerged from the work done at the interface between spectral theory and dynamical systems over the past fifteen years: a kind of dictionary between the time evolution of a quantum system and the dynamical features of an associated family of dynamical systems. Examples can be seen on the left side of the blackboard: in the first column, we have the types of quantum transport behavior, in the second column, we have the corresponding types of spectral measures, and in the fourth column, we have the corresponding dynamical types. This dictionary was developed by Artur Avila. It is usually referred to as his "global theory," and it forms an important part of the work for which he was awarded the Fields Medal in 2014. He is one of the friends I have made in the dynamical systems community, and my collaborative efforts and joint papers with him have been some of the most singular highlights of my career and, really, of my life.

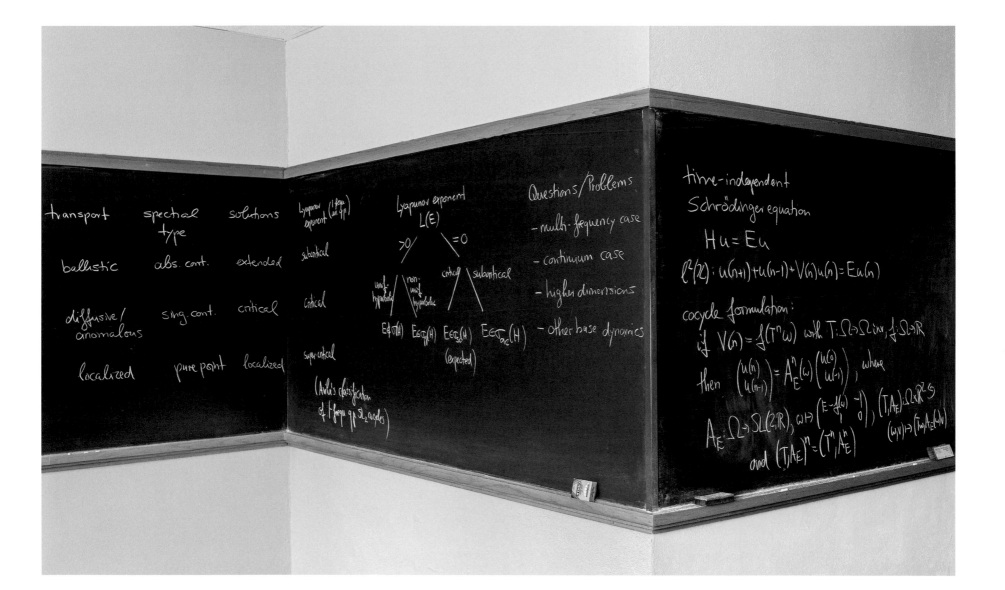

ROY MAGEN

Roy Magen is a PhD student at Columbia University. His family moved to North America from Israel when he was five years old. He attended the University of Toronto for his undergraduate studies, then spent one year in France while obtaining his master's degree. He started as a PhD student in Columbia in the fall of 2019.

One of my favorite parts of the process of doing mathematics is discussing ideas with others. Often, when I discover something that really excites me, my first instinct is to think about who would be interested in hearing about it. I used this chalkboard to share with a friend a new (to me) perspective on how to think about geometry, and to explain an idea I had about how to use this perspective to better understand a certain geometric creature.

Another of my favorite parts of mathematics is the array of perspectives that accompanies each idea. In the preface to Peter Johnstone's book on topos theory, *Sketches of an Elephant*, Johnstone compares studying topos theory (which is not unrelated to what is on this chalkboard) to blind men feeling an elephant, showing how seemingly unrelated forms or perspectives might actually be united by a surprisingly sophisticated creature. Each facet can be better appreciated once it is considered in the context of the whole, rather than in isolation. I find this process of discovery incredibly fascinating.

In order to do geometry, we need not only a space but a "structured space"—a space equipped with geometric structure, defined locally by an algebraic "gadget." A plain space can be defined by the rules governing how we work with local data. For example, both a sphere and a donut are made by gluing together flat patches, but they are distinguished by the way these flat patches (the local data) come together.

The main idea described on the board concerns how to coherently talk about spaces with a certain type of geometric structure, and in particular, the basic kind of geometric structure considered in algebraic geometry. On this board, I also outline an idea I had about how to apply this concept to talk about a slightly more sophisticated kind of geometric structure whose shadow we can sometimes see in algebraic geometry. An important example is a Euclidean space, which knows about all of its lines through the origin.

As I write this during the COVID-19 pandemic, I am reminded that having a physical board that many people can share is highly desirable. Apart from the great collaborative value of having any sort of board, I also prefer chalkboards because of their texture, similar to how it is more pleasant to write on paper than on the glass screen of a tablet.

LRS$((X, O_X), (\text{Spec }A, O_{\text{spec}}))$

$= (\text{Ring}(A, \Gamma(X, O_X)) = RS((X, O_X), (-, A))$

More generally have $\quad LRS \underset{\Gamma}{\overset{\text{Spec}}{\rightleftarrows}} RS$

This general case for Zariski G at relative spec assoc to $G \to G'$ (geometries)

$\rightsquigarrow Top(G) \underset{\Gamma}{\overset{\text{Spec}^G_{G'}}{\rightleftarrows}} Top(G')$

<u>Rmk</u> If G is the Zariski geometry, then $Shv(G)$ classifies local rings ie $Top(E, Shv(G)) = LocRing(E)$ hence $Top(E, Psh(G)) = Rings(E)$

General for \mathbb{Z}-graded rings
Colours $= \mathbb{Z}$
$O(d)_{i \in I}; d)$
$= \mathbb{Z}[X_{i \in I}]_d$
$\deg X_i = d_i$
$(?)$

<u>Definable</u> ... open embeddings
\hookrightarrow open embeddings of ...
$DP... \to \text{Spec}(A)$ étale version ...

es $G = (fp\text{-}rings)^{op}$

$G^{ad} = \{A \to A[f^{-1}]\}$

Topology $=$ Zariski

$Top(G) = Top/Shv(G)$
$=$ left exact colimit preserving functors from G to topoi

<u>Rmk</u> $Pro(G) = Ind(G^{op})^{op} = AFF$

If $X : Aff^{op} \to Set$,
$\dfrac{Pro(G)^{ad}}{X} = \dfrac{Aff^{op}}{X}$

"$\text{Spec }X$" $= Shv(Pro(G)^{ad}/X)$

JAMES H. SIMONS

Dr. James H. Simons is chairman of the Simons Foundation, an organization dedicated to advancing the frontiers of research in mathematics and the basic sciences. Dr. Simons holds a BS in mathematics from the Massachusetts Institute of Technology and a PhD in mathematics from the University of California at Berkeley. His scientific research was in the area of geometry and topology. He received the American Mathematical Society Veblen Prize in Geometry in 1975 for work that involved a recasting of the subject of area minimizing multidimensional surfaces. Dr. Simons's most influential research involved the discovery and application of certain geometric measurements, now called the Chern-Simons invariants, which have wide use, particularly in theoretical physics.

Wherever math is being created, you can be sure chalkboards will somewhere be in evidence. When mathematicians work together, it is very often at a chalkboard. Ideas are sketched out and discussed, but soon the board is erased to make room for the next round of ideas. This can go on for hours. When people leave the room, they often put up a sign: "Do not erase."

When giving lectures, some people put up slides, but it is often difficult to absorb a slide since it comes and goes quite quickly. Much better is a chalk talk. There, the speaker covers the board at a relatively slow pace, slow enough that the audience can absorb the material.

In the early seventies I did some work with the great mathematician S. S. Chern that involved inventing certain geometric measurements, now known as Chern-Simons invariants. I was very pleased with the mathematics, but had no way of knowing at that point that physicists would eventually apply the work to all kinds of physics. I recently learned that, on average, three physics papers a day reference Chern-Simons invariants. I knew little or no physics when our work was done, and still know little or no physics. It is completely amazing.

FRANK CALEGARI

Frank Calegari was born in Melbourne, Australia. He received his PhD under Ken Ribet at the University of California, Berkeley. Since 2015, he has been a professor of mathematics at the University of Chicago. He lives in Evanston with his wife Jennifer and daughter Lily.

When I was a child, there was a small chalkboard attached to my bedroom door. When I was six, my brother gave me the four color theorem as an exercise, and I spent many happy hours at the board trying to find a counterexample (I didn't make much progress). I had decided to become a mathematician by the time I was thirteen. When I was sixteen, my brother was lending me math books from the university library. At seventeen, I skipped school to see Don Zagier give a lecture on dilogarithms, and then, twenty-five years later, we wrote a paper together on a very similar subject. I know this is not everybody's experience, but for me, mathematics has always been a small and friendly world.

I'm far from the strongest mathematician technically, but I like to think that I have a good intuition. A key part of being a mathematician is figuring out what you think is true. Sometimes I like to write up conjectures on the blackboard. The physical act of committing an idea to chalk is a kind of affirmation; do I really believe this? The question on this blackboard is related to one posed by Barry Mazur. Barry's question is intriguing since it falls outside the range of problems our current intuition can answer. The only people who have offered guesses so far have suggested that there might be a positive answer. But I have a hunch that the answer is no. That's my secret advantage: nobody else is working on this problem because I'm the only one who thinks the answer is no.

F, G, G^\vee semisimple.

CONJE

cocharacters

μ^\vee for

$\mathrm{om}(F, \overline{\mathbb{Q}}_p)$

$\{c_v\}$ of

all

$G^\vee(\overline{\mathbb{Z}}_p)$

$\exists ? \, \S \, \times$

$\bar\rho : G_F \longrightarrow G^\vee(\overline{\mathbb{F}}_p)$

$\bar\rho($

s.t.

ρ

lie.

LIFTING PROBLEM

ARTUR AVILA

Artur Avila was born in 1979 in Rio de Janeiro. He is a professor at the University of Zurich and an extraordinary researcher at IMPA. In 2014 he was awarded the Fields Medal for his work in dynamical systems.

I am an analyst, and most of my work focuses on dynamical systems. I normally think of an analyst as someone who loves inequalities, as opposed to someone more algebraically minded. Of course, this is a simplification, since the two concepts interact: for instance, you can show that something is exactly zero by showing that it is arbitrarily small.

My work on dynamical systems intersects with spectral theory: for years, I worked on so-called one-frequency Schrödinger operators, which are of relevance in mathematical physics. On this board, I describe the basic result on which my "global theory" of these operators is based. A real number (the acceleration) turns out to be "quantized," that is, equal to an integer times 2π, which is obtained as a consequence of an infinite number of improving inequalities. It took me a few years to realize the importance of this result, namely, that it leads to a way of breaking up the infinite dimensional space of parameters.

Each mathematician visualizes mathematical objects in their own way. When we communicate, we are trying to translate our internal models. What is passed onto the blackboard is frequently a caricature of the internal imagery that lives in our minds. On this board, we also see my caricature of the infinite dimensional space of parameters, with a codimension-one lamination (corresponding to spectra), broken down by a critical interface, whose nice structure is a consequence of quantization.

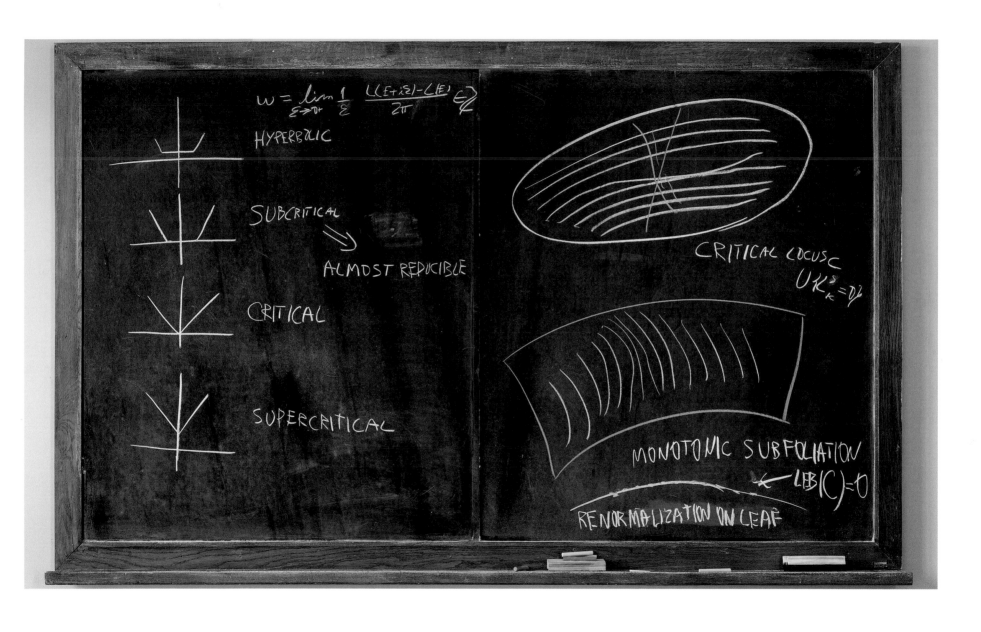

CLAIRE VOISIN

Claire Voisin was born near Paris and is currently a professor of mathematics at the Collège de France. Prior to that, she was a permanent researcher at CNRS, from 1986 to 2016. She was awarded the Hopf Prize in 2015 and the Shaw Prize in 2017.

Mathematical communication is very intense. Writing on the chalkboard is essential for expanding the verbal communication of mathematics, because it allows us to fix notations, introduce notions, and present definitions at an appropriate pace, such that we do not expect the person in front of us to immediately understand and digest what we are saying. The chalkboard looks laborious and artisanal, but in fact, it allows us to better understand what other people have in mind, making communication more effective.

On the chalkboard in this photograph, I was discussing the constraints of a certain cycle class with a visitor. His paper is now written up. It contains a very nice argument, and I am happy that our discussion contributed to simplifying his computations. When I saw this photo of my board a few months after it was taken, I knew immediately which discussion, which circumstance, it was, thanks to the intensity and clarity of the mathematical communication. The writing on the board induced the corresponding writing in my mind, and it was still there, many months later.

ISABELLE GALLAGHER

Isabelle Gallagher was born in Cagner-sur-mer, France, and completed her PhD at Paris 6 (now Sorbonne Université) in 1998. She has been a professor of mathematics at Paris 7 (now Université de Paris) since 2004, and was previously a CNRS researcher at Université Paris—Sud and École polytechnique. She received the CNRS Silver Medal in 2016 and the Sophie Germain Prize of the French Academy of Sciences in 2018.

This blackboard is typical of a good week's work. There are some estimates written by a PhD student explaining his work on the derivation of the Boltzmann equation. Some are written by me for another student, explaining how to iterate a Duhamel formula to gain regularity on the solutions of some nonlinear PDEs. The rest of it is just me and two collaborators struggling on a research project. We are deriving a Hamilton-Jacobi equation for the large-deviation functional associated with the Boltzmann equation.

That's my favorite combination: teaching and learning from students, and working with collaborators.

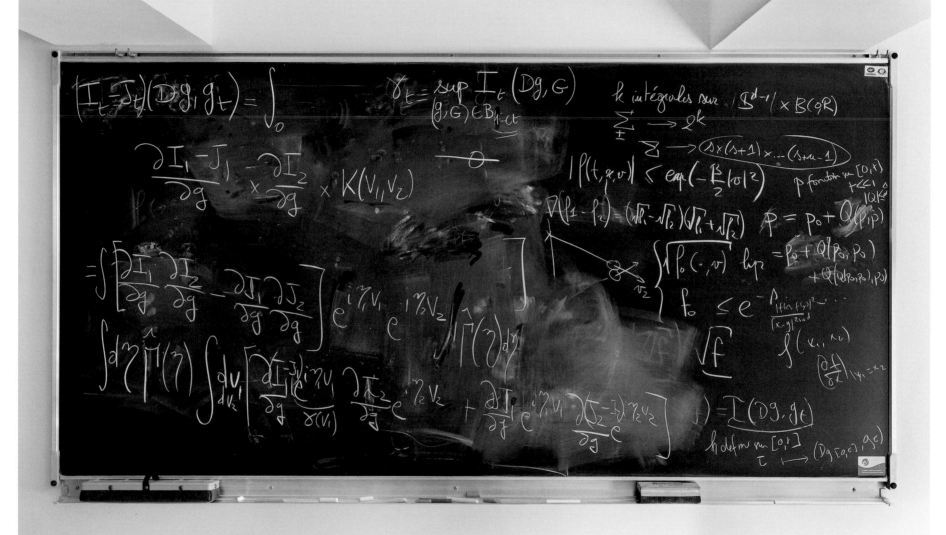

NATE HARMAN

Nate Harman is a member at the Institute for Advanced Study. Previously, he was an NSF postdoctoral fellow and Dickson Instructor at the University of Chicago.

In high school, I joined the math team in a misguided attempt to impress a girl. Actually, that is only partly true: the reality is that I have always loved mathematics. I have early memories of looking for patterns in multiplication tables, of proudly telling my mom about my "new" mathematical invention: negative exponents. Trying to impress that girl was more of an excuse for doing something as "uncool" as joining the math team.

I do my best thinking in front of blackboards. Writing things down helps me clarify and organize my thoughts, and I find the impermanence of writing in chalk is much more conducive to creative thinking than, say, writing in a notebook. I can test small examples right in the middle of a larger argument, and then just erase them. I can go back and change something, or add an assumption, or erase something that's incorrect. Mathematics on a blackboard feels so much more malleable than mathematics on a piece of paper or a computer screen.

This photo is an action shot: it captures a brief moment of understanding as I learned about a subject that was new to me. On the board is a sketch of a proof I had recently come up with, about the structure of finite dimensional representations of certain arithmetic groups. Had this been taken a day or two earlier, I wouldn't have been able to prove the result; a day or two later, and I would have realized that in fact something much stronger is true. A few days after that, I'd realize it was all already known to experts in the field. This is not a sad story, though. I went on to do what I feel is some of my best work yet, building on the intuition I gained by working this result out for myself.

$$SL_n(\mathbb{Z}) \curvearrowright V \otimes V^* \cong \text{End}_{\mathbb{R}}(V)$$

$$\underset{\varphi}{\overset{\uparrow}{V}} \quad \underset{\psi^*}{\overset{\uparrow}{V}}$$

$$\mathbb{1} \in \text{End}_{\mathbb{R}}(V)^{\Gamma_n(\ell)} \quad \text{Since } V_\varphi \cong V_\psi \text{ as } \Gamma_n(\ell) \text{ reps}$$

$$\Rightarrow SL_n(\mathbb{Z}/\ell\mathbb{Z}) \curvearrowright \langle g \cdot \mathbb{1} \mid g \in SL_n(\mathbb{Z}) \rangle$$

$$\text{as } g' = gh \Rightarrow g' \mathbb{1} = g \mathbb{1}$$
$$h \in \Gamma_n(\ell)$$

ESTHER RIFKIN

Esther Rifkin, an associate professor of mathematics at the SUNY Fashion Institute of Technology, NYC, has earned the title of "Mathemagician" for her creative lessons and her rolling cart filled with unique examples of geometry gathered from decades in the field of education. She received the 2018 SUNY Chancellor's Award for Outstanding Adjunct Professor.

I was in elementary school when my mother bought me the most "perfect" gift: my own 9" × 12" blackboard, framed in wood. I used it to practice all my math homework and memorize multiplication tables. I was able to erase answers with a damp sponge, and even redo a problem if it was interesting enough. I liked this better than wasting notebook paper.

When I first taught junior high school mathematics, the blackboards in my classroom afforded every student the opportunity to write their names—with embellishments, prior to working on arithmetic problems. I was lucky: my room had blackboards covering two entire walls, so most of the class could be doing board work simultaneously. To the dismay of the custodians, my room was always veiled in a cloud of chalk dust.

My first semester at FIT presented an unusual challenge: the room I was assigned had no blackboard! I had to beg for a rolling board to be brought into that basement space each week. No individual board work could efficiently take place, and I had to erase as I completed each problem. I bought a twelve-inch-long eraser from Amazon just for this purpose.

Now that I am a tenured professor, I can choose my own classroom with sufficient boards to appreciate the artistic efforts students display. They all want to erase with my old giant eraser. That eraser works just as well on our new whiteboards and glassboards. The thrill I get has never left—but colored chalk is so much more sensuous to hold than those plastic markers designed for the replacement boards in certain remodeled classrooms. And chalk is so much better for the environment. Call me old fashioned, but whiteboards can never enchant me the same way as a well-used, oft-washed slate chalkboard does to this seasoned soul.

Leonhard Euler (1707–1783) was one of the greatest mathematicians of the eighteenth century. Among his many discoveries was an equation that linked the faces, vertices, and edges of all convex polyhedra. His formula shows that for specific solid figures, the faces plus the vertices minus the edges will always equal two. This is the formula that is depicted on the chalkboard: ($F + V − E = 2$).

My favorite course I teach at the FIT, "Geometry and Probability for the Toy Designer," provides a visual and artistic approach to the beauty of mathematics. In the lesson depicted, I create, using chalk, a free-form "design" on the board. With this as a model, I ask students to close their eyes, hold a pencil to a paper and draw their own mathematical "squiggle" artwork. Students are then invited to the chalkboard to draw more of these "doodles." We are now tasked with counting the total number of spaces, dots, and line segments in our unique designs. Together we "discover" that Euler's incredible formula holds for these planar "squiggles" as well as for the three-dimensional convex solids. Voila! Each design is a "one of a kind" mathematical work of art!

The lesson concludes with the Academy Award–winning short cartoon, "The Dot and the Line, a Romance in Lower Mathematics" (1965). One of the characters is an actual "wild and unkempt squiggle." My class of future writers of children's books and designers of toys get to experience the joy of expressing themselves with chalk—and the discovery that mathematics really can be fun!

GOVIND MENON

Govind Menon is a professor of
applied mathematics at Brown
University. He works primarily
on the mathematical structure of
disordered systems, with appli-
cations to algorithms, geometry,
and turbulence. He was a Simons
Fellow and a member of the School
of Mathematics at the Institute for
Advanced Study in 2018–2019.

This picture was taken in Camillo De Lellis's office at the Institute for Advanced Study, at the outset of a year-long sabbatical leave from Brown University. It captures the end of an intense discussion that left me drained for weeks.

I had spent the previous year struggling to develop a new approach to Nash's embedding theorems. An unexpected link with turbulence discovered by De Lellis and Szekelyhidi had inspired me to revisit Nash's work through the lens of statistical mechanics. This is an unorthodox line of attack and I was trying to explain my ideas to Camillo. The expressions on the right and lower left of the board explain why I think probabilistic ideas are natural in this problem (Ito's formula is a fundamental expression in stochastic calculus). The expression in the upper left corner is in Camillo's writing. He is suggesting I look at a simpler problem.

At the time, my ideas were vague, but certain themes had become clear. I had begun by modifying Nash's proofs, but the problem kept changing shape, revealing tantalizing new connections, each of which led me further away from the historical view. I thought I would have it figured out when I arrived at IAS, but even after a year's work, I still couldn't seem to nail it down. At the time of this conversation, I found myself at an impasse. My ideas were not strong enough to convince Camillo, but I was not willing to return to Nash's methods.

The creative act in mathematics lies in the tension between the absolute rigor of a proof and a vague perception of patterns and possibilities. My initial training was in engineering, and it took me many years to develop a feeling for the structure and evolution of mathematical ideas, to see both continuity and extinction of certain ways of thinking, to understand the grandeur of the subject as a universal language of truth. I value comprehension more than conquest and much of my time is spent exploring different viewpoints in search of unity and simplicity. While my tastes are primarily guided by problems in the sciences, it seems to me that the deepest applications of mathematics, such as the development of the computer, emerge from an investigation of the foundations of mathematics. Each generation must learn this lesson anew.

A year has now passed since this picture was taken. My ideas are more robust, and I can formulate a geometric heat flow that captures my viewpoint, though it will take much work to convert this into a proof. I like this photograph because it captures the heat of combat. Most of my work feels messy and frustrating, but once in a while, I hope for a glimpse of the sublime.

BASSAM FAYAD

Bassam Fayad is a research director at the Centre national de la recherche scientifique (CNRS) in France, Institut de mathématiques de Jussieu-Paris Rive Gauche. Fayad is a world expert on the theory of dynamical systems. He was an invited speaker to the ICM in 2018. He was given the best PhD dissertation award of École polytechnique in the year 2000, the Prix des Annales de l'IHP in 2010, and a Knut and Alice Wallenberg Foundation grant in 2017. In 2020, he was nominated Knight of the Lebanon National Order of the Cedar.

I usually do not give very good talks, but if the chalk is bad, then disaster is guaranteed. Everybody should always carry high-quality Japanese chalk, at least until (who knows how soon) there are no more blackboards on earth.

What I cherish about my job as a researcher is the freedom to work on problems that I choose for their interest and importance. I like the research process: the moments of darkness, the periods of obsession, the first clumsy steps and the marvelous moments when you see a light. It is the joy of finding an idea, of sharing with someone or learning from someone. But most of all, it is the possibility, the duty, to remain curious about everything. My job also allows me to keep some distance from what I would call, borrowing from André Breton, the bad taste of our times.

PHILIPPE RIGOLLET

Philippe Rigollet is a professor of mathematics at MIT working on the mathematics of statistics and machine learning. He received his PhD from University Pierre and Marie Curie in Paris before moving to the United States in 2007. He was at Georgia Tech and Princeton University before joining MIT in 2015.

I work on mathematical statistics and, more broadly, the mathematics of data. The main goal of my research is to study algorithms that arise in statistics and machine learning. Often, such analysis calls for new mathematical ingredients, ones that are either borrowed from other fields of mathematics or built from scratch. A good mathematical analysis allows us to better understand existing algorithms, to improve them, and even to propose completely new algorithms.

The formulas on the chalkboard are a proposal for a new sampling algorithm. In its simplest form, "sampling" simply means generating random numbers, or coin flips. This is a simple and well-understood task, but can quickly become more challenging—what about generating a random image of a dog, or a random handwriting style? We need more sophisticated algorithms for these tasks. This chalkboard describes one such algorithm. The work on the board represents a very early step in a long process—it is more a draft than an algorithm at this stage. The algorithm will have to be improved many times before giving good performance and being amenable to elegant mathematical theory.

The algorithm on the board was written mostly by Sinho Chewi, a PhD student who works under my supervision at MIT; most of the board is not in my handwriting. This is the purpose of a blackboard: mixing ideas on the same medium. Indeed, to me, mathematics is a social experience. I teach and I learn from others. Most of the time, both happen at the same time; understanding and explaining go hand in hand. The chalkboard is where it all happens. We take turns standing and sitting, sometimes almost elbowing our way in to write down an idea that needs to come out immediately. Then, when the chalk dust has settled, I often look back at the last chalkboard and reflect on what the white formulas tell me as I stare into the black background.

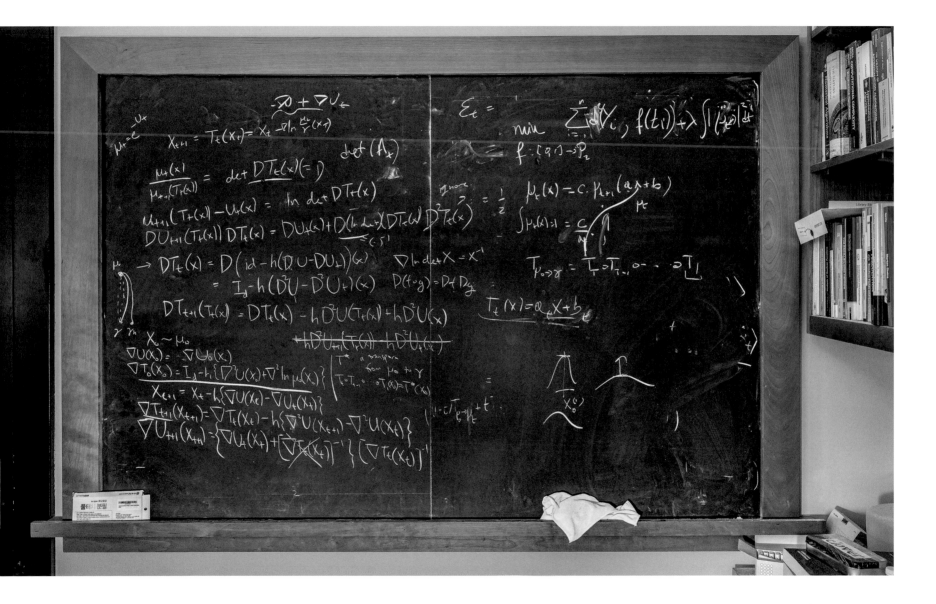

CAMILLO DE LELLIS

Camillo De Lellis was born in 1976 in San Benedetto del Tronto, Italy. After earning his undergraduate degree in mathematics at the University of Pisa in 1999, he wrote his doctoral dissertation in 2002 under the supervision of Luigi Ambrosio at the Scuola Normale Superiore di Pisa. He joined the faculty of the University of Zürich in 2004 as assistant professor of mathematics, and he was appointed full professor in 2005. In 2018, he moved to the Institute for Advanced Study in Princeton, where he holds the IBM von Neumann Professorship. He is active in the fields of calculus of variations, geometric measure theory, hyperbolic systems of conservation laws, and fluid dynamics. He has been a plenary speaker at the European Congress of Mathematics at Krakow in 2012 and is a member of the Academia Aeuropea. He is the recipient of the 2009 Stampacchia Medal, 2013 SIAG/APDE Prize (jointly with László Székelyhidi Jr.), 2013 Fermat Prize (jointly with Martin Hairer), 2014 Caccioppoli Prize, 2015 Amerio Prize, and 2020 Bocher Prize (jointly with Larry Guth and Laure Saint-Raymond).

I do not have a routine for my work. There are moments when I sit down and check my ideas carefully, or study something I find exciting and surprising and I want to understand deeply. In these cases, I like to use a pencil and paper to keep careful track of my computations, remarks, and speculations. But more often than not, my mind is just going its own way, exploring one possibility or another—some crazy notion about some problem. This might happen on a train trip, or while I am running in the woods, or buying groceries, or having a sleepless night.

The time I spend with my collaborators belongs to a somewhat different category. These meetings range from completely disorganized chats that last for hours to very intensive sessions involving complicated computations, but they are almost always done in front of a board, where we either sketch our ideas or we go deeply into the details.

The chalkboard in this photograph shows a probabilistic approach to one of John Nash's famous theorems that was proposed by my friend Govind Menon (who works at Brown University). One possible—and provocative—interpretation of John Nash's theorem is that, no matter how small your pocket is, you should be able to stuff in it a pretty large piece of paper without crumpling it or folding it. This is indeed a fact, which can be modeled mathematically by the existence of special solutions to some partial differential equations, excluding certain kinds of "obvious" singularities (it is in fact impossible to put a large piece of paper in your pocket without doing something "bad" to it). One of my most important mathematical discoveries is that examples similar to John Nash's counterintuitive theorem also arise in fluid dynamics when we attempt to describe the behavior of turbulent motions. At the moment, we can only get to our conclusions through complicated computations, but it feels right to Govind and me that probability should help us explain this phenomenon in a simple way.

Working on a chalkboard helps me communicate my thoughts to others, but it's also often the fastest way for me to clarify my own ideas. I sometimes write things on a blackboard just for myself, when I am alone in my office.

That said, one of my fondest memories involves a collaboration with my friend László Székelyhidi, a colleague who works at the University of Leipzig. We had just had a casual chat about the possibility that a particular phenomenon might be a manifestation of a principle used in a completely unrelated area. László took out a notepad, and we started working in a nice cafe in the center of Zürich, where we ordered lunch. Things quickly began to fall into place, and we became very excited. I suppose we became *too* excited—a stern old lady soon approached our table and severely reproached us for being too loud.

There is a big sense of elation when, after being in the dark for a long time, you finally understand something. It is exhilarating to finally envision the completion of a big, complicated jigsaw puzzle. When I was a kid, I used to watch a TV show called *The A-Team*; one of the characters (who co-starred in *Breakfast at Tiffany's* alongside Audrey Hepburn, I later realized) often said, "I love it when a plan comes together." I sometimes feel like he did, though with two big differences: my plans usually take years to come together, and my success rate is a far cry from that of Hannibal Smith.

Euler – Reynolds system

$$\begin{cases} \partial_t v_q + \operatorname{div}(v_q \otimes v_q) + \nabla p_q = \operatorname{div} \mathring{R}_q \\ \operatorname{div} v_q = 0 \end{cases}$$

$$\mathring{R}_q(x,t) \in \operatorname{Sym}_0^{3\times 3} = \{A \in \mathbb{R}^{3\times 3} : A^T = A, \operatorname{tr} A = 0\}$$

$$\left(\operatorname{Ric}(g) - \tfrac{1}{3} R g\right)$$

$\forall e : E, D \to \mathbb{R}^+$ **Theorem** (D-Sz-...)

smooth $\exists (v_q, p_q, \mathring{R}_q)$ solving system s.t.

- $(v_q, p_q) \to (v, p)$ uniformly
- $\mathring{R}_q \to 0$ unif
- $\frac{1}{2} \int |v_q|^2(x,t)\, dx \to e(t)$

AUDREY NASAR

Audrey Nasar is mathematics professor, as well as an MFA student in illustration, at the Fashion Institute of Technology in New York City. She holds an MA in pure mathematics from Hunter College and a PhD in mathematics education from Columbia University. In addition to teaching mathematics, in 2012, Audrey cofounded Urban Cricket, a New York City–based streetwear brand. Audrey is interested in teaching mathematical concepts through illustrations, graphic novels, and animation. Her preferred mediums are chalk, ink, and digital.

My goal in teaching mathematics is to bring the excitement of problem solving and the beauty of proof into the classroom. Regardless of one's background, I believe it is possible to see what has dazzled mathematicians for centuries. Personally, I'm fascinated by the intersection of mathematics and art. At the Fashion Institute of Technology in New York City, I teach a course called the Geometry of Art and Design. On the chalkboard pictured, you'll see a lesson from this course on star polygons, which are used in many areas of design and are chock full of mathematical discoveries.

Star polygons can be found in logos, such as the logos for Starbucks, Converse All Stars, Heineken, and Pret A Manger. We see them on country flags, including those of the USA, Israel, Morocco, and Vietnam. They are also prevalent in Islamic art and architecture.

Star polygons are constructed by connecting points equally spaced around a circle in a specific way. A star polygon described by the notation $\{n/k\}$ is made up of n points equally spaced around a circle. Edges are drawn connecting every kth point. Star polygons are classified according to whether or not they can be drawn without lifting a pen, or more appropriately, a piece of chalk.

In this lesson, students took turns drawing star polygons on the chalkboard and counting the number of cycles they each contain. For example, the star polygon $\{5/2\}$ can be drawn without lifting the piece of chalk, so we say it has one cycle of length five. On the other hand, to draw the star polygon $\{6/2\}$ you have to lift the chalk once, so it is made up of two cycles of length three. Students explore the relationship between the number of cycles and the cycle length. In addition to exploring cycles and cycle length, students can use different colored chalk to show how star polygons can be nested inside one another and to identify rotational and reflection symmetries.

$\left\{ \begin{array}{c} n \\ k \end{array} \right\}$

$\gcd(10,4) = 2$ 2 cycles of
length 5

$\left\{ \begin{array}{c} 5 \\ 2 \end{array} \right\}$

$\left\{ \begin{array}{c} 6 \\ 3 \end{array} \right\}$

$\left\{ \begin{array}{c} 6 \\ 2 \end{array} \right\}$

$\left\{ \begin{array}{c} 10 \\ 4 \end{array} \right\}$

DAN A. LEE

Dan A. Lee is an associate professor of mathematics at Queens College and the CUNY Graduate Center. He is the author of *Geometric Relativity* (American Mathematical Society), which aims to make geometric relativity more accessible to graduate students.

This board shows some calculations for a paper I am finishing up with Lan-Hsuan Huang of the University of Connecticut. We work in an area called geometric analysis and, more specifically, on applications of geometric analysis techniques to problems in general relativity. In this particular paper, we are studying the relationship between local energy-momentum density (which describes the masses of the everyday objects around us) and the "total" global energy-momentum of a gravitational system (which refers to the total mass of a large system such as our galaxy and measures how strongly faraway objects are attracted to our galaxy). In classical Newtonian gravity, this relationship is simple, but the nonlinearities of general relativity make this a rich source of fascinating math problems. This relationship has been mined for decades and continues to produce gems.

When people hear the words geometry and physics, they naturally imagine a field of research involving lots of pictures and visualization. However, most of the work we do looks like this board—lots of equations involving derivatives and indices—partly because the geometry we study is too complicated to visualize in our minds, much less draw. When I do make drawings, they are usually simplistic and not intended to be accurate representations. Based on my handwriting, you might guess that I'm not great at drawing anyway.

Typically, I prefer to work with pen and paper rather than chalk and blackboard, but when it comes to collaboration, blackboards are perfect for quick sharing of ideas. The lack of a large, physical blackboard is possibly the most inconvenient part of online collaboration. Since most math papers are written collaboratively, it's essential to find people you can work well with. Mathematicians have a reputation for being socially awkward, but progress in mathematics is a communal endeavor. I try to remember this when I'm engaged in the actual day-to-day business of math research, which can feel quite solitary. When I attend small conferences and workshops, I enjoy seeing colleagues whom I've known for over a decade, and I enjoy welcoming newcomers into the fold, knowing that we're all pushing toward a common goal.

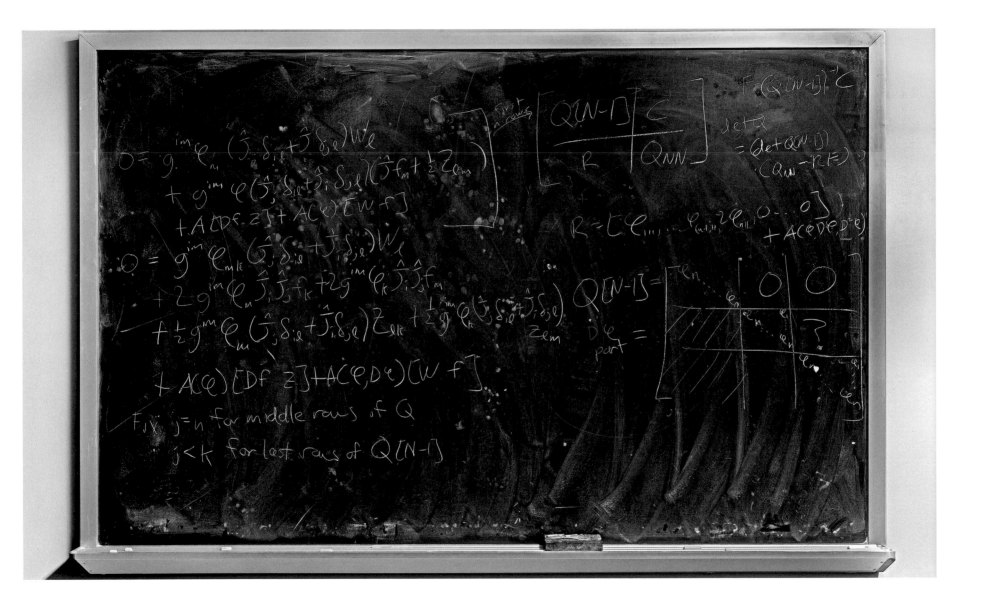

LAURA DeMARCO

Laura DeMarco is professor of mathematics at Harvard University. She was elected to the National Academy of Sciences in 2020; she was awarded the Satter Prize from the American Mathematical Society in 2017; and she held a Simons Fellowship during the academic year 2015–2016. Prior to her arrival at Harvard in 2020, she was the Henry S. Noyes Professor of Mathematics at Northwestern University. She became a fellow of the American Mathematical Society in the inaugural class of 2012.

The writing on this chalkboard is not mine; it is from my student, Shuyi Weng, who was describing one of the results that appeared in his PhD thesis. His work develops surprising connections between geometry and complex analysis: he studies three-dimensional shapes that are curved or bent by an amount governed by an associated two-dimensional shape. Shuyi graduated this year.

When at the board, we draw pictures to explain ideas. It is much easier to describe something in person at a board, with images, than it is to convey the same idea in formal writing. I use the board all the time (or paper if I'm not in my office) when discussing mathematics with my collaborators, students, and colleagues. And these days, I am in the habit of taking photos of the board with my phone, to record the discussion. (I rarely look back at those photos, but it's reassuring to have them in my files.)

My use of the board has evolved since I finished graduate school. I didn't use it much then, but perhaps I have many more conversations and interactions with other mathematicians now than I used to.

I remember receiving a chalkboard as a present from my aunt when I was a little girl. I loved that chalkboard and would spend hours in our basement pretending to be a teacher, even assigning homework and grades to my pretend students. (My Aunt Lu worked in the public school system in New York and had access to the teacher's editions of various elementary school textbooks.) It's funny to think back on that now. I always wanted to be a teacher. But then the more mathematics I learned, the higher the level I wanted to teach.

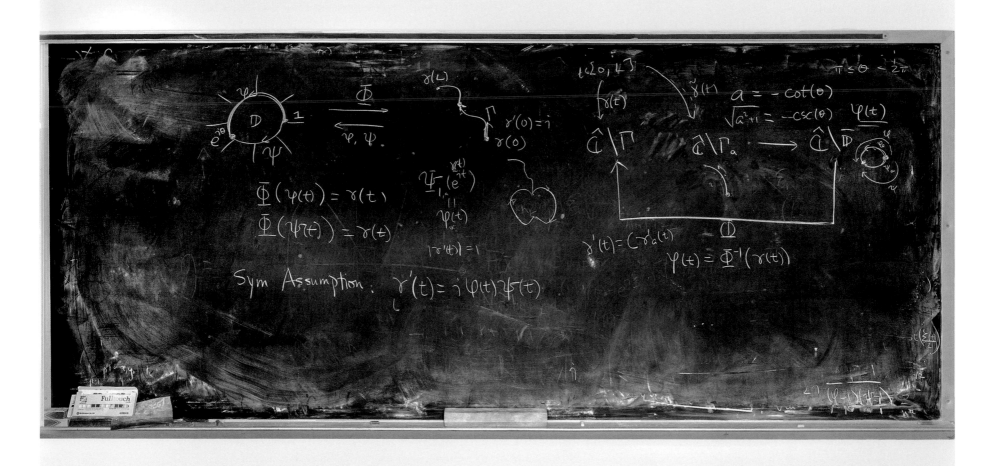

LEILA SCHNEPS

Leila Schneps is a mathematician at the French National Center for Scientific Research, as well as a fiction writer. She has written mathematically themed murder mysteries under the pen name Catherine Shaw. She also works to promote the proper use of mathematics and statistics in criminal proceedings.

I came to mathematics through a love of words and language. I thought I would major in literature, and if I took math and physics classes in my first year, it was because reading Solzhenitsyn fired me up to change the world, and I thought technology would be the way to go. Once I found myself in math class, though, I became fascinated by the words, and by the symbols that were also like mysterious words, unlocking worlds I didn't know about. I used to flip through the books in the math library and just wonder what $PSL_2(\mathbb{R})$ could be, what a flat morphism of schemes looked like, what might lie concealed behind the impenetrable terms of cohomology theory.

As the years passed, all of these notions became like familiar friends—just additional words in the language I use to speak about things each day, just a richer, fuller vocabulary to describe specific objects with precision. But the fascination with language remained in me, latent, and flared up again when I encountered the remarkable work of Jean Écalle. Here, finally, was a mathematician who invented brand new words to describe the new objects and the new symmetries that he studied, rather than repurposing ordinary words as all other mathematicians did, either without imagination ("good" groups) or with great talent ("crystalline" cohomology). Going far beyond this, Écalle created a whole new area—mould theory—and a whole new language to describe and understand it. Words like alternil, mantar, arit, preiwa, dimorphy, teru, gaxit! Formulas like zig = mono(swap).zag or gepar(invpil) = pic! It was the language of his papers that pulled me in. I became fascinated and just wanted to plunge into the world those words described. And when I did (and it wasn't easy), I discovered a treasure trove

of beautiful ideas: new definitions, remarkable observations, unusual approaches, astonishing generalizations. All expressed in an invented language that was uniquely suited to capturing numerous subtle variations on a theme. A whole splendid toolbox that I could apply to my own research.

We write mathematics down for ourselves, because it is difficult to keep many complex elements in our head simultaneously, and easy to fall into error: writing is an antidote to the psychological effects of wishful thinking. We draw and write mathematics on blackboards as a form of transmission, as a reflection of the mental image of an inner landscape that cannot be transplanted directly into the mind of another. If the language is adequate, it will serve as both the bricks and the instructions that allow others to rebuild the mental image in their own mind.

My blackboard contains a fundamental identity of mould theory, one that can be applied in remarkably diverse situations. It sounds wonderful to read aloud, but many colleagues have told me that the unfamiliar vocabulary makes Écalle's papers and mine too hard to read. Some have encouraged me to rebaptize all the notions and rewrite the formulas in a more normal way: $Z = F(s) \cdot Y$ or $G(p^{-1}) = p_c$. But I can't imagine doing that, because to me, the attractive sonorities and the perfect suitability and flexibility of the language are beautiful. And if we do mathematics at all, we do it for its beauty.

Applying the same method to an yields the

operator ira, defined as

$$ira(A,B) = swap\left(a_{i}, (swap(A), swap(B))\right)$$

$$= ax.t(B, -push(B))A + ma(A,B)$$

$$- ax.t(A, -push(A)) \cdot B - mu(B,A)$$

We then define preiwa as follows:

$$preiwa(A,B) := swap\left(preaw, (swap(A), swap(B))\right)$$

$$= swap\left(amit, (swap(B), swap(A))\right)$$

$$+ swap\left(anit(anti \cdot neg(swap(B))) \cdot swap(A)\right)$$

$$+ swap\left(mu(swap(A), swap(B))\right)$$

JAN VONK

Dr. Jan Vonk obtained his doctoral degree from the University of Oxford in 2015 and is currently a member at the Institute for Advanced Study, Princeton.

Doing mathematics is a deeply chaotic process, with many dead ends and false positives. Often it is helpful to go for long solitary walks to mull things over, or to sit at your desk, scribbling away and endlessly experimenting to try and find some clarity and order in your ideas and attempts. But to me, mathematics is fundamentally a social activity. We keep gathering religiously around our blackboards, where we share our aspirations and doubts, our successes and failures, our insights and confusions, and most importantly, our excitement and passion for mathematics.

My work is in number theory. This field is one of the oldest disciplines in mathematics, whose practice was common to many of the ancient cultures across the world. Today it has become more than ever a vibrant research area. To its Babylonian practitioners, our modern methods would most likely be quite unrecognizable, after the discipline underwent several revolutions throughout the centuries, resulting in the injection of a wide variety of tools from seemingly very different fields of mathematics such as abstract algebra, geometry, and analysis. I study questions related to solutions of polynomial equations, such as:

$$441x^4 - 264x^3 + 271x^2 - 264x + 441 = 0.$$

Depending on your experiences as an adolescent, this may make your toes curl in the anticipation of lots of painful algebra ahead. What you may not expect is that some of the deepest secrets of polynomials like this one are encoded in certain mysterious geometric shapes. These shapes are quite rigid, like a rock, and are difficult to extract information from. One of the themes in my research is to study these rocks by looking at them through a different lens, making them less rigid, like a ball of dough. This is done by studying them in a universe equipped with a peculiar warped version of the usual notion of distance and size. For any prime number p, this bizarre procedure gives us a more malleable "p-adic" version of these rocks. After they are kneaded around with care, they can be swayed into sharing some of their deepest arithmetic secrets with us.

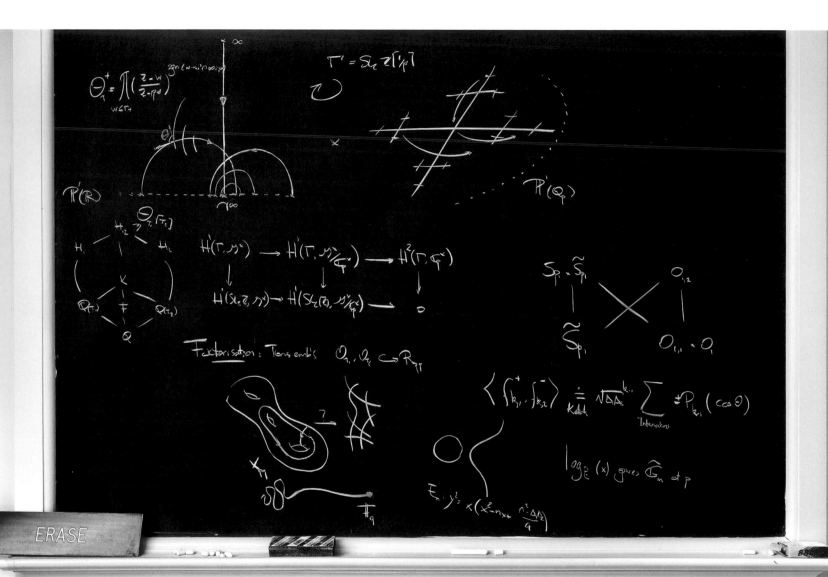

JONATHAN PILA

Jonathan Pila is the reader in mathematical logic at the University of Oxford. He was born in Melbourne, Australia, and obtained his undergraduate degree at the University of Melbourne before completing his doctorate at Stanford University under the supervision of Peter Sarnak. He received a Clay Research Award in 2011, was a plenary speaker at the International Congress of Mathematicians in Seoul, 2014, and was elected a fellow of the Royal Society in 2015.

This photograph was taken during one of the three Weyl Lectures I gave at the Institute for Advanced Study in 2018. The Weyl Lectures, named after the German mathematician Hermann Weyl (1885–1955), are an annual lecture series intended to introduce topics of current interest to a broad mathematical audience.

The focus of my lectures was a collection of problems I have been thinking about, alone and in collaboration, over many years. These problems are part of a picture that unifies and extends some of the most classical problems in the area of Diophantine equations, a field that is named after Diophantus of Alexandria (third century CE) and falls within the broader area of number theory. It studies when systems of algebraic equations with rational coefficients can be solved in whole or rational numbers, and related questions. The methods I have been using to study some of these problems have some quite distinctive and surprising aspects. One is their combination of ideas from the different mathematical areas of number theory and logic, and another is their use of a rather naive and elementary idea to tackle some quite deep and sophisticated problems. A schematic diagram of one of those problems, and part of its transition into a formal proof, is shown on the chalkboard. Chalkboards are wonderfully adapted to the process of connecting intuitive pictures and formal symbols that is at the heart of communicating mathematics.

Giving the Weyl Lectures was a real pleasure for me. The problems chart an intellectual journey that has now spanned over three decades and several different mathematical areas, as well as a personal journey that began with a collaboration at the IAS when I was a young postdoc visiting there. It was wonderful to have the opportunity to speak about my work at the place where it all began.

I believe that, for many mathematicians, the great unsolved problems are like signs of the zodiac: you are born under one of them and then guided by it throughout your mathematical life. That has certainly been the case for me, the unsolved problem being Schanuel's conjecture on transcendental numbers. This conjecture governs the possible algebraic relations among values of the exponential function, including, for example, numbers like e and pi. It says, more or less, that the relations are as few as they could be, and formulates these relations in a clean and wonderfully compact statement. This conjecture, also somewhat surprisingly, animates the problems discussed in my Weyl Lectures in several different ways.

ensures. $[\mathbb{Q}(X,Y,Z):\mathbb{Q}] \geq c_Y \max(N,M)^{\delta_V}$

\mathbb{H}^3

$\begin{bmatrix} u & v & w \end{bmatrix}^3$ $gu = v, \quad hv = w \qquad g \in GL_2^+(\mathbb{Q})$

$H(g,h) \leq c \max(N,n)^\Omega$ $h \in GL_2^+(\mathbb{Q})$

\mathbb{C}^3

$(x,y,z) \in \bar{V}$

atypical

$Y = \{(u,v,w,\ g,h) \in \mathbb{H}^3 \times GL_2^+(\mathbb{R})^2 \qquad gu = v, \ hv = w$

$Z = \gamma^{-1}(V) \cap F^3$

$X = \{(g,h) \in GL_2^+(\mathbb{R})^2 : Y_{g,h} \cap Z \neq \emptyset\}$

$Y_{g,h} \cap Z$

YVES BENOIST

Yves Benoist is a researcher at CNRS in Paris, where he has worked for more than thirty years.

Five years ago, I was studying fractal sets with my collaborator, Dominique Hulin. We were interested in the fractal sets on the sphere that look roughly the same at all scales. After zooming in very closely on any individual part of the fractal set, we were hoping to see that the picture still looked like the original set, only viewed through an angle-preserving transformation of bounded size. We called these fractal sets "conformally auto-similar fractal sets" because these fractal sets look roughly the same at all scales.

We were surprised to discover that not only do these fractal sets exist, but they can be elegantly described using Kleinian groups, which were discovered by the mathematician Felix Klein more than a hundred years ago. These groups play a central role in three-dimensional topology.

The joy of this blackboard is that these very abstract mathematical concepts are not only very useful but also give rise to splendid drawings. With my chalk, I was only able to give an approximation of the beauty of three of these fractal sets.

To improve these drawings, you can use either a computer or your imagination. The pictures that I program on computers sometimes reveal something unexpected—even better than I could imagine. For me, computers and blackboards are two important aspects of my job, together with pens, books, discussions, and gatherings.

I went into mathematics because I wanted to become a teacher, so I could share the hidden beauty of mathematics. I ended up becoming a researcher, so I could try to find new hidden beauties.

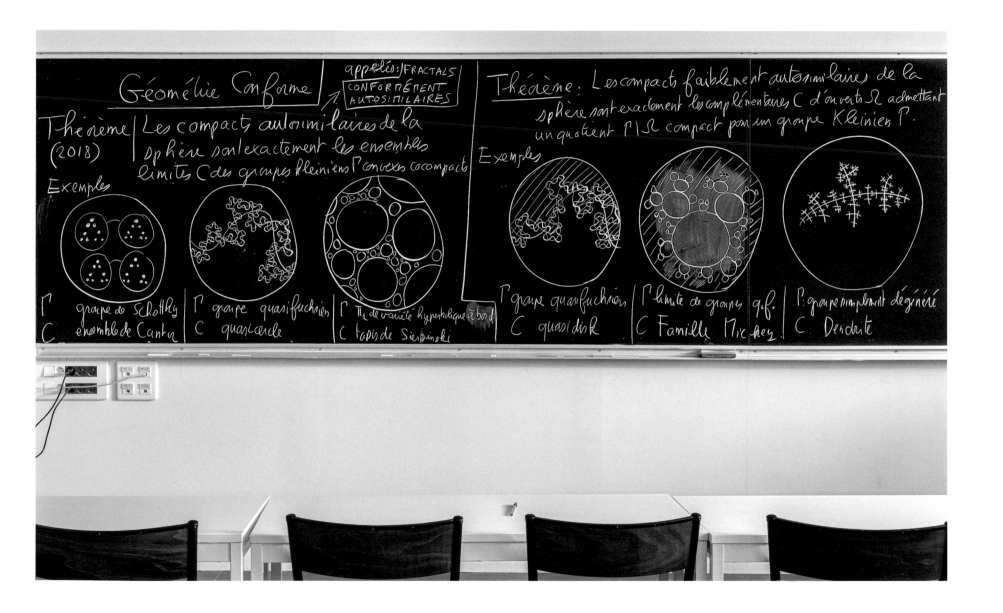

Géométrie Conforme

appelés: FRACTALS CONFORMÉMENT AUTOSIMILAIRES

Théorème (2018) | Les compacts autosimilaires de la sphère sont exactement les ensembles limites C des groupes Kleiniens Γ convexes cocompact

Exemples

Γ: groupe de Schottky
C: ensemble de Cantor

Γ: groupe quasifuchsien
C: quasicercle

Γ: π_1 de variété hyperbolique à bord
C: tapis de Sierpinski

Théorème: Les compacts faiblement autosimilaires de la sphère sont exactement les complémentaires C d'ouverts Ω admettant un quotient $\Gamma \backslash \Omega$ compact pour un groupe Kleinien Γ.

Exemples

Γ: groupe quasifuchsien
C: quasidisk

Γ: limite de groupes q.f.
C: Famille Mickey

Γ: groupe simplement dégénéré
C: Dendrite

ENRICO BOMBIERI

Enrico Bombieri is an Italian math-
ematician, known for his research
in number theory, algebraic geom-
etry, complex analysis, and group
theory. He was awarded the Fields
Medal in 1974 and the Balzan Prize
in 1980. Bombieri is currently pro-
fessor emeritus at the Institute for
Advanced Study in Princeton, New
Jersey.

I was born in Milan, Italy. Up until the third grade, I had some difficulty doing arithmetic—adding and multiplying numbers. Then I found a little book at home with the title *Curious and Amusing Mathematics*. It caught my attention, and my grades in math improved quite a bit. By the time I was fourteen, I was reading advanced mathematics.

When I was fifteen, things changed. My father, realizing that he could no longer help me in my studies of mathematics, sent a paper that I had written on a fairly difficult mathematical problem to a professor of mathematics at the University of Milan, without mentioning my age. When the professor found out how old I was, he took me under his wing and coached me (very gently) on continuing my study of mathematics. He was my first mentor, and I published my first mathematical paper when I was sixteen years old.

Other people say that I am a very good mathematician, but that is not my goal. My goal is to understand some of the mysteries concealed inside the fabric of mathematics. If I get a prize, I say thank you and try to work harder.

I do not give up on trying to understand things. When I realize that I am short of new ideas, I put the problem aside for a while, work on other things, and revisit it with a fresh mind. This is how I make progress. There was a problem (the classification of the so-called Ree groups, whatever those are) that was important to algebraists; a friend of mine proposed it to me because I was not an algebraist and he thought that perhaps I could attack the problem from another angle. I worked on it for about a year with absolutely no progress, so I put it aside. Four years later, it still had not been solved, so I decided to have another look at it. Within a half hour, I was able to overcome the biggest obstacle.

I love art, and if I had not found mathematics, I would have tried to become a professional artist. I do a lot of painting on the side, nothing abstract—a lot of oil portraits, drawings, and prints.

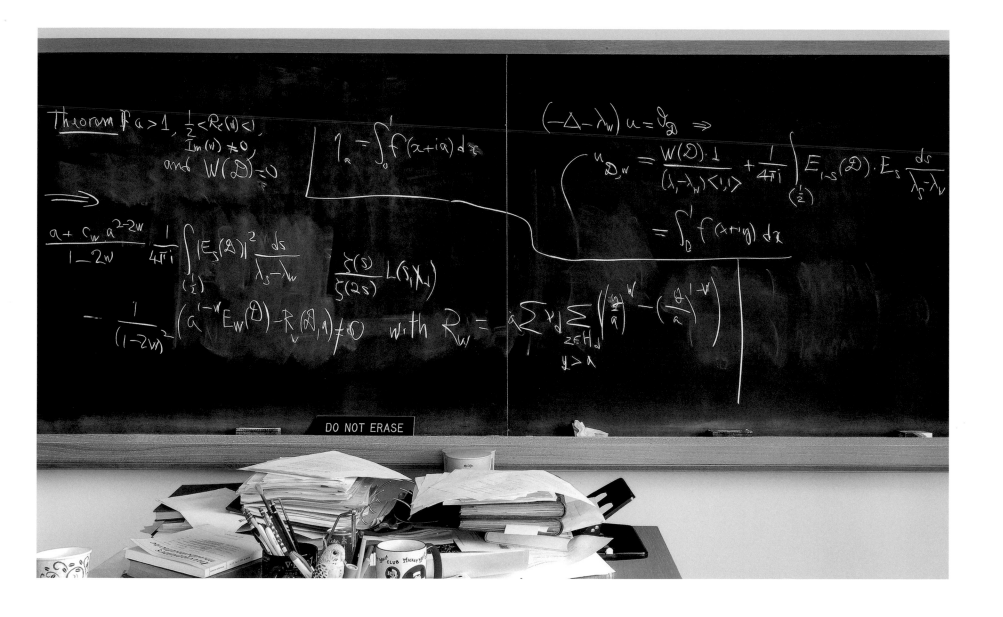

PETER WOIT

Peter Woit is senior lecturer in mathematics at Columbia University. After completing a PhD in theoretical physics at Princeton, he spent three years as a postdoc at the Institute for Theoretical Physics at Stony Brook and a year as a mathematics postdoc in Berkeley before coming to Columbia in 1989. He is most well known for the "Not Even Wrong" blog, which covers topics in both physics and mathematics.

Despite their age, chalkboards are an unequaled technology for thinking about and communicating mathematics. The language of mathematics involves a huge variety of symbols, diagrams, and ways of representing relations between them. These can be reproduced with some significant effort on a typeset page, but this is a language most fluently and effortlessly communicated by a hand writing on a page or on a chalkboard. Unlike writing with pen on paper, the language on a chalkboard can be continually erased, edited, and improved. While you can communicate with one or two other people by writing on a piece of paper, the chalkboard allows you to communicate with any number of people, from just yourself to a filled auditorium.

The only technological improvement I've seen in recent years is that now you can take out your cell phone and make a copy of what's on a chalkboard for future reference. It's hard to know what future technology will bring, but I'm willing to bet that a hundred years from now, mathematicians will still be using chalk and chalkboards.

What's on the blackboard has to do with something I've been struggling with for a while: how to think about the solutions of basic equations of quantum mechanics, not as functions but as "hyperfunctions." This involves keeping track of what is happening in two different complex planes (related by the Fourier transform). While as usual I'm mostly frustratingly confused, I've enjoyed the way this story relates fundamental physics and some beautiful mathematics.

$$\left(\frac{d^2}{dt^2} + \alpha^2\right)\phi = 0$$

$$\left(E^2 - \alpha^2\right)\tilde{\phi} = 0$$

$$\oint_{-\infty}^{\infty} \frac{1}{2\alpha}\left(\frac{1}{E-\alpha} - \frac{1}{E+\alpha}\right)e^{iEt}\, dt$$

$$\frac{1}{E^2 - \alpha^2} = \frac{1}{2\alpha}\left(\frac{1}{E-\alpha} - \frac{1}{E+\alpha}\right)$$

$$\oint_{-\infty}^{\infty} \tilde{\phi}(E)\, dE$$

$$= \int_{-\infty}^{\infty}\left(\tilde{\phi}(E+i\epsilon) - \tilde{\phi}(E-i\epsilon)\right) dE$$

$$|t+i\tau$$

$$e^{i\alpha(t+i\tau)}$$

$$e^{+i\alpha(t+i\tau)}$$

EDEN PRYWES

Eden Prywes is a postdoctoral
research associate in mathematics
at Princeton University.

My research centers around the geometry of complex
numbers. This is a classical subject that dates back
to the eighteenth century and deals mostly with two-
dimensional objects, similar to the surfaces shown on the
chalkboard in this photograph. In my work, I try to gen-
eralize theorems in the classical theory to higher dimen-
sions. For example, an important problem is to understand
whether a given higher-dimensional object is geometri-
cally the same as a flat space (like the two-dimensional
plane). It becomes challenging to draw objects of more
than three dimensions on a blackboard. However, I use the
drawings in two dimensions as intuition for what occurs
more generally. Drawings are particularly useful in geom-
etry: geometric problems are often described by esoteric
equations that are difficult to immediately understand,
but a picture is a straightforward way to evaluate and de-
velop intuition for a set of problems.

The drawing on this board depicts how to represent
a surface using a flat shape. If the opposite sides of a
square sheet of (flexible) paper are glued to each other,
the surface that emerges is a torus. This is shown by
the top two figures on the board. The square with arrows
on its sides denotes a surface that can be transformed
into a torus by gluing the sides with the same number of
arrows to each other. The result is the figure on the top
right, where the dotted lines denote the glued sides. A
more complicated example is drawn below them. Instead
of two gluing operations, four are necessary. The drawing
shows how to convert an octagon into a surface with two
holes. Conversely, a surface can be cut along certain lines
and unfolded to give back a flat shape. This technique
can be used for any surface, and the number of cuts that
are needed depends on the number of holes in the sur-
face. These pictures can be formalized in a mathematical
language, and the techniques can be used to understand
whether two surfaces are the same or not.

MARIA JOSÉ PACIFICO

Maria José Pacifico was born in Guariba, a small town in the interior of São Paulo. She arrived in Rio de Janeiro in the 1970s to study at IMPA, where she completed her doctorate in 1980. She has since joined the Federal University of Rio de Janeiro, where she is a full professor. She specializes in dynamic systems, with an impressive number of central contributions in the field, many of which are published in leading mathematical journals.

The pleasure of discovery is what has always thrilled me. Finding a solution to a problem that provides an undeniable explanation for an initial puzzle is priceless. Solving is like composing a musical score, where the chords come together in a final, exhilarating melody.

To solve is also to put the finishing touches (with the correct color palette) on a painting that has been carefully planned. For me, it is in this analogy that the blackboard comes into play. Doodling on the blackboard—making a drawing that somehow not only represents the problem but also indicates a trace of the path to the solution—is a fundamental step for me. The drawing scribbled on the chalkboard comes first, and makes me think about the problem over and over, without the need to write equations and do numerical calculations. It is a purely abstract way of thinking, born from a real design. It is amazing that in mathematics, we can solve problems as if we were making art, composing a melody, or painting a landscape.

This idea has always been present in my life. I knew from a young age that it was mathematics I would choose to pursue professionally. But as I come from a family of immigrants who transformed a small town in the interior of São Paulo into their home and who had roots in music and art, I could not have become a mathematician if I had not been able to find that deep connection between art, music, and mathematics.

Before solving a problem, I need to have a geometric image that I can always remember, without any other device. And the first step on this journey is the use of the blackboard.

The drawing on the blackboard in this photograph is a Lorenz geometric attractor, one of the most intriguing phenomena I have encountered in my academic career.

BRYNA R. KRA

Bryna R. Kra is the Sarah Rebecca Roland Professor of Mathematics at Northwestern University. She was awarded the Centennial Fellowship of the American Mathematical Society in 2006 and the Conant Prize of the American Mathematical Society in 2010, and in 2012 became an inaugural fellow of the American Mathematical Society. In 2016 she became a fellow of the American Academy of Arts and Sciences, and in 2019 she was elected to the National Academy of Sciences.

This board reflects my activity as a mathematician, displaying a combination of research and teaching. The drawing in the center relates to one of my longstanding research interests: finding patterns in seemingly random configurations. For me, such problems become especially interesting when the patterns are not readily apparent and can only be found by studying and understanding the abstract structures that govern the configurations.

This particular illustration is motivated by a combinatorial conjecture about the existence of regular configurations in arrangements of black and white checkers on an infinite board. The original problem is about finding and counting certain patterns, but that does not appear in this picture. Instead, I have translated the problem into a dynamical setting, in which the general objective is the study of repeated applications of the same rule on a space. By carrying out this translation, the tools of dynamics, including deep results on the long-term behavior of systems, become available for addressing this question. Numerous variations of this picture have appeared on my board over the past five years, with subtle changes in angle, color, and shading reflecting different approaches to the problem.

Partly overlaying and surrounding this drawing is a discussion of an exercise from a graduate class in dynamics that I teach. Again, the problem arises in another field of mathematics—this time, number theory. As before, the first step is to translate the question into a dynamical one, and then use dynamical tools to find a solution. Making connections across seemingly unrelated areas of mathematics has led to some of the most beautiful and appealing aspects of my research.

$$R_{\gamma}(y,g) = (y, g\gamma)$$

$$x \longmapsto x + \alpha$$

$$\{\exists \alpha\} : \Pi \to \mathbb{R}/\mathbb{Z}$$

G

$$T : X \to X$$

$$g \in G \quad T x = g x$$

u_3

u_2

u_1

(X, T) compact

$y_0 \in Y$ is recurrent. (y_0, e).

$\exists g \in G$ s.t. $(y_0, g) \in \overline{O(y_0, e)}$

(y_0, g)

y_0

$$R_g(y_0, g) \in \overline{O(y_0, g)}$$

$$\subset \overline{O(y_0, e)}$$

$$R_g^n(y_0, g) \in \overline{O(y_0, e)}$$

RAFAEL POTRIE

Rafael Potrie is an associate pro-
fessor of mathematics at Centro
de Matemática, Universidad de la
República, in Uruguay. He works on
geometry and dynamical systems in
low-dimensional manifolds. During
the 2019–2020 year, he spent a
sabbatical as von Neumann Fellow
at the Institute for Advanced Study,
where the photo was taken.

Mathematics had always captured my attention, but being a mathematician never seemed like a possibility to me early in my life. In fact, I was not even aware of the existence of such a career. When I started my undergraduate studies in engineering, I met true professional mathematicians, which blew my mind. I was lucky enough to have support from both my partner and my family for starting a career in mathematics, which seemed a risky choice in a country like Uruguay. In the process, I met many generous people who helped me on my journey.

The process of doing mathematics is maybe as hard to explain as the mathematics itself. It is quite personal. I collaborate with people who have extremely diverse approaches to mathematics. For my part, I usually approach math by trying to understand work that has already been done; I spend lots of time trying to own the ideas and feel them as if they were my own. Sometimes this leads to new points of view, or to questions that capture my attention. It always leads to learning new and beautiful ideas that later can be used in other projects.

Collaboration is also crucial in my work. Having people with whom I can communicate and exchange points of view is fundamental in my process. Blackboards (and sometimes whiteboards) are important tools for collaboration. We learn this beautiful language of mathematics when we become mathematicians, and it is important to remember that this language has a nonspoken component, which we learn to convey in drawings and body language. I do not claim that there aren't other ways to communicate about mathematics, but blackboards have proven quite important in the advancement of our understanding.

The chalkboard that was captured here represents a collision between two different collaborative processes. One amazing thing that happens in math is that when one finds an apparent contradiction, it means that some subtle phenomenon is taking place.

The drawing on the board reflects a contradiction that, after it was solved, led to two of the works I am most proud of. It also aims to tell the story of a current project I am working on with collaborators, in which we are trying to explain from a conceptual point of view how this apparent contradiction is actually very natural. It has to do with the quest for understanding the relation between the asymptotic behaviour of a deterministic system and the shape of a phase space where it takes place. I am mostly interested in obtaining information about these asymptotics by information that can be gathered in finite time. This leads to connections with a lot of mathematics that I find incredibly beautiful, in particular the understanding of low-dimensional topology and dynamical systems.

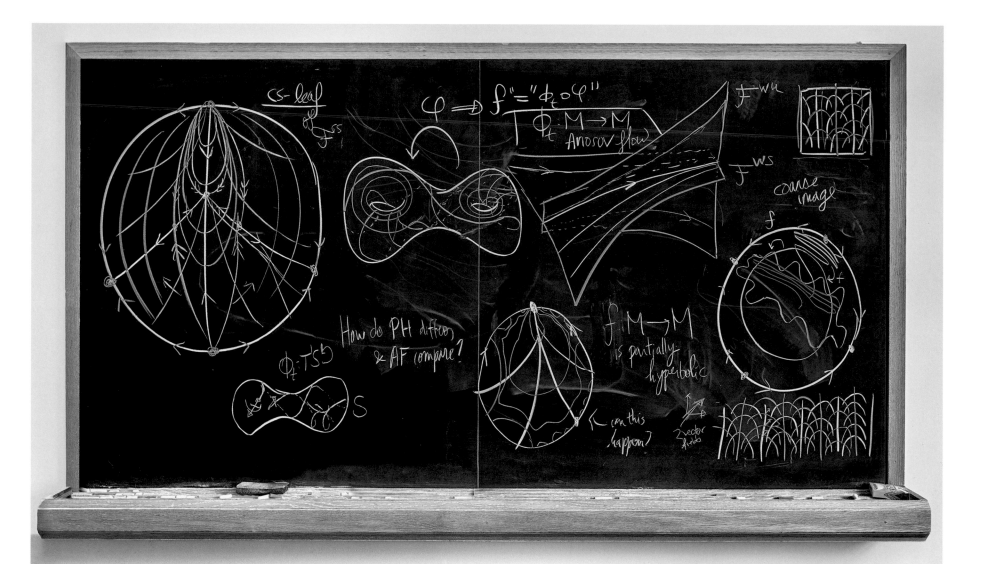

BRUNO KAHN

Bruno Kahn is director of research at Centre national de la recherche scientifique (CNRS).

Ideas in mathematics are exciting. They can lead to a breakthrough, or to nothing. Or they can lead to something, much later than we ever expected, or maybe we didn't expect.

This blackboard is a memory of a discussion I had with my colleague Yves André in his office around Tannakian things, months before this photograph was taken. We don't need "Do not erase" signs in Jussieu, as cleaning blackboards is not a part of the negotiated assignments of the cleaning staff. Some mathematicians do their personal musings with chalk on their blackboard, but many use paper or TeX instead and reserve the blackboard for exchanges with other colleagues or students. So a blackboard can remain intact forever, or at least until the next discussion.

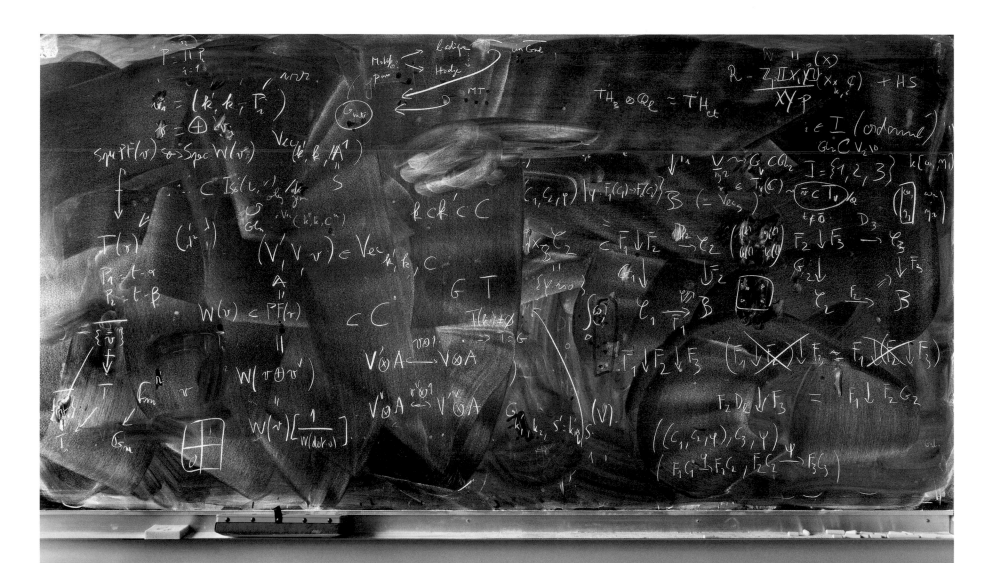

BOYA SONG

Born and raised in China, Boya Song moved to the United States at age eighteen for undergraduate study and completed her BS in applied mathematics in UCLA in 2016. She is currently a PhD student at MIT studying physical applied math, advised by Prof. Jörn Dunkel.

I'm in the field of physical applied math, where we focus on building mathematical models for physical or biological phenomena. On this blackboard, I was trying to understand the Vicsek model, a mathematical model describing collective behavior (usually for animals or micro-swimmers). The model itself describes the dynamic of a group of objects that are moving in a given direction, while also trying to align their direction of movement with their neighbors'. What's amazing about this model is it can produce different patterns—swarming, flocking, vortex, or chaos—under different scenarios.

To me, working on a blackboard is like painting a portrait of the mathematical problems in my mind. These "portraits" should be accurate, yet also personal in their details, reflecting what I know about a problem and why it is interesting to me. Painting one of these portraits on a blackboard can bring a problem to life: it provides a concrete image of a problem that is, more often than not, highly abstract, an image that I can share with other people to convey my ideas. For these reasons, working on blackboards has become an inseparable part of my teaching and research.

JOHN MORGAN

John Morgan joined Columbia
University in 1974 and became a
tenured professor of mathematics
in 1977, after instructorships in
mathematics at Princeton and MIT.
In 2009, he retired from Columbia
to become the founding director of
the Simons Center for Geometry and
Physics at Stony Brook University.
He held this position from 2009
until 2016 and remained at the Cen-
ter until 2019, when he returned to
Columbia as an emeritus professor
of mathematics.

I did not know there was such a thing as a theoretical mathematician until my sophomore year of college. I was taking an advanced undergraduate mathematics class, when one day the professor, instead of teaching us the material in the syllabus, decided to give us a lecture on more advanced material about certain higher-dimensional spaces. I was immediately captivated. Soon I was thinking about nothing else. There is a very special, and to me immensely appealing, quality to the study of these spaces.

While no one can actually see these spaces directly, our geometric intuition can be trained to guide us in understanding their fundamental properties. The best we can do is to draw three-dimensional pictures, typically on a chalkboard, to capture the essence of the higher-dimensional situation and stimulate our higher-dimensional imagination.

The picture on my chalkboard is a three-dimensional example of a fundamental property of spaces of all dimensions. In its simplest incarnation, the property expresses the idea of perpendicularity. In ordinary space, perpendicular to a straight line is a plane and perpendicular to a plane is a straight line. This perpendicularity holds in linear (Euclidean) space of any dimension n: perpendicular to a linear subspace of dimension k is a linear subspace of dimension $(n-k)$. This generalizes to curved spaces of dimension n. Curved spaces can have rich geometric and topological properties not seen in linear spaces. Many of these are related to the cycles in the space. A loop in the space is a one-dimensional cycle; a surface in the space is a two-dimensional cycle; more generally there are cycles of every dimension. The duality of space is now expressed in the fact that in a

space of dimension n for each cycle of dimension k there is a "dual" cycle of dimension $(n-k)$. This fundamental duality was discovered by Henri Poincaré around 1900 and is named for him—Poincaré duality. The picture on my chalkboard shows small pieces of a one-dimensional cycle and a two-dimensional cycle in a three-dimensional space meeting in one point—they are dual cycles. I produced this picture in preparing my graduate lecture on Poincaré duality.

Speaking of chalkboards, when I became the director of the Simons Center for Geometry and Physics at Stony Brook University, I made it my mission to equip the center with high-quality chalkboards. These are becoming harder and harder to find as people opt for whiteboards or various types of smart boards. But none of these can compare to a high-quality chalkboard as a medium on which to think about mathematics and to present it to others. Whiteboards and low-quality chalkboards do not erase well, and hence remnants of previously erased material detracts from the current use of the board. (The pens that one uses on whiteboards also nauseate me.) Many mathematics lectures are now given using prepared slides and computer projection. While these are more polished presentations, I prefer the pace that is forced on the speaker by having to write on the board. This laborious process slows down the rate of information flow, but to my mind this is a real plus, for it increases the percentage of the material that is comprehended by the audience. Also, there is more spontaneity in giving the lecture "live," rather than reading from a prepared script. I hope chalkboards never disappear, for it would be a real loss for the subject.

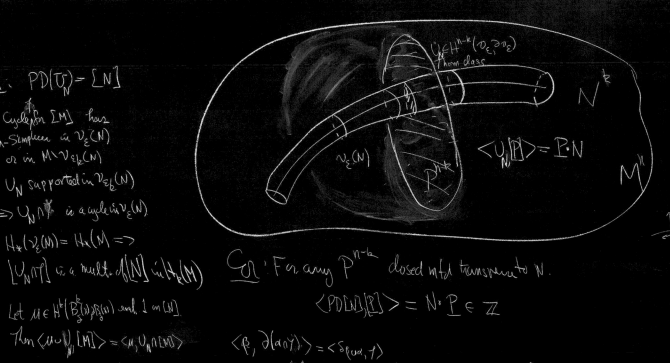

Claim: $PD(U_N) = [N]$

Pf: Cycle for $[M]$ has
n-simplices in $\nu_\varepsilon(N)$
or in $M \setminus \nu_{\varepsilon/2}(N)$

U_N supported in $\nu_{\varepsilon/2}(N)$

$\Rightarrow U_N \cap \sigma$ is a cycle in $\nu_\varepsilon(N)$

$H_*(\nu_\varepsilon(M)) = H_*(M) \Rightarrow$

$[U_N \cap \sigma]$ is a mult. of $[N]$ in $H_k(M)$

Let $\mu \in H^k\left(B^k_{\varepsilon/2}(N), \partial B^k_{\varepsilon/2}(N)\right)$ eval. 1 on $[N]$.

Then $\langle \mu \cup U_N, [M] \rangle = \langle \mu, U_N \cap [M] \rangle$

$= 1 \Rightarrow$ mult is 1

$U_\xi \in H^{n-k}(\nu_\xi, \partial \nu_\xi)$
Thom class

N^k

$\nu_\xi(N)$

P^{n-k}

$\langle U_N, [P] \rangle = P \cdot N$

M^n

Cor: For any P^{n-k} closed mfd transverse to N.

$$\langle PD[N], [P] \rangle = N \cdot P \in \mathbb{Z}$$

$\langle \beta, \partial(\alpha \cap \gamma) \rangle = \langle \delta \beta \cup \alpha, \gamma \rangle$

$\partial(\alpha \cap \gamma) = \partial \alpha \cap \gamma + (-1)^{|\alpha|} \alpha \cap \partial \gamma$, $\langle \delta(\beta \cup \alpha) - (-1)^{|\beta|} \beta \cup \delta \alpha, \gamma \rangle = \langle \beta \cup \alpha, \partial \gamma \rangle - (-1)^{|\beta|} \langle \beta, \delta \alpha \cap \gamma \rangle$
$= \langle \beta, \alpha \cap \gamma \rangle$

HELMUT HOFER

Helmut Hofer is a faculty member in mathematics at the Institute for Advanced Study (Princeton). He received his PhD from the University of Zürich, and later held faculty positions at the University of Bath (UK), Rutgers University (New Jersey), Ruhr-Universität Bochum (Germany), ETH Zürich (Switzerland), and Courant Institute of NYU (New York).

I had the privilege to start the field of symplectic topology with others and, later, the field of symplectic dynamics. Symplectic topology was jump-started by a number of mathematicians with a variety of mathematical backgrounds. Most importantly, each field had a different culture; the mathematical tools used and the ways to think about a problem were very different.

During these "pioneer days," this cultural diversity created an experience very different from that in a more mature field, where graduate students are often "spoon-fed" the already processed general knowledge of those who have been there before. This "processed" knowledge usually has been streamlined with respect to certain goals and, more often than not, has lost some or even most of its original context, which is a pity.

I like to think in pictures or images. For me, a picture—a mental image or a blackboard drawing—is a tool to summarize and represent knowledge in a condensed way. These mental images are the building blocks of my mathematical reasoning, with the potential to represent complex mathematical arguments via a gallery of pictures curated under strict rules. For a given problem, my gallery might be a big room with a few large pictures, or a small room with many small pictures. The publication of a result is the painful process of turning the "gallery" into text written adhering to mathematics' rigorous standards.

The picture on my blackboard represents the mathematical concept of "finite energy foliations" in symplectic dynamics. For me, this is a gallery with one picture. It is the end result of several years of work and describes an important new mathematical structure in a very condensed form, which takes several hundred pages to write down in a mathematically rigorous style.

I love the lunch table of the mathematicians at the Institute for Advanced Study. It is the place where I do my "sociological" studies, probing the thinking of researchers in different fields to try to remove vagueness in the areas I am interested in. With many mathematicians in residence, these lunches produce warehouses full of pictures. I am sure that certain collections of them, properly curated, would make spectacular exhibits.

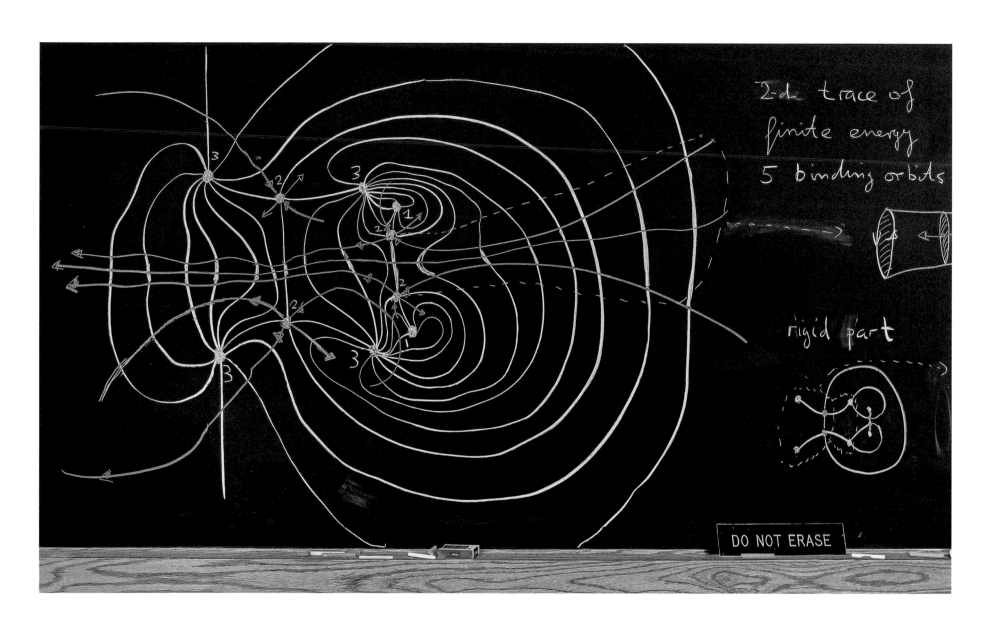

NANCY HINGSTON

Nancy Hingston works in Riemannian geometry and Hamiltonian dynamics. The study of closed geodesics has led her to the domains of equivariant Morse theory and string theory. She graduated from the University of Pennsylvania in 1975 with majors in physics and mathematics, and studied physics at Cornell for a year before moving to Harvard, where she studied mathematics under Raoul Bott, earning a PhD in 1981. She taught at the University of Pennsylvania and is now a professor at the College of New Jersey. She has been a regular visitor at the Institute for Advanced Study and has been involved with the Women and Math program there since 1994.

Part of the excitement of mathematics is that it is completely unpredictable. There is no knowing when or on what front progress will occur. You can strike it rich (with a thunderclap of insight) or lose all (by discovering an error in your own work, or finding out that someone else has just proved it) in a matter of minutes.

Collaborative research is much more productive, and more fun, than toiling alone. Mathematics most often proceeds by following ideas that turn out to be wrong but that have some truth in them. The chalkboard facilitates both of these aspects of the mathematical process. Different people can work on different aspects of the problem on different parts of the board, so there is no need for anyone to wait their turn. Pieces of ideas that have not worked out can easily be erased to make way for the next brilliant mistake.

A mathematician in a remote galaxy, or one in another universe, would understand the message on this chalkboard were it to arrive in a bottle. They would see that the two surfaces labeled "2" are "the same" in a way that the surfaces labeled "6" are also "the same." They would not recognize the symbols 2 and 6, but the message could serve as a definition. I invite the reader to draft an appropriate reply to this message.

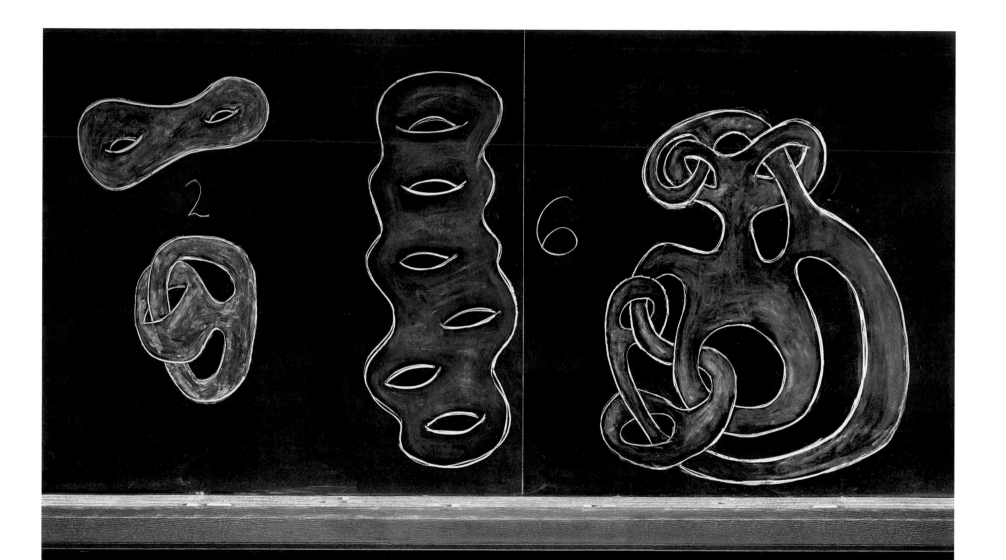

VINICIUS G. B. RAMOS

Vinicius G. B. Ramos is an associate professor at the Institute for Pure and Applied Mathematics (IMPA) in Rio de Janeiro, Brazil. A native of Rio de Janeiro, he finished his PhD at UC Berkeley in 2013 under the supervision of Michael Hutchings. After that, he was a postdoc in Nantes, France, and at IMPA before being hired as an assistant professor in 2017. In 2019, he was one of eight researchers in Brazil to be awarded a BRL 1,000,000 grant by the Serrapilheira Institute.

Mathematics has been a passion of mine since I was a child. For a child, learning about numbers and operations is experimental, and I remember discovering small truths by trial and error. One of the most remarkable ones was realizing that the sequence of the differences of two consecutive squares is the sequence of odd numbers. After learning some algebra, this is an easy observation, but when I first came across this fact I was blown away. I liked other disciplines as well, but mathematics always had a unique appeal, combining truth and aesthetics like no other subject. The process of discovering new theorems is an interesting journey. Just knowing what is not known and what should be true is an enormous step. Trying to figure out a proof is another one. Writing your results up for publication can also be challenging, yet is very important. It can be difficult to explain everything in your mind, but without being able to explain your proof, nobody else can understand why what you claim is actually true. The whole process involves reading, thinking, sketching ideas and equations, and drawing pictures.

Although I regularly use pencil and paper, the blackboard is often the best place to develop my thoughts. Being able to step back from what I have written and just stare at it all can open my mind to new ideas, which can lead me closer to the solution of a problem. On the other hand, when it's all wrong, I can easily erase it and start over. One of the biggest breakthroughs in my research happened a few years ago, when I managed to draw several triangles inside a bigger one on the blackboard—that was what I needed to prove a much more abstract result. My field of study is called symplectic geometry, and it concerns the geometric structures behind classical physics. More recently, I have been studying its interactions with billiard dynamics, the study of the movement of a ball in a possibly non-rectangular pool table. The blackboard in this photograph shows how billiard dynamics in an ellipse are related to a symplectic domain with convex and concave parts.

GILBERT STRANG

Gilbert Strang is the MathWorks Professor of Mathematics at MIT. This is his fifty-eighth year on the MIT faculty. He has authored ten textbooks, and his video lectures for linear algebra 18.06 are still among the most watched on OpenCourseWare. Professor Strang is a member of the US National Academy of Sciences. He has been honored with the Henrici Prize for his research, the Haimo Prize for his teaching, and the Su Buchin Prize for his contributions to mathematics.

I believe strongly in blackboards. It is certainly no exaggeration to say that blackboards have changed my life. To explain what I mean by that, I will have to make this a personal story. The story says something about teaching, and about one part of the life of a mathematician, but it doesn't speak to the most important subject: mathematics itself.

In an age of technology and online courses, I believe that writing on the board still makes a human connection with the viewer that PowerPoint cannot achieve. A little background: I had always admired the lectures of Gian-Carlo Rota, a mathematician whose great contribution was to put the subject of combinatorics on a sound foundation, and I hoped that Rota would leave recordings for future generations to watch. I expressed that idea to a friend who happened to know about the Lord Foundation of Massachusetts, which supports MIT, and how to apply for a grant. My friend Dick Larson made it happen, and suddenly my linear algebra class was to be videotaped as well. This was in 1999.

It was a series of lucky choices and events: the cameraman was already filming freshman physics, and my lectures for Math 18.06 followed in the same room. Fortunately, I had chosen to use big chalk (railroad chalk). This makes your handwriting look better than it is. The good luck continued when MIT's president, Charles Vest, suddenly decided to create OpenCourseWare—to put information about all of MIT's courses online, with videos if possible. It was natural to include my 18.06 linear algebra course—taught entirely on blackboards—among the two thousand other courses on OpenCourseWare's website, with materials aimed to help teachers worldwide. But

it is students (not their teachers) who actually read the notes and watch the videos.

By a third stroke of luck, linear algebra has surged in importance. Students need to learn it, and many *want* to learn it. The audience for 18.06 has surpassed ten million, and they are all still looking at an MIT blackboard.

$(\langle v, w \rangle = X^* A Y)$

$\overline{X^* A Y} = \overline{X}^* \overline{A} \overline{Y}$

$A = A^*.$

Rules: $(AB)^*$

$= \overline{(AB)}^t = \overline{(AB)}^t = \overline{B}^t \overline{A}^t = \overline{B A}^{t_0}$

$(AB)^* = B^* A^*$

$A^{**} = A$

$(A+B)^* = A^* + B^*.$

$= X^t \overline{A} \overline{Y} = (\overline{Y}^t A X) = (\overline{y}^* A X)^t$

$\boxed{X^t \overline{A} \overline{Y} = X^* A^* Y}$

True all x, y

$\overline{A} = A^t$

$A = A^*$ A herm:

If $A = \begin{vmatrix} a & b \\ c & d \end{vmatrix}$

$A^* = \begin{pmatrix} \overline{a} & \overline{c} \\ \overline{b} & \overline{d} \end{pmatrix}$

$A = A^*$ mean

$a = \overline{a}, d = \overline{d}, c = \overline{b}$

$\begin{pmatrix} r_1 & b \\ \overline{b} & r_2 \end{pmatrix}$

3b Looking for numbers $U_1 = ? \; U_2 = ?$ from 3a.

in n dimensions

2a $u_1 \; u_2 \; v_1 \; v_2$ could be any 4 vectors,

$A = u_1 v_1^T + u_2 v_2^T$ is a matrix. Rank?

$\begin{bmatrix} u_1 \end{bmatrix} \begin{bmatrix} v_1^T \end{bmatrix} + \begin{bmatrix} u_2 \end{bmatrix} \begin{bmatrix} v_2^T \end{bmatrix}$

ALAN REID

Alan Reid is Edgar Odell Lovett Chair and professor in the Department of Mathematics at Rice University. Previously, he was a Royal Society University research fellow and fellow of Emmanuel College at Cambridge, as well as an Alfred P. Sloan fellow. He was an invited speaker at the International Congress of Mathematics in Rio de Janeiro, Brazil in 2018. He is also a fellow of the American Mathematics Society.

In much of my work, I try to understand the geometric and topological properties of certain manifolds. Intuitively, an n-manifold is a space that looks locally like n-dimensional Euclidean space. So, for example, a 1-manifold looks locally like a small interval in a line, a 2-manifold (also called a surface) looks locally like a small disc on a table, and so forth. Manifolds are constructed in many ways, one of which is by identifying—that is, "gluing" together—faces of polyhedra. For example, the torus in dimension 2 is constructed by identifying opposite faces of a unit square.

In trying to understand a manifold, it is fruitful to look at the lower-dimensional manifolds (called submanifolds) that are embedded in them, for instance, great circles on a 2-sphere, circles on the 2-torus, surfaces in 3-manifolds, and so on. The pictures on this blackboard are an aid in attempts to study certain minimal-complexity hyperbolic 4-manifolds. The blackboard displays these manifolds in two dimensions (classical) and four dimensions (as constructed in the work of J. Ratcliffe and S. Tschantz). The figures on the blackboard help me visualize certain symmetries in a useful schematic way, which turn out to be important in the proof in the 4-dimensional case.

The blackboard is an important component in my work, particularly when I'm talking with my PhD students and other mathematicians. If I'm working alone, I tend to instead "doodle" on pieces of paper.

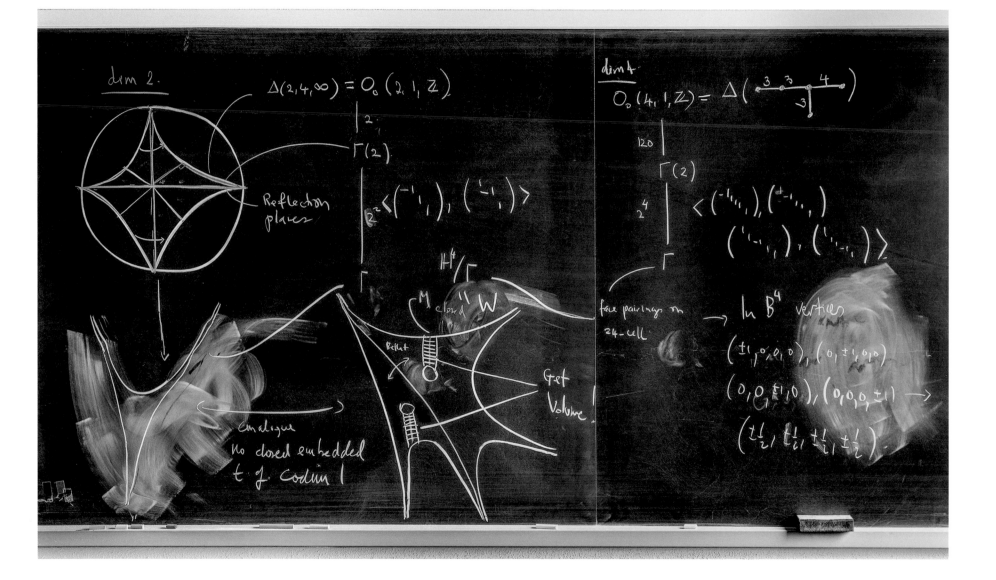

MARTIN BRIDGEMAN

Martin Bridgeman is a professor of mathematics at Boston College. He was born in Dublin, Ireland, and received his BA in mathematics at Trinity College Dublin. He received his doctorate in mathematics from Princeton University under the supervision of William P. Thurston. He has received grants from the National Science Foundation and has published numerous articles in mathematics. He was elected a Simons Fellow in 2013 and 2021, and was elected a fellow of the American Mathematical Society in 2018. Bridgeman has held visiting positions around the world, including the Institut Henri Poincaré in Paris, the National University of Singapore, and Massey University in Auckland, New Zealand.

Problems are often impossible to capture fully in a drawing, so drawing on a blackboard is part illustration, part simplification, and part abstraction. It can take years to solve a problem, and during that time, the drawing may hardly change, becoming a kind of daily incantation where you hope to eventually become enlightened.

With the vast expanse of the board to lay out your thoughts, a good approach is to present different ideas on separate parts and then try to connect them—convening in front of a blackboard is the moment when you really get down to work. The blackboard gives thoughts an immediate elegance and a feeling of significance, but allows for easy erasure if what you wrote turns out to be nonsense. The ability to erase is vital: few initial ideas work, and most end up being modified or thrown out. The blackboard often acts as a receptacle for an idea or a thought on a problem you're working on, and the simple act of seeing it daily on your office wall can spur a new insight. Sometimes the idea stays on the board for so long that you become embarrassed by your lack of progress and you erase it.

On the blackboard is a formula I discovered in 2009, while working on a seemingly unrelated problem. It describes the relation between the shape of the surface drawn and the lengths of a family of curves on it. The formula was subsequently named the Bridgeman identity by colleagues in the field. This identity is part of a family of dilogarithm identities that include ones discovered by Euler, Abel, and Ramanujan. The dilogarithm function is somewhat mysterious. It arises in many disparate fields, including geometry and number theory in mathematics, and quantum theory and string theory in physics. These identities point to a deeper connection between these fields that we have only just begun to understand.

Surface
with
geod
boundary

orthogeodesic

α

finite
Case
$n = 6$

α

2-bdy
Cusps

$N_S = 6$

$$\sum \mathcal{L}\left(\frac{1}{\cosh^2 \ell(\alpha)/2}\right) = -\frac{\pi^2}{12}\left(6\chi(S) + N(S)\right)$$

finite case

$$\sum \mathcal{L}\left(\frac{1}{\cosh^2 \ell(\alpha)/2}\right) = \frac{(n-3)\pi^2}{6}$$

NICOLAS CURIEN &
CYRIL MARZOUK

Nicolas Curien is a mathematics
professor at Université Paris-
Saclay. He is specialized in prob-
ability theory, and studies the
geometric properties of random
combinatorial objects such as ran-
dom planar graphs or random trees.
A common theme in his research
is the use of continuum random
objects (so-called scaling limits)
to describe asymptotic universal
properties of a class of random
discrete graphs.

Cyril Marzouk is assistant profes-
sor in mathematics at École poly-
technique, France. Specialized in
probability theory, he studies the
behavior of large random graphs
and other combinatorial structures,
focusing lately on the vivid theory
of random planar maps.

The blackboard in this photograph depicts our joint work on the "ant in the labyrinth" phenomenon on random planar graphs. This phenomenon was popularized by the Nobel Prize—winning physicist Pierre-Gilles de Gennes. Imagine an ant walking randomly in the streets of an ideal Manhattan two-dimensional grid. If, at each intersection, the insect chooses one of the four directions (north, south, east, or west) with equal likelihood and independently of the past, then, as Polya proved, it will visit all points of the grid infinitely often. Surprisingly, in dimension 3 or higher, a flying bug will eventually escape to infinity.

The central limit theorem implies that the ant needs on the order of n^2 steps to reach a large distance, n, from its starting point. In our random graphs, one should imagine that some of the streets of the grid are blocked, as in a labyrinth; this tortuous structure may produce dead ends and bottlenecks, which slow down the walking ant. The ant now needs n^c steps to reach distance n, with $c > 2$.

Our research makes extensive use of drawings and simulations, which are often the starting point for understanding the situations we study. Only large (preferably chalk-) boards offer the possibility of drawing several large pictures. Very useful when working alone, the chalkboard becomes indispensable when discussing with a collaborator or when teaching. The two of us actually met in front of a blackboard. Back when Cyril was a PhD student and Nicolas had just been appointed professor, we discussed possible research projects by drawing many pictures in the coffee room.

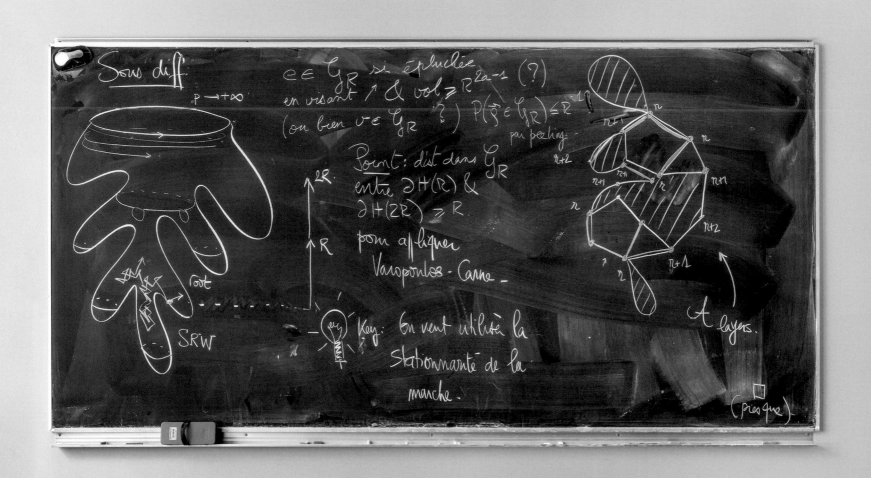

ANDRÉ NEVES

André Neves was born in 1975 in Lisbon, Portugal. He finished his PhD in 2005 at Stanford University under the direction of Richard Schoen and is currently a professor of mathematics at the University of Chicago. In 2016 he was awarded the New Horizons in Mathematics Prize and the Veblen Prize in Geometry, and in 2018 he was elected a Simons Investigator.

The work on this blackboard was developed in part with my collaborator, Fernando Codá Marques, during a Thanksgiving dinner in Palo Alto in 2011. My wife and our soon-to-be three-year-old daughter and newborn son enjoyed the party while Fernando and I obsessed over the Willmore conjecture, a well-known problem that proposes what ought to be the "optimal" shape among all doughnut-like shapes. Geometers love to think about these kinds of questions.

Fernando and I had developed a promising approach to solve the problem and felt that we were heading in the right direction, but we couldn't figure out the closing argument—the final piece that would hold all of the other pieces together. At some point that day, things clicked for us—it was the degree of the boundary map! (The degree of a boundary map is a number that, when nonzero, tells you that the map cannot be shrunk to a point.) This solution looked so natural and simple that we could tell we had pretty much nailed it. After that, we were able to just enjoy the rest of the day, and we met early the next morning to start ironing out the details of our proof.

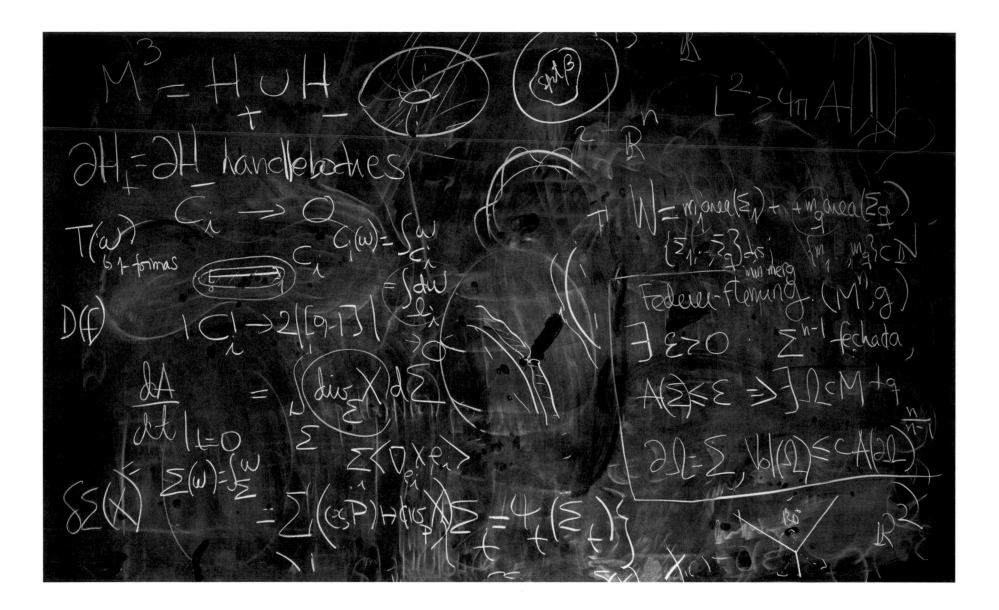

FERNANDO CODÁ MARQUES

Fernando Codá Marques was born
in São Carlos in 1979 and grew up
in Maceió, in the state of Alagoas,
Brazil. He received a BS from the
Federal University of Alagoas
in 1999 and a PhD from Cornell
University in 2003. He became a
professor at Princeton University
in 2014, after having worked at the
National Institute for Pure and
Applied Mathematics in Brazil.
He gave lectures at the 2010 and
2014 International Congresses of
Mathematicians and has received
honors such as the Ramanujan Prize
for Young Mathematicians from
Developing Countries and the AMS
Veblen Prize. He is a member of the
Brazilian Academy of Sciences.

I think there is an artistic component of writing with chalk on a blackboard. It is simple and elegant. It makes the action of writing slower, leading to contemplation. Whiteboards, by contrast, are not that appealing to me. Using chalk requires energy, which induces respect for the craft. Whenever possible, I give chalk presentations because I enjoy preparing my lectures on paper rather than doing slides.

In recent years, I have studied surfaces in three-dimensional spaces. People tend to think that equations can be satisfied only by numbers, but surfaces can satisfy equations too. The most fundamental equation associated with surfaces is the minimal surface equation, which has been studied since the eighteenth century. A minimal surface is in such a perfect position that the forces associated with surface tension, which act to decrease the total area, cancel one another out, and the surface is in equilibrium. This calculation of forces gives the actual equation the surface satisfies.

Soap films are physical models of minimal surfaces. Apparent horizons of black holes are also governed by the same equation. Minimal surfaces can have the shape of a sphere, or they can have a different topology, like that of a torus, the surface of a doughnut. (A torus is featured on the board.)

The appealing question to the geometer is whether these special surfaces exist in a given space, M. On this chalkboard, M represents a three-dimensional space with a given geometry. We can think of a three-dimensional analogue of the surface of the earth, which is two-dimensional. We can also think of the universe, which has three spatial dimensions and is curved according to general relativity. It has been known since 1981 that there is one solution to this question. Recently, there has been a revival in the subject, which has led to the discovery that there exists an infinite number of solutions. In fact, there are so many that minimal surfaces generally fill the space.

Mathematicians, like artists, are guided by an esthetic sense in their search for truth. This sense goes beyond the actual elegance of the mathematical symbols and diagrams. Every symbol written on the chalkboard corresponds to an idea. There is beauty in the unexpected ways different ideas relate to each other, revealing a wonderful and coherent structure.

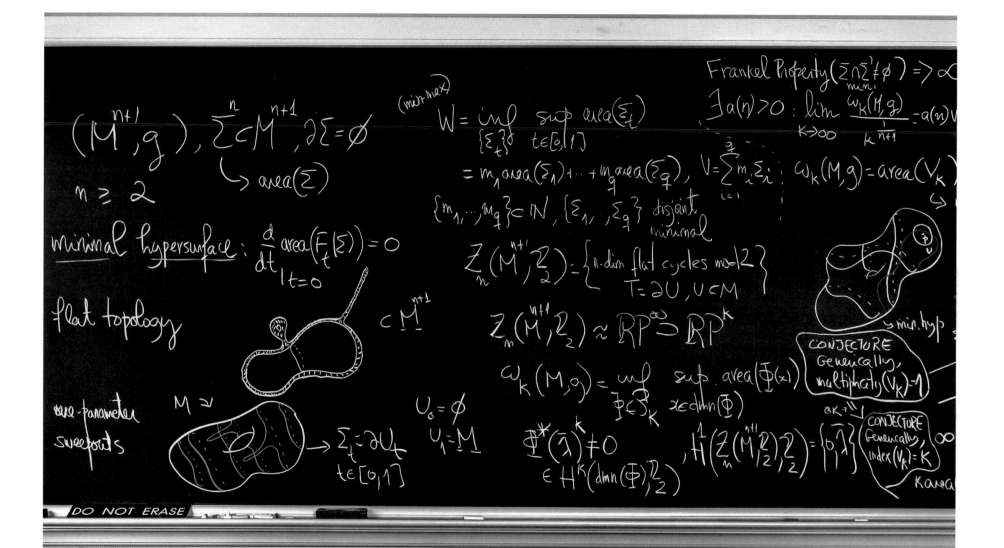

$(M^{n+1}, g), \quad \Sigma \subset M^{n+1}, \partial\Sigma = \emptyset$

$n \geq 2$

$\hookrightarrow area(\Sigma)$

minimal hypersurface: $\dfrac{d}{dt}\Big|_{t=0} area(F_t(\Sigma)) = 0$

flat topology

one-parameter sweepouts

$M \backsim$

$\longrightarrow \Sigma_t = \partial U_t$
$t \in [0,1]$

$\subset \underline{M}^{n+1}$

$U_0 = \emptyset$
$U_1 = \underline{M}$

(min-max)

$W = \inf_{\{\Sigma_t\}} \sup_{t \in [0,1]} area(\Sigma_t)$

$= m_1 area(\Sigma_1) + \cdots + m_q area(\Sigma_q), \quad V = \sum_{i=1}^{q} m_i \Sigma_i$

$\{m_1, \cdots, m_q\} \subset \mathbb{N}, \{\Sigma_1, \cdots \Sigma_q\}$ disjoint, minimal

$\mathcal{Z}_n(M^{n+1}, \mathbb{Z}_2) = \{$ n-dim flat cycles mod 2 $\}$
$\qquad T = \partial U, U \subset M$

$\mathcal{Z}_n(M^{n+1}, \mathbb{Z}_2) \approx \mathbb{RP}^{\infty} \supset \mathbb{RP}^k$

$\omega_k(M, g) = \inf_{\Phi \subset \mathcal{P}_k} \sup_{x \in dmn(\Phi)} area(\Phi(x))$

$\Phi^*(\bar{\lambda})^k \neq 0$
$\in H^k(dmn(\Phi), \mathbb{Z}_2)$

$H^1\left(\mathcal{Z}_n(M^{n+1}, \mathbb{Z}_2), \mathbb{Z}_2\right) = \{0, \bar\lambda\}$

Frankel Property $(\Sigma \cap \Sigma' \neq \emptyset) \Rightarrow \infty$
$\qquad\qquad\qquad\qquad$ min

$\exists a(n) > 0 : \lim_{k \to \infty} \dfrac{\omega_k(M,g)}{k^{\frac{1}{n+1}}} = a(n) V$

$\omega_k(M, g) = area(V_k)$

\hookrightarrow min. hyp

CONJECTURE
Generically,
multiplicity$(V_k) = 1$

$\partial k = 1, \cdots$

CONJECTURE
Generically,
index$(V_k) = k$

∞

Kawai

ÉTIENNE GHYS

Étienne Ghys is a French mathematician. His research focuses mainly on geometry and dynamical systems. He is currently a CNRS directeur de recherche at the École normale supérieure in Lyon. He received the 2015 Clay Award "for the dissemination of mathematical knowledge" and has been recently elected permanent secretary of the French Academy of Sciences.

MARCH 2009

I attended an administrative meeting in the Academy of Sciences in Paris, and the colleague sitting next to me was even more bored than I was. Obviously Maxim Kontsevich had something else on his mind. Suddenly, he passed me a Parisian métro ticket containing a scribble and a single word: "impossible." That was the new theorem he wanted to share with me! It took me a few minutes and some whispering before I could guess the statement of the theorem and a few more minutes to find the proof. I was fascinated: a new elementary result on four polynomials in 2009!

JULY 2009

I wrote a short paper in *Images des mathématiques*, an electronic journal aimed at the general public, presenting Kontsevich's theorem at a high school level. Immediately after writing this paper, it appeared to me that it was just the first step towards a more difficult and profound question so difficult that I could not solve it. I kept the question in the back of my mind.

OCTOBER 2012–MAY 2016

For almost four years, I have been fighting against this problem in a discontinuous way, depending on my mood. I am tired and irritated by my inability to make any reasonable progress. The problem that fascinated me is now irritating.

MAY 2016–NOVEMBER 2016

At the same time, the problem is wonderful, and I am eager to share this research area with others. I decide to write a book on this topic, hopefully one that is accessible to beginners.

NOVEMBER 2016

I ask a very young student to read this first draft. After a few weeks, he knocks on my door and explains that I have been looking at the problem the wrong way, and that if we were to look at it the other way around, we could hope for a fully satisfying result. He was right. The path to the solution was now wide open. I had a new collaborator, forty years my junior.

NOVEMBER 2019

I could present our joint work in an international meeting at Collège de France, Paris. Our paper is written and has been accepted for publication. Christopher-Lloyd Simon is now preparing his PhD under my supervision.

On the blackboard in this photograph, I wrote our theorem. It is about understanding the nature of what we call a singular point of a curve. Such a curve gives rise to a combinatorial object called a chord diagram. We proved that the chord diagrams coming from a singularity are precisely those that do not contain the specific examples that I drew on the blackboard.

For me, the blackboard is basically a good tool for teaching or for structuring a conversation with a colleague. When I was a beginner, I thought that a board could help me as a tool for suggesting ideas. I even convinced my wife that I should hang a blackboard in our bedroom, and I did so. Six months later, my wife was happy when I told her that it was useless and that we had enough chalk dust on our sheets; the board left the room . . . and never came back!

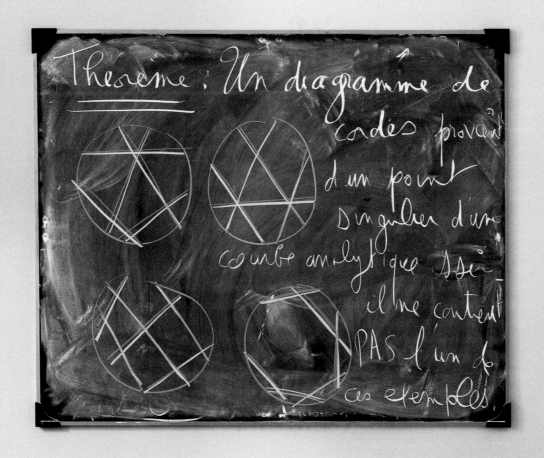

GEOFFREY ROGERS

Geoffrey Rogers is a physicist and
teacher working at the Fashion
Institute of Technology in New York
City, where he teaches courses in
color science. He has a PhD from
New York University. He does re-
search on the physics of color and
regularly publishes his work in
Color Research and Application and
the *Journal of the Optical Society
of America A.*

The field I work in is the physics of appearance, which
involves understanding why things look the way they do
in terms of the physics of light interacting with matter.
Most of my work is theoretical—I use mathematics in the
development of my theoretical models.

The calculation I wrote on this board is part of a
larger calculation that I have been working on for sev-
eral months. A number of years ago, I developed a model
of photon diffusion in nontransparent media based on a
photon random walk through the medium. The random walk
is a mathematical technique widely used in a number of
disciplines, including economics as well as physics. I
recently applied my random walk model of diffusion to
obtain the statistics of photons transmitted through a
translucent slab. I am currently extending this theory to
include the partial internal reflection of the photons at
the slab boundaries—the fact that a photon may be re-
flected back into the medium as it transits a boundary.
While this photograph was being taken, I was looking at
the calculation, and a different way of thinking about it
came to me, which eventually led to its solution.

I see mathematics not just as a tool but as a very deep
aesthetic process. I often know I am on the right track
when doing a calculation by the beauty of the expressions
that arise. Sometimes I know what the physical solution
should be, and I "force" the mathematics to reflect that
by going more deeply into the mathematical structure.
Sometimes an unexpected result appears that I later
find describes a physical characteristic that had not
occurred to me.

OFER GABBER

Ofer Gabber has been a CNRS research director at the Institut des hautes études scientifiques (IHES) since 1984. Over the past four decades, he has contributed to arithmetic and algebraic geometry, touching on many areas of these vast domains. In the early 1980s he proved several conjectures, and he has continued to do profound work ever since. He was awarded the Erdős Prize from the Israel Mathematical Union in 1981 and the Prix Thérèse Gautier from the French Academy of Sciences in 2011.

Trying to describe the chalkboard in this photograph makes me realize how the things that are so familiar and precise in my head can look obscure and confused from the outside. The symbols, scribbled down, illegible at times, denote objects in category theory whose definitions and properties are very clear inside my mind. Categories, commutative rings, morphisms, cohomology: these odd-sounding words constitute a language common to mathematicians through which I structure my thoughts and conversations every day.

It is this common language, which consists not only of words but also of symbols, that makes blackboards so functional to mathematics: an idea that might require a long sentence to be conveyed is summarized with extreme precision by a diagram. Arrows quickly drawn in between letters on a chalkboard have the power to clarify and make a discussion more precise as it unfolds.

I don't remember exactly when I elected mathematics as my main language. My mother recalls that at age ten or so, I decided to stop taking piano lessons because I wanted to do mathematics instead. Then, at sixteen, I was invited to start a doctoral program at Harvard, and at that point it was already clear to me that mathematics was what I was going to dedicate my life to.

Nowadays, I spend most of my time at the Institut des hautes études scientifiques, a research institute located in the verdant southern Parisian suburbs. When I am not in my office, you can find me wandering in the woods surrounding the institute. Walking helps me form my ideas.

Although my chalkboards might look messy, I am known within the mathematical community for my rare capacity to detect any small inconsistency. I make this skill available to colleagues and students who reach out to me for feedback and help. Much of my work nowadays gets done through these correspondences. More than on blackboards, traces of my insights are to be found in the letters and e-mails I have exchanged over the years.

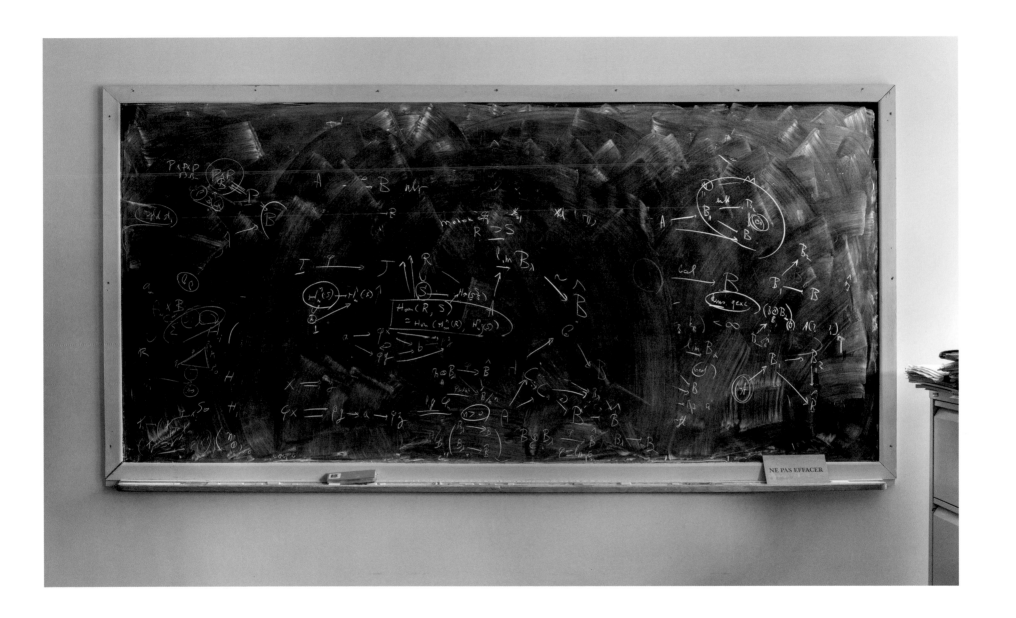

CLARK BUTLER

Clark Butler received his PhD in mathematics at the University of Chicago in 2018, Since then, he has been working as a Veblen Research Instructor at Princeton University, which is a joint appointment with Princeton and the Institute for Advanced Study.

Most often, when I am at the blackboard, it is with a partner from one of my research collaborations. During our time together, we will produce mosaics, built from fragments of concepts that we have combined in (hopefully) novel ways. The result is often a collection of smaller pictures that combine into a loosely organized story, which we then use as a launchpad for the next stage in our project.

The blackboard depicted here was created during discussions with Jairo Bochi, a mathematician working at the Pontifical Catholic University of Chile. The left side shows some motivating discussion for the problem that we were considering. The right side is a collection of equations governing the phenomenon that we were studying. The middle is a visualization we created that shows these equations in motion. We noted that it looks something like the pages of a book being flipped around its spine. This research project is still ongoing.

I'm happy to be able to provide a window into the working lives of mathematicians. I think non-mathematicians would be surprised at how concrete our thinking is, and how many analogies we draw to everyday objects and experiences.

$\rightarrow \pi^{lm}$ lin, toral
automorphism

turbation of f.

fiber
bunched

$E_1^f \oplus E_2^f$

$\lambda_1 > \lambda_2 > 0$

exponents

$E_1^g \oplus E_2^g$ dom splitting

$+ (Dg | E_2^g, \nu) = \lambda_-(Dg | E_2^g, \nu)$

all inv. measures ν

0-Hölder

\Rightarrow Cts amenable reduction

of $Dg | E_2^g$.

"book"

V_w^l

\tilde{w}

H^u

\hat{u}

V_w^2

V_w^n

\hat{p}

\hat{z}

E_1

E_3 E_2

$\psi_{z_1, \ell}$

$\dot{f}^\ell(z)$

$f_{z_2}^{-\kappa}$ $f^{-\kappa}_{z_1}$

z_2 \hat{p} z_1

A const.

$\psi_{z, \ell} = A^\ell(z) \circ H^u_{p \rightarrow z}$

$= A^\ell(z) \circ A^\kappa(f^{-\kappa}_z) H^u_{p \rightarrow f^{-\kappa} \circ}$

$= A^{\ell+\kappa}(f^{-\kappa}_z) \circ A^{-\kappa}(p)$

$\psi_{z_2, \ell} \circ \chi_{z_1, \ell} = A^{\ell+\kappa}(f^{-\kappa}_{z_2}) \circ A^{-\kappa}(p)$

$\circ A^{\ell+\kappa}(f^{-\kappa}_{z_1}) \circ A^{-\kappa}(p)$

$\psi_{z_1, \ell} \circ A^\kappa(p) \circ \psi_{z_1, \ell} \circ A^{-\kappa}(p) = A^{\ell+\kappa}(f^{-\kappa}_{z_2}) \circ A^{\ell+\kappa}(f^{-\kappa}_{z_1})$

$\tilde{=} A^\ell(w)$

$\psi_{z_2, \ell} \circ A^\infty \circ \psi_{z_1, \ell} \tilde{=} A^\infty(V)$

JOSÉ EZEQUIEL SOTO SÁNCHEZ

José Ezequiel Soto Sánchez is a research assistant at the Visgraf Lab at IMPA, in Rio de Janeiro, where he obtained his PhD degree in mathematics, in the area of computer graphics. His current research is in geometric patterns, tilings, and tessellations. He is also interested in geometric processing, digital fabrication, mathematical visual arts, and computational music. He has many years of experience in math education and communication, and he continues to develop education and popularization tools.

Some of my earlier memories related to mathematics involve car rides and conversations with my family. My father would pose puzzles and problems to give us something to think about. Usually, the problems were too advanced for me, since they were addressed to my older siblings. Some of the puzzles were from Yakov Perelman's book, *Arithmetic for Entertainment*. I proceeded to spend several summers reading it, thinking about the problems in it, and solving them. Mathematics and puzzles became life passions for me.

Before going to college, I spent a year teaching in a high school in Jaltepec, an indigenous community in Oaxaca, Mexico, using the chalkboard a lot. I was very young, and my only resource for teaching was to imitate the best practices I had seen in my student years. (Luckily, I had good teachers.) After teaching for a year, I went to the applied mathematics program at ITAM, in Mexico City, where I spent long hours in front of the green chalkboards in the library study rooms, discussing problems from class, drawing things, and even playing games with colleagues on them. It was there that I developed most of my chalkboard skills. Sometimes, my mates would ask me to write out solutions on the board because of the clarity of my writing.

After graduating with my degree in applied math, I spent several years teaching and developed an even deeper relationship with the chalkboard. I used colored chalk to draw pictures, graphics, and diagrams that illustrated my explanations, and to highlight important parts of texts and solutions. My students used to complain about it, claiming they didn't have enough colors to copy the notes as they were.

I then spent some years away from chalkboards, using only paper and the computer for consulting jobs and entertainment. When I moved to Brazil in 2012, with few employment options, I started a master's in engineering at the Universidade Federal do Rio de Janeiro. In 2016, I was accepted to the applied mathematics to computer graphics program at the Instituto de Matemática Pura e Aplicada. Most of the work that we do involves discussing ideas on the chalkboard and translating them to computer code. When I first arrived at IMPA, one of the first things that caught my attention was the chalkboards—there were so many of them all over the place. There is one in the coffee room and several in the corridors, and the classrooms have entire walls covered with them.

My research focuses on periodic tilings of the plane with regular polygons. The chalkboard in the photograph has an example of these. The central question is: how many ways are there to make a periodic tiling of the plane with regular polygons? The research requires a lot of visual support to make it comprehensible, and all the results happen to be drawings: periodic wallpaper patterns with regular polygons, which have a mesmerizing beauty. In any meeting with my advisors or colleagues, we use the chalkboard a lot to explain ourselves and discuss ideas. At the end, the chalkboard is frequently filled with sketches, notes, and equations. It is always a pleasure to admire it and take a photo before leaving the room.

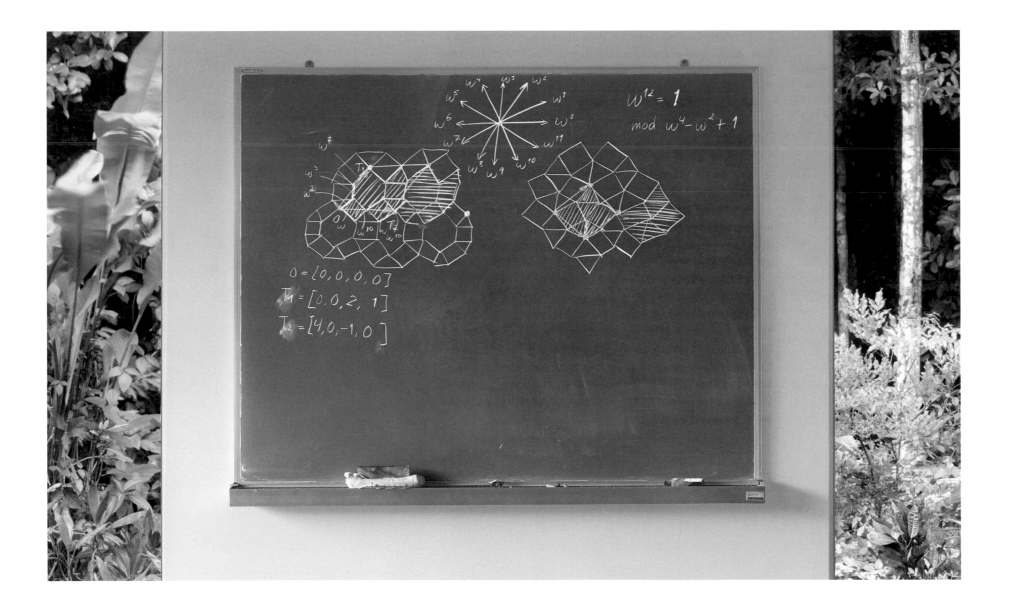

ANA BALIBANU

Ana Balibanu is a Benjamin Peirce
Fellow and NSF postdoctoral fellow
in the mathematics department at
Harvard University.

I like chalkboards because they are so simple and so tac-
tile. When you write on a board, you feel the chalk wear-
ing down, and you feel the texture of the board through it.
Because your space is so limited, you can't write an end-
less jumble of words. The simplicity of the board forces
you to bring the same simplicity and clarity to your
thoughts. It forces you to distill your own ideas down to
something meaningful.

This chalkboard has a schematic outline of a project
about a family of geometric objects called Hessenberg
varieties. An individual Hessenberg variety can be very
complicated—inscrutable, even. Instead, we have to con-
sider all possible Hessenberg varieties together and un-
derstand the relationships between them. Their geometry
then becomes clear through the way they interact.

The diagrams on the board map out these interactions,
and the arrows show how different Hessenberg varieties
can be deformed into one another. The lists are specu-
lations about which direction the results might take.
(In hindsight, some of them are true and some of them
are not.) The board is a snapshot of an exciting moment
in the project—there are many uncertainties, but also
many possibilities.

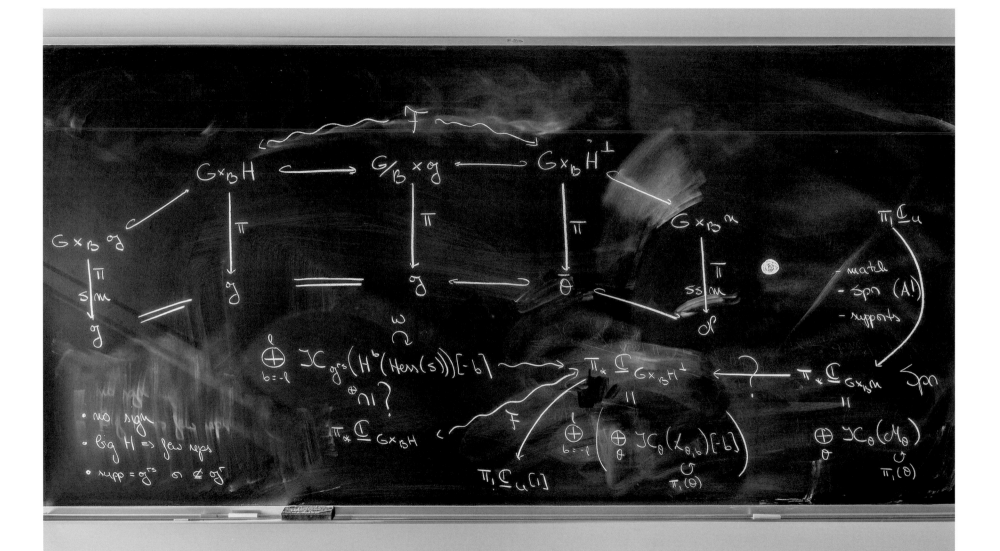

LAUREN K. WILLIAMS

Lauren K. Williams is the Dwight Parker Robinson Professor of Mathematics at Harvard and the Sally Starling Seaver Professor at the Radcliffe Institute. Before coming to Harvard, she was a faculty member at UC Berkeley from 2009–2018. She is a fellow of the American Mathematical Society and a recipient of the AWM-Microsoft Research Prize.

Arrangements of stones
reveal patterns in the waves
as space-time expands

This is the haiku abstract for a paper, "Combinatorics of KP solitons from the real Grassmannian," that I wrote a few years back with Yuji Kodama. The paper is about the patterns that one sees in certain solutions of the KP equation, which in turn are supposed to model the interaction of shallow water waves, like beach waves. One can analyze where in the plane a solution of the KP equation takes on its maximum values—or, roughly speaking, where a configuration of waves will have their peak. My blackboard shows some of the possibilities for the peak sets of solutions of the KP equation.

From the time I was in elementary school, I enjoyed math and loved finding patterns. I don't think there was any particular moment when I decided to become a mathematician, but in college it occurred to me that I'd try following the academic path and see if it worked out.

Much of mathematical research is fairly routine: you try to understand the related work and results, you do lots of examples, maybe write computer code. You want to identify the patterns in what might look like chaos and figure out the underlying reasons for the structure that you see. Most of the time, you're probably stuck and it's frustrating. But every once in a while, if you're sufficiently steeped in the problem at hand, some idea or insight might fall into your brain, and that can happen at the most random times: maybe you're sitting in a dark room, rocking your baby to sleep, or sitting in a concert hall half-listening to a Mahler symphony.

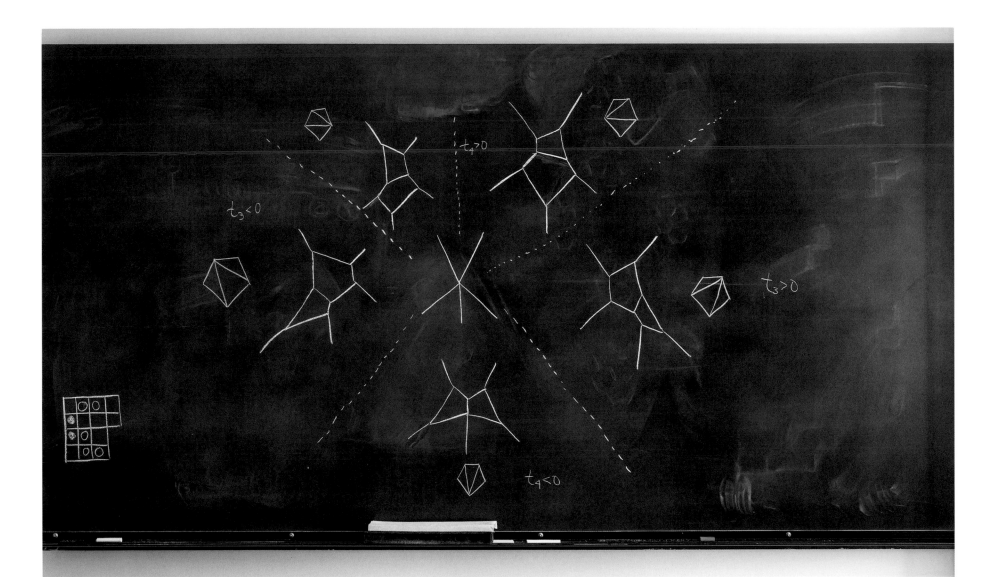

ANKUR MOITRA

Ankur Moitra is an associate professor in the Department of Mathematics at MIT. He is a principal investigator in the Computer Science and Artificial Intelligence Lab and a core member of the Theory of Computation Group, Machine Learning@MIT, and the Center for Statistics. The aim of his work is to bridge the gap between theoretical computer science and machine learning by developing algorithms with provable guarantees. He is the recipient of a Packard Fellowship, a Sloan Fellowship, an ONR Young Investigator Award, an NSF CAREER Award, an NSF Computing and Innovation Fellowship, and a Hertz Fellowship.

Mathematics is about truth and beauty, but I spend most of my time being confused. When you start working on a new problem, it is hard to know what makes it challenging. You try a few things, and the problem fights back. Sometimes months or even years later you look back, and your early attempts seem so naive. But that also gives you confidence in how much you've learned about your opponent along the way.

The days when things seem clear are few and far between. I actually find them quite exhausting. For me, when I can finally see a clear path towards solving a problem, I can't keep my mind on anything else. I can't sleep, and sometimes I wake up in the middle of the night and pace for hours. I scribble furiously, and I sit in every chair in the house, as if the solution I'm looking for is just a change of scenery. I'm sure this behavior seems pretty weird to non-mathematicians, but you just become so invested in some problems over time.

In the beginning, I secretly dreaded being confused. I always felt like it was some fault or limitation of my own. But I think over time you learn to embrace these things. I even find it exhilarating, like I'm exploring some new uncharted territory. So what if I don't know where I'm going? I'll figure it out. And when you finally solve a problem and get to go around giving talks about it, and teaching other people about it, it's like chronicling your adventures. And what kind of adventure would it be, if it weren't tough and uncertain the whole way up the mountain?

The proof depicted on the board might be my personal favorite (among my own papers, that is). It shows that the first six moments uniquely determine a mixture of two Gaussians. I was working with Adam Kalai and Gregory Valiant, and this was the last step we needed to get learning algorithms with provable guarantees. We had all sorts of ad hoc ways of attacking the problem, some of which were honestly quite ugly. But then we found a proof that was simple, and showed us why six moments suffice in a visual way that, once you see, you can never unsee.

MITCHELL FAULK

Mitchell Faulk is a postdoctoral scholar in the math department at Vanderbilt University. He received his PhD in 2019 from Columbia University under the direction of Melissa Liu. His research is centered upon understanding the existence of canonical metrics in complex geometry.

A chalkboard, if I were to try to give a precise definition, is a tool made of dark slate that can be marked with sticks of calcium sulfate. But this sterile definition is misleading: it fails to address the human element inherent to this timeless medium.

A board is, after all, just a blank canvas. Its contents, on the other hand, are completely up to the person wielding the chalk. And it is through this unrestricted manner of self-expression that the medium becomes one of art.

What is marked upon the board, how that marking is done, and when—all are a reflection of the person doing the marking. The white dust, organized into symbols that are themselves organized around the sections of the board, adheres to the dark surface as fingerprints of a mind at work.

Some markings are expository. Deliberate, organized, precise—these marks adorn boards intended for observation, the permanent residents of classrooms and lecture halls, where they are proudly displayed, even gliding up and down for better viewing. Other markings, however, are enigmatic. Personalized hieroglyphics, these marks are scribbled in haste in an attempt to record novel, fleeting ideas, dreamt up in research offices amid stacks of books and papers.

What all these marks have in common—and likely what makes them most alluring—is the theme of impermanence. A small imperfection can be scrubbed instantly with just the tip of a finger. An entire board of bogus calculations can be brushed briskly from existence, leaving only inscrutable piles of dust as evidence.

I can't remember exactly what it was that I wiped from the board in this photograph. At the time the picture was taken, I was reading about toric varieties, which are an important class of examples in algebraic geometry obtained from combinatorial descriptions. Their explicit nature facilitates computations, and so they represent a fertile testing ground for results and conjectures. It seems plausible that what I initially wrote—then erased—was related to these readings, although, with erasure marks as the only lasting evidence, I'm unable to venture anything more certain than a conjecture.

This ephemeral nature of expression is perhaps what is most reinforced by the chalkboard. A thought is, after all, only finite in time and, despite one's best efforts, seems to escape attempts to capture it in its entirety.

AFTERWORD

Mathematicians know what mathematics is but have difficulty saying it. I have heard: Mathematics is the craft of creating new knowledge from old, using deductive logic and abstraction. The theory of formal patterns. Mathematics is the study of quantity. A discipline that includes the natural numbers and plane and solid geometry. The science that draws necessary conclusions. Symbolic logic. The study of structures. The account we give of the timeless architecture of the cosmos. The poetry of logical ideas. A means of seeking a deductive pathway from a set of axioms to a set of propositions or their denials. A science involving things you can't see whose existence is confined to the imagination. A precise conceptual apparatus. The study of ideas that can be handled as if they were real things. The manipulation of the meaningless symbols of a first-order language according to explicit, syntactical rules. A field in which the properties and interactions of idealized objects are examined. The science of skillful operations with concepts and rules invented for the purpose. Conjectures, questions, intelligent guesses, and heuristic arguments about what is probably true. Laboriously constructed intuition. The largest coherent artifact that's been built by our civilization. The thing that all science, as it grows toward perfection, becomes. An ideal reality. No more than a formal game. What mathematicians do, the way musicians do music.

Bertrand Russell said that mathematics is "the subject in which we never know what we are talking about, nor whether what we are saying is true." As for other scientists, Darwin said, "A mathematician is a blind man in a dark room looking for a black cat which isn't there." Lewis Carroll wrote that the four operations of arithmetic

(addition, subtraction, multiplication, and division) were ambition, distraction, uglification, and derision. A complicating circumstance is that mathematics, especially in its higher ranges, *is* hard to understand. It begins as a simple, shared language (everyone can count) and becomes specialized into dialects so arcane that some of them are spoken by only a few people in the world.

Some mathematicians regard mathematics as a story that has been being written for thousands of years, is always being added to, and might never be finished. No scripture is as old. More than history, mathematics is the record that humanity is keeping of itself. History can be revised or manipulated or erased or lost. Mathematics is permanent. $A^2 + B^2 = C^2$ was true before Pythagoras attached his name to it, and will be true when the sun goes out and no one is left to think of it. It is true for any alien life that might think of it, and true whether they think of it or not. It cannot be changed. So long as there is a world with a horizontal and a vertical, a sky and a horizon, it is inviolable and as true as anything that can be said.

None of these thoughts is my own and they are, to a degree, a kind of boilerplate, but even so I find them fascinating. Mathematicians live within a world that is certain. The rest of us, even the scientists in other disciplines, live within one where what represents certainty is So-far-as-we-can-tell, this-result-occurs-most-of-the-time. Because of Euclid's insistence on proof, mathematics can tell us, within the range of what it knows, what happens time after time.

Mathematics is the most explicit language we have for the description of mysteries. Being the language of physics, it describes actual mysteries—things we can't

see clearly in the natural world, suspect are true, and later confirm—and imaginary mysteries, things that exist only in the minds of mathematicians.

A question is, Where do these abstract mysteries exist? What is their home range? Some people would say that they reside in the human mind, that only the human mind has the capacity to conceive of what are called mathematical objects—meaning numbers and equations and formulas and so on, the whole glossary and apparatus of mathematics—and to bring these into being, and that such things arrive as they do because of the way that our minds are structured. We are led to examine the world in a way that agrees with the tools that we have for examining it. (We see colors as we do, for example, because of how our brains are structured to apprehend the reflection of light from surfaces.) This is an informed but minority view, held mainly by neuroscientists and a certain number of philosophers and mathematicians inclined toward philosophy. The more widely held view, but perhaps only slightly, is that no one knows where math resides. There is no mathematician/naturalist who can point somewhere and say "That is where math comes from." The belief that mathematics exists somewhere else than within us, that it is discovered more than created, is called Platonism, after Plato's belief in a non-spatiotemporal realm that was the region of the perfect forms of which the objects on Earth were imperfect reproductions. By definition, the non-spatiotemporal realm has always existed, is outside time and space, and is not the creation of any deity. A third point of view, historically and presently, for a small but not inconsequential number of mathematicians, is that the home of mathematics is in the mind of God.

Georg Cantor, the creator of set theory, said, "The highest perfection of God lies in the ability to create an infinite set, and its immense goodness leads Him to create it." And Srinivasa Ramanujan said, "An equation for me has no meaning unless it expresses a thought of God."

Like artists, mathematicians often work at the edge of what they know, in a twilit territory. Arriving at a problem worth considering is sometimes an interior adventure that takes a lot of effort and covers a lot of ground, not all of it conscious. With old and venerable problems, it is a little like standing in front of a citadel and planning an assault under what, from the reports of many others who have tried, appear to be impossible circumstances.

Wynne's photographs are select dispatches from the territory of complex mathematical reasoning. Some represent frontiers of human thought, problems that are still being considered and worked on. Some are explanations, some are narratives, and some are speculations. The formulas and drawings seem to vibrate, as if they had a life of their own. They remind me of the hallucinations I had when I was young, taking LSD, seeing writing I could almost read in the grain of a piece of wood and thinking, If I could understand this, I would understand everything.

The people who made these drawings and wrote these formulas and explanations don't understand everything, but they are in pursuit of new knowledge, much of which might serve no practical purpose other than to enlarge mathematics. Nevertheless, even if modestly, something they learn might be something that no one has ever known before.

The chalkboard images are symbols in the sense that they are directions left for returning to where the

thinking concluded or for reconstructing a series of thoughts. Their texts could be reassembled anywhere in the world by people unable to speak to each other except in the language of mathematics, which is universal. If you erased the images on the chalkboards they would still exist as entries in the big book of mathematics.

These photographs document years of learning and thinking. As portraits might, they personify a state of mind, character, and something about the workings of the inner life. Their chasteness reminds me of the photographs of farmers and field hands and their families made by Disfarmer in his studio in Arkansas in the early twentieth century. Wynne's photographs of these drawings and equations have a similar staring-back-at-you, stripped down quality, as if revealing their essential natures. They portray the liveliness of a thought enacted, as if Wynne had traced the pattern of a dance. Her close eye seems to follow each line. The photographs have the fixed sense of a document, but they suggest motion, too, in the movement of the hand. All of them typify the mathematician's historic engagement with beauty. They also have the immediacy of an encounter, of a creature met on its home ground. Some of the chalkboards are so alluring that I imagine Wynne almost catching her breath on first seeing them. Her interest is not only in their formal appearance but also in the layers of meaning that each board suggests. There is the explicit meaning of their first impression, but there are further meanings in the erasures and redrawings and the progress of the reasoning, as if they were unfolding in time.

In all, the photographs are a kind of testimony, a record of a belief in the higher powers of human thought, and that speculative thinking has merit even if it is not useful in any obvious way, as very little of abstract mathematics is. Pure math it is called, which has a suggestion of nineteenth-century snobbishness to it—and perhaps was intended to, the way poets sometimes regard their writing as loftier than prose. Nevertheless, there is a distinction to be made between pure thought and practical thought that is something like the one between, say, a poem and a piece of simple reporting, and it is one that Plato would have made, too. It is difficult to say whether mathematics is an art or a science or both.

The mathematician Alain Connes has said that in mathematics the word "exist" means exempt from contradiction. Each of these elegant photographs preserves a detail in the canvas of rigorous human thought.

—Alec Wilkinson

ACKNOWLEDGMENTS

There are many people whom I would like to thank for their support along the way:

Amie Wilkinson and Benson Farb, for your friendship and generosity. You are the inspiration for this book, and I am eternally grateful to you both for opening up your world to me.

The following friends, who have guided me over the years: Abelardo Morell, Alec Wilkinson, Amiee Savage, Banks Tarver, Brooke Singer, Catharine Tarver, Christina Roccos, Curtis Willocks, Dara Gottfried, Deborah Klesinki, Dennis Overbye, Doug Kehl, Elisabeth Biondi, Eugenia Kaye, Gregory Crewdson, Irwin Miller, Joel Smith, Jordon Ellenberg, Lewis Tarver, Mary Ann Haase, Matt McCann, Mia Fineman, Natan Last, Nicole Hyatt, Peter Cohen, Rebecca Karamehmedovic, Reagan Louie, Sara Barrott, Todd Jatras, Walker Tarver, William Wegman, and William L. Schaeffer.

Everyone at Edwynn Houk Gallery, for their support, especially Edwynn Houk, Christian Houk, and Veronica Houk.

My editor, Susannah Shoemaker, and editorial assistant, Kristen Hop, for their patience and guidance in making this book. To Vickie Kearn, for her insight. And to my incredibly talented designer, Chris Ferrante.

To all of the mathematicians, thank you for letting me have a glimpse into your universe. And a special thanks to André Neves, Deane Yang, Hélène Esnault, Helmut Hofer, Jim Simons, Misha Gromov, Philip Ording, Sahar Khan, Shuai Wang, Sylvain Crovisier, and Zeze (Maria) Pacifico.

Finally, my gratitude and appreciation for my family. Especially my parents, for their love and encouragement. And, most importantly, to my daughter Molly, for always inspiring me.

THE MATHEMATICIANS

Ian Adelstein 26
Noga Alon 52
Yves André 96
Paul Apisa 78
Denis Auroux 50
Artur Avila 134
Ana Balibanu 212
Laura Balzano 22
Yves Benoist 164
Enrico Bombieri 166
Mario Bonk 102
Alexei Borodin 34
Jean-Pierre Bourguignon 104
Tai-Danae Bradley 82
Martin Bridgeman 194
Clark Butler 208
Keith Burns 62
Frank Calegari 132
Sun-Yung Alice Chang 118
Alain Connes 44
Gilles Courtois 12
Sylvain Crovisier 56
Nicolas Curien 196
David Damanik 126
Camillo De Lellis 150
Laura DeMarco 156
Lorenzo J. Diaz 80
Nathan Dowlin 70
Matthew Emerton 36
Hélène Esnault 24
Benson Farb 8
Mitchell Faulk 218

Bassam Fayad 146
Jonathan Feng 66
Simion Filip 72
David Gabai II
Ofer Gabber 206
Isabelle Gallagher 138
Wilfrid Gangbo 10
Katrin Gelfert 124
Silvia Ghinassi 48
Étienne Ghys 202
Misha Gromov 32
Nate Harman 140
Michael Harris 64
Nancy Hingston 186
Helmut Hofer 184
Peter Jones 100
Bruno Kahn 178
Linda Keen 98
Sahar Khan 30
Bryna R. Kra 174
Patrice Le Calvez 74
Dan A. Lee 154
Yang Li 60
Roy Magen 128
Alexei A. Mailybaev 114
Grigory Margulis 110
Fernando Codá Marques 200
Cyril Marzouk 196
Dusa McDuff 86
Govind Menon 144
Philippe Michel 2
Maggie Miller 14

Ankur Moitra 216
John Morgan 182
Ronen Mukamel 68
Audrey Nasar 152
André Neves 198
Ka Yi Ng 84
Hee Oh 38
Kasso Okoudjou 40
Philip Ording 20
Stan Osher 116
Maria José Pacifico 172
Jacob Palis Jr. 112
Jonathan Pila 162
Rafael Potrie 176
Eden Prywes 170
Enrique Pujals 54
Vinicius G. B. Ramos 188
Alan Reid 192
Esther Rifkin 142
Philippe Rigollet 148
Geoffrey Rogers 204
José Ezequiel Soto Sánchez 210
Will Sawin 28
Leila Schneps 158
Jalal Shatah 42
Dimitri Y. Shlyakhtenko 58
Peter Shor 108
James H. Simons 130
Boya Song 180
Christina Sormani 106
Gilbert Strang 190
Terence Tao 6

John Terilla 76
Tadashi Tokieda 16
Virginia Urban 120
Marcelo Viana 94
Nicholas G. Vlamis 88
Claire Voisin 136
Jan Vonk 160
Shuai Wang 18
Amie Wilkinson 4
Lauren K. Williams 214
Calvin Williamson 92
Peter Woit 168
Jared Wunsch 90
Deane Yang 46
Eric Zaslow 122

Published by Princeton University Press
41 William Street, Princeton, New Jersey 08540
6 Oxford Street, Woodstock, Oxfordshire OX20 1TR

press.princeton.edu

Library of Congress Cataloging-in-Publication Data

Names: Wynne, Jessica, 1972- author, photographer.
Title: Do not erase : mathematicians and their chalkboards / Jessica Wynne.
Description: Princeton : Princeton University Press, [2021] | Includes index.
Identifiers: LCCN 2020040062 | ISBN 9780691199221 (hardback)
Subjects: LCSH: Blackboards. | Mathematics—Study and teaching. | Mathematics—Equipment and supplies. | Mathematicians—Biography.
Classification: LCC QA16 .W96 2021 | DDC 510.028/4—dc23

LC record available at https://lccn.loc.gov/2020040062

British Library Cataloging-in-Publication Data is available

Printed on acid-free paper. ∞

Printed in Italy

10 9 8 7 6 5 4 3 2 1

Editorial: Susannah Shoemaker and Kristen Hop
Production Editorial: Mark Bellis
Text and Cover Design: Chris Ferrante
Production: Steve Sears
Publicity: Matthew Taylor and Kathryn Stevens
Copyeditor: Molan Goldstein

Typefaces: Hermes Condensed (Optimo) and Pantograph (Colophon)
Typesetting: BookComp, Inc., Belmont, Michigan
Paper: 150gsm Sappi Magno Satin
Separations: Professional Graphics Inc., Rockford, Illinois
Printing and Binding: Graphicom, S.p.A., Verona, Italy

Frontispiece: Chalkboard of David Gabai, Princeton University
Cover: Chalkboard of Laura Balzano, University of Michigan